SUPPORT NETWORKS

Cover images
Front: "How We Learn" program series organized
by AREA Chicago with Stockyard Institute and
Neighborhood Writing Alliance, presented at
the Hyde Park Art Center, Chicago, as part of the
exhibition *Pedagogical Factory*, 2007. Courtesy of
AREA Chicago and Stockyard Institute.
Back: Chick Loehr, portable signboard, 1994.
Courtesy of John Ploof. Signs: Teamer's Signs.

The School of the Art Institute of Chicago
Department of Exhibitions and Exhibition Studies
Sullivan Galleries
33 S. State Street, 7th floor
Chicago, Illinois 60603
www.saic.edu/exhibitions

Series Editors
Mary Jane Jacob and Kate Zeller

Editorial Assistants
Raven Munsell
Elisabeth Smith

Design
Jess Mott Wickstrom

Design Concept
Corey Margulis

Copyeditor
Jeremy Ohmes

Print
The University of Chicago Press

Distribution
The University of Chicago Press
1427 E. 60th Street
Chicago, Illinois 60637

ISBN-13: 978-0-982-87985-6

The *Chicago Social Practice History Series* was
developed by the School of the Art Institute
of Chicago's Department of Exhibitions and
Exhibition Studies as part of the series of
exhibitions, programs, and symposium launched
in 2014 as "A Lived Practice."

Chicago Social Practice History Series

SUPPORT NETWORKS

Edited by Abigail Satinsky
Series Editors Mary Jane Jacob and Kate Zeller

The School of the Art Institute of Chicago
Distributed by the University of Chicago Press

CONTENTS

Preface

Mary Jane Jacob

Chicago—one satellite orbiting in the constellation of the art world. That's how it used to go. In the early twentieth century, when New York was trying to affirm its status and overtake Paris, to be outside Manhattan was to be dubbed a style at best ("regionalism") or be simply invisible. By postwar, with identity as the center won by New York, all else was defacto provincial, second-string. Meanwhile Chicago took it as a moniker, an improvisational theater that opened its doors in 1959 made it a brand, and the self-determination of this second city came to mark the indefatigability of local culture here. But mid-century also felt the gravitational force of what Arthur Danto dubbed "the artworld." While in his well-known 1964 essay the philosopher was seeking to explicate the conceptual relationship of the new art (Pop Art) to knowledge of art theory and art history, this term increasingly came to signify the place of professionals, commerce, and power, and of who's in and who's out as the times bore out.

In Chicago the art world has been about association, some formally named, others ready to access when a call is made or to find faith in just knowing that others like you are out there. In the classroom I often say: look around; these are your colleagues, not just for the semester but potentially for your professional life. This is not a lesson in networking. It is the possibility of community that can come about within a supportive network. Among these like-minded doers and thinkers who found each other in classrooms at the School of the Art Institute were Abigail Satinsky, Bryce Dwyer, Roman Petruniak, and Ben Schaafsma, who in 2007 created InCUBATE (the Institute for Community Understanding Between Art and

the Everyday), later joined by collaborator Matthew Joynt. As emerging arts administrators, they were looking to rethink functional operations and just what this profession could mean when it came into union with other creative individuals. Their hallmark became Sunday Soup, which is addressed in this volume in Dwyer's recount of ethical innovations in arts funding.

What is addressed here instead, and what today's artworld overshadows, is the human story behind the working mechanisms of making, showing, and sharing art; motivations sparked with a sense of necessity; and the organicism of the processes at play which are always relational. Satinsky's own role as an organizer, writer, and listener has included bringing people together in the same room, whether from around the city or across the country, to be at least for a time a community in conversation. Such efforts matter because, wherever they seem to end up, they are always generative in the long run. Satinsky's fine introduction sets out those terms through her personal experiences that manifest the reasons why she does what she does. Her evocation of John Dewey's understanding of community—as simultaneously a democratic way of being and a way of continually enacting democracy—find its relevance as much in the push-and-pull discourse of social practice today, as in Chicago's social and artistic alliances, that is, in the reality of this place in which Dewey's own ideas took form.

This volume is part of a larger effort to come to terms with where Chicago fits into the part of the art world that today we call social practice. In the course of our research, Dewey and his comrade-in-arms Jane Addams were historical touchstones, for their long lineage is widely respected among artists and activists here. The program within which this publication series is nestled, *A Lived Practice*, also includes two other chief aspects: the exhibition *A Proximity of Consciousness: Art and Social Action* and a symposium around the intersection of a life practice and an artistic practice. *Support Networks* remembers alliances over the decades and the work brought about when artists join with each other, as well as with those who, at first glance, might seem to be outside the artworld. It seeks to convey what it is to be together productively, creatively, and dare I say, authentically. For that we at SAIC and the editor thank all who generously participated in sharing their words and images with you, the reader.

As editor, Abigail Satinsky would like to thank Shannon Stratton whose vision for an artist-centric organization led to the establishment of Threewalls, a mainstay of the Chicago art community. She acknowledges that it was Stratton who kept her in Chicago upon graduation and thanks her for that as well as for providing the kind of work environment that creates space for research and critical inquiry. She thanks Anthony Romero for feedback on the texts and support along the way. InCUBATE has remained a part of Satinsky's life, and there she thanks members Bryce

Dwyer, Roman Petruniak, and Matthew Joynt, and especially remembers the memory of Ben Schaafsma, for he informed much of her thinking on support for creative practices and alternative ways of sustaining oneself in the arts. Satinsky would also like to thank her family, collaborators, and mentors, including Nato Thompson, Stephanie Smith, Ted Purves, Daniel Tucker, and Joseph del Pesco for their early support and continuing inspiration; allies of InCUBATE and the *Sunday Soup* network, including Sunday Soup at the DAAC in Grand Rapids, Brooklyn FEAST, Philly Stake, Baltimore Development Cooperative/Baltimore Stew, Providence Provisions, FEAST Mass, and especially the friendships of George Wietor, Theresa Rose, Kate Daughdrill, Scott Berzofsky, Jori Ketten, Gina Badger, Sam Gould and Red76, Adam Bobbette, Geraldine Juarez, Josh Greene, Robin Hewlett, Material Exchange, Hideous Beast, Gavin Kroeber, Works Progress, and Jeff Hnilicka; collaborations with *Common Field* and participants in the *Hand in Glove* conferences for building a community of radical art administrators across the United States; and Bad at Sports, Ox-Bow, ACRE, and Harold Arts/8550 Ohio for providing space for reflection, friendship, and retreat since she first arrived in Chicago in 2006.

We appreciate Satinsky's thanks to us in the Department of Exhibitions and Exhibitions Studies and the editorial team headed by Kate Zeller, who has overseen and implemented all aspects of production of the *Chicago Social Practice History Series*. For anyone who has come into such a process in their own work, they'll appreciate the myriad of tasks that called upon Zeller's acuity, patience, and even diplomacy. Working side-by-side with her were Raven Munsell and Elisabeth Smith who served as editorial assistants, a practicum training that went beyond the classroom, achieving a level of professionalism that enabled us to achieve the high standard required. We thank Jeremy Ohmes who functioned as copyeditor. With this volume we welcome Jess Mott Wickstrom as designer; we are thankful for her keen sense of style and context, as well as speed, accuracy, and good humor. It is a pleasure to continue to team up with The University of Chicago, and we would like to thank Carol Kasper, Marketing Director, and the print production team, Robby Desmond and Kewon Bell. Finally, we wish to cite the essential support for the series from SAIC's Earl and Brenda Shapiro Center for Research and Collaboration, the Graham Foundation for Advanced Studies in the Fine Arts, Elizabeth Firestone Graham Foundation, and the Illinois Arts Council, a state agency.

Introduction

Abigail Satinsky

A Glaring Spotlight

A person can tear their hair out trying to figure out where social practice begins and ends. All in all, it may just be a red herring. Sometimes a dinner party should just be a dinner party. Sometimes calling a dinner party an art project makes it a richer experience for the individuals participating. Social practice art doesn't necessarily create more democratic exchange between art and audience; it can also create hierarchical distinctions between artists in art school and ordinary people with creative hobbies and interests that lie outside an art career. Yet clearly it strikes a chord with today's artists: graduate schools now teach it as a discipline; yearly academic conferences are held; books like this come forward to intervene in the discourse. Despite the general lack of boundaries as to what social practice is and whether it constitutes anything new at all, it is clear that its meteoric rise as a discipline stems from a question as to why art matters and what place artists have in today's world.

To be part of this field one must hold on to the sometimes-foolhardy belief that contemporary art has the power to transform the social and cultural conditions of the world in which we live, or, at the very least, be interested in the question. Yet this relatively new phenomena, the social practice artist, is stuck between a rock and a hard place. Often trained in art school, seeking relevance outside a largely cynical and rapidly expanded commercial art market and a depressingly competitive job market, these artists go looking for "community," either self-made or the disenfranchised kind, to call into being the social change they imagine. Arts organizations

and institutions welcome this effort since it allows them to connect with new audiences they couldn't otherwise reach and build their own profiles of engagement. Support can become available in local economic development and creative place-making efforts, though artists can be asked to produce the results of social workers or community development corporations while untrained for those particular complexities and at a bargain rate.

Historically the small to mid-sized, artist-founded non-profit organizations provided somewhat of a haven for contemporary artists interested in working in this vein, giving safe space for experimentation, artists' employment, and fostering what used to be a vibrant multicultural sector. What started as an artist-run and artist-employing field shifted to be staffed by administrative professionals, when the Comprehensive Employment and Training Act (CETA), which had been employing and training artists to work in these organizations, became defunct in 1982, and non-profits were massively defunded and defanged by the culture wars of the 1990s. Today the non-profit field endures, many still working to retain an artist-centered ethos, but often struggling to be able to pay artists to produce new work or to just stay afloat themselves. The expense of top-tier US college and graduate art education, still conferring powerful gate-keeping credentials, narrows who can participate in the discourse or receive support as a socially engaged artist. In this current era of professionalization and specialization, these artists are also often unaware of legacies of community arts efforts that preceded them, as contemporary graduate studio education often keeps these histories at arm's length.

Though there is much to be said about this state of affairs, it is also important to remember that this impulse of artists building spaces and communities for themselves and struggling with the relevancy of their discipline to a broader public has a long history.

This book seeks to bring some of those histories into relief, to turn them over in our hands, and look again from different angles, seeing what it may offer today. Ideally, this would generate new questions about what kinds of support networks are relevant now for what is currently called social practice; support meaning literal resources, such as particular spaces, groups of people, and money streams needed to actually produce this culture, as well as what kinds of cultural spaces, networks of people, and situations allow critical questions to emerge. It stands to reason that a politically theorized and socially engaged art practice would also demand a politically engaged art infrastructure, though this is not always the case if arts organizations are put in the position to weigh their politics against their funding streams. Artists have to weigh their options; to paint very broad strokes, more resourced organizations and major institutions can offer publicity and bigger audiences, grassroots arts organizations can offer direct access to communities.

Certain curators and administrators within these organizations make or break the project. These negotiations become part of the artwork; the infrastructure behind a socially engaged project is part of its content. It is for this reason that the infrastructures themselves and their particular ethos and way of working require some scrutiny. Nato Thompson has written about interpreting work in this way as within an "infrastructure of resonance":

> Infrastructures of Resonance/ n. 1. the basic, underlying framework or features of a system of organization. 2. the fundamental facilities serving a country, city or area, as transportation and communication systems, power plants, and roads. 3. the military installations of a country.

> In framing questions of aesthetics and politics, it is important that we consider the networked web in which they are operating. That is to say, we cannot detach the position within power that a particular project possesses. No project, in and of itself, will possess all the attributes necessary to make an all-encompassing political statement and/or action. Effectiveness requires a sort of content triage which, when viewed alone, can be complicit with some sort of ineptitude... Meaning becomes compensated through its connection to an infrastructure. The infrastructure provides a chorus of intentions that facilitate a more robust interpretative model.[1]

In other words, such a framework allows us to see and understand such artist projects within the networks that they circulate and to think about the scale and intentions of their audiences. Therefore, we are able to have a meaningful discussion about the difference between showing politically and socially engaged artworks at, to take Thompson's examples, the Guggenheim Museum versus a community anarchist space, with both being sites of complexity and negotiation as well as having different forms of power and legitimacy. With this in mind, the histories brought to bear within this volume are mostly modest in scale and locally based to look closely at how grassroots artist initiatives can and do impact the discourse as it's forming, though they are often discounted or marginalized as stepping stones to larger institutional acceptance.

We Want More

In January 2009 I co-organized a retreat in Chicago called *We Want More* with Rozalinda Borcilă, Robin Hewlett, Nicholas Lampert, Nato

Thompson, and Daniel Tucker. We were drawn to the idea of convening socially and politically engaged artists from across the country to have a conversation around a national organizing structure or means of collaboration. It was at a moment when it felt like there had been a significant amount of scholarly conferences happening around the intersection of art and politics, and we had a desire to hold a self-organized gathering that could imagine how this nascent network could begin to work together. A starting point was a series of "Town Hall Talks" that Daniel Tucker and Nato Thompson had organized through Creative Time the year before as part of their exhibition *Democracy in America*; they had traveled to five cities (Baltimore, Chicago, Los Angeles, New Orleans, and New York) asking politically engaged artists to talk through local and national concerns. Building on this from within our various networks, we loosely assembled a group of people in a room to struggle with the social and political issues at play in their work.

We invited about eighty participants to gather for a weekend to have a series of discussions about what might be possible at Co-Prosperity Sphere in Bridgeport, a multi-use art and music space and home of the Public Media Institute. It included political printmakers, public artists, community-engaged museum people, curators, art historians, and activists from across the country; representatives from the editorial collective of the Los Angeles *Journal of Aesthetics and Protest*; Justseeds, a decentralized group of artists making print and design work about radical social, environmental, and political issues; and the Baltimore Development Cooperative, an artist group doing exhibitions and public projects examining and critiquing urban spatial politics. The program took the form of a series of breakout sessions (along with some potlucks and social gatherings) structured around asking three sets of questions that echo throughout this book:

How does cultural work, that is, the projects we engage in, move beyond commenting on or critiquing our contemporary social reality in order to influence its direction?

How do we make choices about where to locate ourselves and our struggles? What are some inspiring and meaningful examples of working across scales—from the immediate and local, to the regional or global?

What kinds of infrastructures could sustain our relationships and practices? How can we imagine moving forward from here? How might we constitute a political body, other forms of association, and/or a more sustainable, strategic microeconomy?

By most accounts, the weekend was a spectacular failure. The first problem was that it was invitational, and therefore exclusionary. So participants were grumbling from the get-go. I could make all sorts of arguments as to why that was the case (from providing food and lodging to creating manageable and focused conversational space), but it doesn't really matter because the question of who was or wasn't in the room is a political one, and the community we were trying to enact wasn't defined enough to accept this provisional first step before creating something larger and open. So the "we" in the *We Want More* was stopped before it began. Did we mean a radically inclusive "we" of different kinds of bodies, identities, gender expressions, and educational levels? Or were we replicating what happens all the time in institutional art settings where certain artists are anointed spokespeople for communities because of their capacity to navigate the system through charisma or education and, thus, become the regularly invited person to represent on behalf of others? And it was not only the "we," we also came together with radically different expectations of what "more" could be. Some people were ready to get together and do something, anything; others were possibly looking to expand their professional networks; some people were suspicious as to whether there was any shared politics in the room between the broad spectrum of professional artists showing in museums and galleries and those more committed to grassroots communities and street actions. It was terribly frustrating as we went around and around in circles trying to find common ground. But we were clearly there because we wanted something to happen; that desire was at least was palpable. Moreover, there was a feeling in the room that with the emerging professionalization of the field happening, we needed to form alliances that could transcend those hierarchies.

I can't speak for others, but I know what I was looking for. Three months before, in the fall of 2008, Ben Schaafsma, my collaborator in InCUBATE, an artist group we had started together, had suddenly passed away after being hit by a taxicab in New York City. It was heartbreaking and confusing in so many ways, but one of the things I struggled with was how to carry on with the work we had been doing together, which in some ways was defined and contextualized within this nascent community of socially and politically engaged artists that we had started to connect with. I was looking for some support, both intellectually and emotionally, to feel that we were part of something larger than ourselves so that I could continue something we had begun as collaborators together. I was trying to figure out where I belonged. Though that may be incredibly personal to me, I wonder if it translated in some way for others in the room, needing to find support and fellow travelers in a competitive and individualizing contemporary art field, and looking for a place to share strategies and have critical discus-

sions about the capacity for art to provide some tools. Yet in that situation it seemed the "we" was too much of a leap, flattening out the real and important differences of people in the room. The people there didn't all share their personal situations or hold the same political urgencies. So for whatever reasons, our mutual interests could not be articulated in that moment. *We Want More* wasn't a total bust. Relationships that were formed during that gathering have continued on for years. There were other meeting points for the group in the years following, including the *City from Below* conference in 2009, organized by the Baltimore Development Cooperative, as well as the *US Social Forum* in Detroit the next year. You never really know what results out of experiments like these and they can take years to cohere or just result in a passing moment of coming together.

In hindsight, perhaps it's more useful in addressing the diversity of practices in that gathering to talk in terms of solidarity rather than collectivity, because regardless of specific success or failures, it is the attempt to think through something together that matters. As Dan S. Wang writes, this can be a fleeting but worthy proposition:

> Solidarity is a coming together of atomized causes, interests, and desires that produces both political and subjective impact. A hallmark of solidarity is the extraordinary demonstration of allegiance on the part of individuals and groups to causes not obviously belonging to them. Solidarity is achieved when people redefine and rearrange in common purpose the interests normally assigned and administered by society. But solidarity is phantom-like, materializing only long enough and frequently enough to assert its reality before dissipating. Solidarity never seems to live long before or after short periods of generalized resistance, and never can be grasped and held. Even when in recession, solidarity remains a promise of strength and for that reason deserves analytical attention.[2]

The Search for the Great Community

To look again at these questions, "What kinds of infrastructures could sustain our relationships and practices? How can we imagine moving forward from here? How might we constitute a political body, other forms of association, and/or a more sustainable, strategic microeconomy?" In other words, how do we make this tenuous solidarity and ongoing set of conversations result in concrete action? According to John Dewey, we figure this out in the process of forming community and testing our ideas out

with others, and this informs the ways we enact political change. In *The Public and Its Problems,* he wrote that in order for individuals to be actively engaged in the process of democracy, they must become embedded in the "Great Community" in which, through communal life and associations of mutual benefit and sociality, people achieve a sense of agency in the public sphere within a participatory democracy. With Dewey, democracy is work-in-progress, to be continually challenged and recalibrated. It is community life itself—people interacting and communicating, collectively producing the kind of shared knowledge that results in social action. It happens in a range of local sites and associations, including everything from political meetings, neighborhood associations, book clubs, and cultural spaces in which individuals define themselves in relationship to others, express issues of public concern, and develop shared language and affinities. He writes, "Without such communication the public will remain shadowy and formless...Till the Great Society is converted into a Great Community, the Public will remain in eclipse. Communication can alone create a great community."[3]

The conditions Dewey lays out for community as a mechanism for democratic engagement can define the parameters for many of the creative experiments that play out through this volume. People have to come together under some sort of assumption of shared trust and mutual benefit, and take responsibility for the direction of the given community they are forming. There has to be the free distribution of knowledge and inquiry; the community must be invested in a social process of knowledge sharing. Different and disparate viewpoints must be taken into account and present in community formation. And finally, people have to develop shared languages and reference points; they must be able to talk to each other, not past each other.

Community comes from a deeper understanding of communication, and one important means that Dewey turns to for this is art, seeing art as having the unique ability to move beyond just the exchange of information and shared resources to an articulation of what a meaningful life can be. Dewey's conception of art is close to the ground, accessible to all, and an integral part of everyday life:

> Men's conscious life of opinion and judgment often proceeds on a superficial and trivial plane. But their lives reach a deeper level. The function of art has always been to break through the crust of conventionalized and routine consciousness. Common things, a flower, a gleam of moonlight, the song of a bird, not things rare and remote, are means with which the deeper levels of life are touched so that they spring up as desire and thought.[4]

While Dewey asserts that art can lead us to new awareness and common understandings, his great public community remains complex because it is a modern democracy, neither a homogenized constituency nor one of tacit consensus of thought. He saw this take form, in the flesh, in the Chicago streets of the 1890s. In Dewey's America conflict and difference prevail, and so must tolerance. This society is continually dynamic, so democracy needs to be, too. Complaint, contention, and change by many (if not any) means possible is a constant state of affairs. The most important thing for Dewey was the public having the tools to comprehend and thus continually transform its world. Specialized knowledge and institutional authority had to be challenged, an informed public needed to be catalyzed, and art had a role to play. "Presentation is fundamentally important, and presentation is a question of art...Poetry, the drama, the novel, are proofs that the problem of presentation is not insoluble. Artists have always been the real purveyors of news, for it is not the outward happening in itself which is new, but the kindling by it of emotion, perception and appreciation."[5] Reading Dewey today, I feel some combination of hopefulness and ambivalence. Can this conception also encompass those artists whose condition has resisted representation, or who chose to never be fully assimilated into the so-called majority, or who want to remain informal, or are dedicated to being outside in protest and refusal as they seek interventions or counter-institutions? The question of what art can do, and whether it has any business transforming society is the same question that guides the discourse surrounding social practice and contemporary art as a social change agent. How to answer this question and whether to remain focused on it or to allow the very practice of social engagement to guide civic transformation is at the core of this volume.

Studying Together

The gathering *We Want More* was built tenuously on many catalytic precedents—too many to list—that were concentrated on both historical models of resistance and informal, rotating casts of Chicago collaborators who had come together for moments on many projects over the years that re-imagined the project of creating a "we." A book such as this tries to make these local happenings and networked webs of events, public and open to inquiry. Dewey writes, "a thing is fully known only when it is published, shared, socially accessible. Record and communication are indispensable to knowledge. Knowledge cooped up in private consciousness is a myth, and knowledge of social phenomena is peculiarly dependent upon dissemination for only by distribution can such knowledge be either obtained or tested.

Dissemination is something other than scattering at large. Seeds are sown, not by virtue of being thrown out at random, but by being so distributed as to take root and have a chance of growth." There is no desire here to claim that all the works included in this volume are social practice as such, but rather to create a broader context for this work and see where alignments may be happening. Hopefully, this will allow us to see Randolph Street Gallery or South Side Community Art Center or Experimental Station not as falling within certain categories of art gallery or community center, but as inter-locking sites that challenge our perceptions of where culture happens and what form it takes. We can also draw connections with the Dil Pickle Club or Jane Addams's Hull-House as historical progenitors, as relevant to social practice artists as museums, galleries, and artist-run spaces, and start inter-rogating the actual conditions of building community within a range of political contexts and social histories.

Furthermore, the visual arts in this volume overlap with some of Chicago's poets, writers, and musicians in order to help facilitate a richer and more diverse history to draw upon and learn from. If one wants to talk about how artists have networked together to build a context and sustain-able infrastructure for experimental creative work, it's next to impossible to leave out these legacies. As Wang writes, "With an endlessly diversifying field of often mutually unintelligible subcultural codes, histories are what substantiate one group's claims in the eyes of another, as actors step for-ward to produce histories, and then discover that their narratives crisscross those of others, as a collection of fluid, tactical, and often highly labile sol-idarities."[6] Thus, with that framework in mind, there is no hope for com-prehensiveness, since a contingent and provisional frame can only produce more questions about the terrain of this kind of art.

Finally, while it may be too much to ask of the reader to think about this book itself as an attempt at solidarity among a range of creative prac-tices in Chicago (albeit backed and supported by an institutional frame), within an expanding field, this study is but one moment in a social process. Undertaking it required some experimenting. I take some inspiration from how poet and author Fred Moten, in his book with Stefano Harvey, uses the term "study," much like Dewey uses "communication," as a practice of being open to the many ways that discourse is formed socially and as a continual, improvisational process:

> We are committed to the idea that study is what you do with other
> people. It's talking and walking around with other people, working,
> dancing, suffering, some irreducible convergence of all three, held
> under the name of speculative practice. The notion of a rehearsal—
> being in a kind of workshop, playing in a band, in a jam session, or

old men sitting on a porch, or people working together in a factory—there are these various modes of activity. The point of calling it "study" is to mark that the incessant and irreversible intellectuality of these activities is already present. These activities aren't ennobled by the fact that we now say "oh, if you did these things in a certain way, you could have been said to have been studying." To do these things is to be involved in a common intellectual practice. What's important is to recognize that that has been the case—because that recognition allows you access to a whole, varied, alternative history of thought.[7]

If we can stretch ourselves to see a range of histories as interacting and operating in tandem, then art worlds emerge as they work in real life—messy and boundless and confusing sites of inclusion and exclusion. If social practice narrows its scope, accessible practices get brought into institutions, and the marginalized and overtly political voices get left outside of the discourse. But if we see these things as inextricably linked, as making sense within a network, then the door cannot be shut so easily and social practice can get to be a more interesting place, with a range of supportive infrastructures that reflect and challenge the ethos and values of the work happening therein.

1 Nato Thompson, "Contributions to a Resistant Visual Culture Glossary," *The Journal of Aesthetics and Protest* 3, http://www.joaap.org/new3/thompson.html.

2 Dan S. Wang, "New Solidarities: After Ideology and Culture, There Is History," *Journal of Aesthetics and Protest* 4, September 2006, http://joaap.org/4/wang.html.

3 John Dewey, "The Public and its Problems," *John Dewey: The Later Works, 1925-1953, Volume 2*, ed. Jo Ann Boydston (Carbondale and Edwardsville, IL: Southern Illinois University Press), 324.

4 Ibid., 350.

5 Ibid., 349–350.

6 Wang, "New Solidarities: After Ideology and Culture, There Is History."

7 Stefano Harney and Fred Moten, "The General Antagonism: An Interview with Stevphen Shukaitis," *The Undercommons: Fugitive Planning and Black Study* (New York: Minor Compositions, 2013), 110.

Art Ensemble of Chicago performing at the Bergamo Jazz Festival, Teatro Donizetti, 1974 (detail).

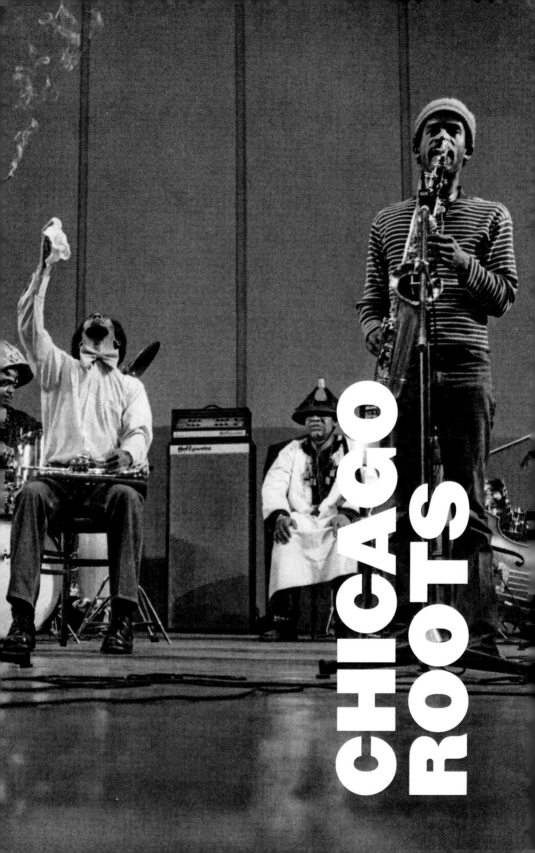

CHICAGO ROOTS

Little Rooms: Chicago's Creative Communities, 1889-1939

Paul Durica

Chicago's creative community began with a story—specifically a short story written by a lock-maker's heir, Madeline Yale Wynn, and called "The Little Room." It's set in a New England farmhouse where some visitors see a set of doors leading into a comfortably appointed little room while others perceive, in the same spot, a china cabinet. This story of a space visible to some and not others, seemingly appearing and disappearing at random, proved immensely popular upon its publication in *Harper's Monthly* in 1895. A group of Chicago writers, artists, academics, and society figures liked Wynn's story so much that they started calling their weekly meeting place, the tenth-floor studio of painter Ralph Clarkson in the Fine Arts Building, the Little Room. The studio had become for them a magical place.

The gatherings in Clarkson's studio grew out of a desire to keep the conversation going that had started after the weekly concerts by the Chicago Symphony Orchestra in the Auditorium Building, a structure that had been built with the specific purpose of fostering the growth of art and culture in Chicago. Financed by real-estate magnate Ferdinand Peck and designed by architects Dankmar Adler and Louis Sullivan, the Auditorium boasted a four-thousand-seat, acoustically perfect theater, as well as several smaller theaters, ballrooms, studios, offices, and even hotel rooms. Peck had foreseen the need for a single structure that could host the best in arts and cultural programming—with enough offices, studios, and hotel rooms attached to allow it to turn a profit—in a city that had quickly become the second largest in the country.

(Peck would also become one of the principal supporters of the 1893 World's Columbian Exposition; several World's Fair receptions would be held offsite at the Auditorium.) The program for the December 9, 1890 formal opening offers a sense of the mixed purposes to which the building would be put.[1] On that night the Chicago Symphony Orchestra, under the direction of its first conductor Theodore Thomas, played works by Richard Wagner. Stephen Foster's sentimental "Home Sweet Home" was also performed by the popular singer Adelina Patty—with the entire experience capped by the recitation of a dedicatory ode written by a local talent, Harriet Monroe. The musical and theatrical performances at the Auditorium provided an opportunity for the city's artists and academics to mingle with the various merchant princes and princesses upon whose financial support they often depended. During an intermission, a poet like Monroe might converse with Bertha Honoré Palmer, wife of a hotel owner and the head of high society, and such casual exchanges might have concrete effects upon creative production in the city. In 1912 when Monroe decided to start *Poetry* magazine, she would turn to the same society figures encountered at concerts at the Auditorium for support.[2]

The Auditorium provided a common gathering place for the fledgling creative community in Chicago, but it was the building adjacent to it on Michigan Avenue that became the heart of this community. It had been built in the mid-1880s as a showroom and repair shop for Studebaker car-

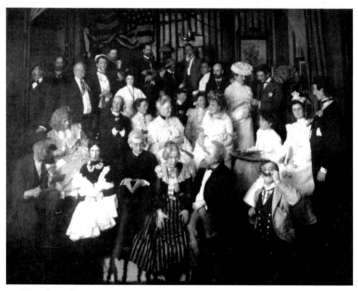

Cast photo of *Captain Fry's Birthday Party*, staged by the Little Room in the Fine Arts Building, 1904. Courtesy of the Newberry Library.

riages, but in 1898, the company moved out; the number of floors was increased from eight to ten; and a number of artists, musicians, and writers became tenants. The Fine Arts Building, as it is still known today, is perhaps the oldest example of creative reuse in Chicago. In addition to Clarkson's studio, where the Little Room gathered, the building would house at various times the editorial offices of three significant literary journals (*The Dial, Poetry*, and *The Little Review*); a bookstore run by *The Dial*'s editor with an interior designed by Frank Lloyd Wright; the Alderbrink Press, inspired by William Morris's Arts and Crafts movement; the studio of sculptor Lorado Taft, whose work can still be found throughout the city; and, starting in 1912, the Little Theater, which made accessible to Chicagoans serious dramas by more modern figures like Henrik Ibsen, George Bernard Shaw, and William Butler Yeats. Work got done at the Fine Arts Building, but it was in the more informal social gatherings where this work would be shared and something like a sense of community would emerge.

The Little Room and similar spaces within the Fine Arts Building—such as the eighth-floor studio of drama teacher Anna Morgan or the fourth-floor Little Theater, where Harriet Vaughn Moody liked to host tea parties after the performances—collected together not just practitioners of the various arts but also the book publishers, gallery owners, theater managers, and society patrons who supported their creative work. And there were always enough academics from the University of Chicago and reformers from Jane Addams's Hull-House to keep the conversation from becoming too frivolous. At a typical Little Room gathering in the early 1900s, Harriet Monroe would be drinking tea and engaging in conversation with the men and women who, a decade later, would serve as *Poetry*'s editorial advisors (the novelists Henry Blake Fuller and Edith Wyatt), designer (the artist Ralph Seymour Fletcher), and benefactor (socialite Hobart Chatfield-Chatfield Taylor). Not all collaborations that grew out of Little Room encounters produced significant work like *Poetry*, which introduced readers to the poems of T. S. Eliot, Carl Sandburg, Edna St. Vincent Millay, and Rabindranath Tagore, among others and is still being published after more than a century—some were simply fun. In 1904 the Little Room staged in Anna Morgan's studio a one-act farce written by journalist George Ade and based on a strip by cartoonist John T. McCutcheon. *Captain Fry's Birthday Party* poked fun at the creative community of the era—one character has just finished reading *The Humorous Works of Hamlin Garland*, a detail that is only funny if you know about Garland, a realist writer, teetotaler, and spiritualist remembered for his memoirs and short stories about the harsh conditions and intellectual limitations of life on remote Wisconsin farms.[3] For the play, various members of the Little Room designed the costumes, sets, and props according to their talents, and a surviving cast photo shows

them all—even the normally sober-looking Monroe—in costume, replete with wigs and pasteboard mustaches. These people were clearly having fun and enjoying each other's company. Informal groups like the Little Room cut across the social divisions normally imposed by sex, class, and education—its members all shared a passion for the arts, for creative endeavors, whether they were producers or patrons. As Chicago continued to grow in size and wealth, Little Room members would become attached to groups and institutions more formal and less inclusive.

The Whitechapel Club had followed a similar path. This informal group of journalists, professionals, and politicians had formed around the same time that the Auditorium was dedicated. Whereas that site gathered around it figures associated with the fine arts and respectable institutions such as the University of Chicago and the Art Institute of Chicago, the Whitechapel Club culled its membership from the city and its streets. It took its name from the area of the East End of London where the "Jack the Ripper" crimes had occurred in 1888, and the unknown and uncaught killer was the club's honorary president. The majority of the members were journalists who filled their saloon clubhouse with objects connected to the stories they'd covered—the more morbid the object, the better. Nooses used to execute infamous criminals hung from the ceiling while the skulls of said criminals served as sconces and drinking goblets; a coffin acted as a table around which the men could sit, swap stories, smoke cigars, and sing songs. Like the Little Room, the Whitechapel Club stressed informality and congeniality, but it was also a place where professional ties were strengthened and creative efforts were supported. Long before the professionalization of creative writing and the rise of Master of Fine Arts programs, aspiring writers from modest backgrounds turned to journalism for their apprenticeship (and the somewhat steady income it offered). Some of the first literary writers from Chicago to find a national audience—George Ade, Finley Peter Dunne, Eugene Field, and Opie Read—started their careers as newspapermen and passed some of their leisure hours at the Whitechapel Club.[4] There they could read a poem or a short story or perhaps even part of a novel they had written and receive sincere if somewhat snarky critiques. Some of the journalists associated with the club would draw upon connections made there to enter into a career in politics. Whitechapel member Brand Whitlock would go from journalist to novelist to the mayor of Toledo and, later, ambassador to Belgium, while Wallace Rice, a journalist and poet, is better remembered today for having designed the municipal flag of Chicago. The raucous Whitechapel Club had a short life. By the end of the decade, the majority of its members had aligned themselves with the more formal and professional Press Club of Chicago. The Whitechapel Club followed a path taken by many creative communities in Chicago wherein a period of inno-

vation and collaboration centered around an informal social network and an ad hoc space would give way to a formal organization convening at an established site, accompanied by a charter, scheduled programs, formal banquets, and membership dues. Many of the latter survive to the present but lack the energy and innovation associated with their freewheeling forebears.

The founding of the Cliff Dwellers Club provides perhaps the clearest illustration of this pattern. After almost a decade of gathering weekly in Ralph Clarkson's studio, certain members of the Little Room decided the time had come for the creation of something along the lines of a men's social club that brought together the most accomplished individuals within the creative and commercial communities. In 1907 they drafted an organizational charter and a list of potential members and planned a large inaugural banquet. Like the Little Room, early members included artists, sculptors, writers, musicians, and architects as well as academics, doctors, lawyers, and bankers.[5] They were called the Attic Club, since their meeting place was the ninth floor of the recently completed Orchestra Hall, but they switched the name after two years to honor the Pueblo people who had also inspired Henry Blake Fuller's 1893 novel about the inhabitants of skyscrapers, *The Cliff-Dwellers*. Fuller turned down his invitation to join the club. It was open to men only and had membership fees, making it exclusive in ways the Little Room was not. The Cliff Dweller's first president, Hamlin Garland, forbid the serving of alcoholic beverages at all club functions, which ensured that the conversation would be more serious than stimulating. With Garland's departure to New York, this policy was dropped, and the Cliff Dwellers became at times as rowdy as the defunct Whitechapel Club, particularly when engaged in such larks as a scavenger hunt at the Indiana Dunes (where one of the "items" was a young woman who was buried beneath the sand and who almost suffocated before her discovery) and a fake Native American raid upon their clubhouse. More representative of the club's activities was the 1914 dinner held in honor of the visiting Irish poet William Butler Yeats where the most memorable event turned out to be Illinois native Vachel Lindsay performing his poem, "The Congo," which included the use of musical instruments and the poet speaking in a range of voices. Dinners, lectures, readings, and art exhibitions made up the majority of the Cliff Dweller's programs, but unlike the Little Room affairs, they were all well-planned, well-financed, and accessible only to the elect. A poor poet like Lindsay was merely a guest and had to turn elsewhere for the support of his work and some sense of community. By the early 1910s, he would look outside the city's center.

One can easily walk from the Auditorium to the Fine Arts Building to the Art Institute to Orchestra Hall, former home of the Cliff Dwellers. All stand in a line along Michigan Avenue within the center of Chicago's busi-

ness district. In the early 1900s, the newspaper and publishing industries were situated a few blocks west. There were a few outliers—such as the sculptor Lorado Taft's studios built along the Midway Plaisance near the University of Chicago on the Far South Side and Jane Addams and Ellen Gates Starr's Hull-House, the settlement house, on the Near West Side— but by and large all creative work clustered around the city's center. This began to change as a younger generation of writers, artists, musicians, and dancers gained prominence (although certain sites like the Fine Arts Building, which would house both the thoroughly modern Little Theater and *The Little Review*, remained significant in this period). An immense amount of creative innovation and output across the arts occurred between roughly 1912 and 1925, and this period has become known as the Chicago Renaissance. It had two main centers, one to the south and one to the north of the city's old creative core.

Few structures associated with the World's Columbian Exposition had survived into the second decade of the twentieth century, but among them were a series of single-story wood buildings with gingerbread trim that had been used for selling concessions at the fair. They were located just west of Jackson Park, the former site of the World's Fair, and not far east of the University of Chicago; and the low rents made these structures ideal for coffeehouses, used bookstores, art galleries, printing houses, and artist studios. When teacher Margery Currey and her husband Floyd Dell, the literary critic for the *Chicago Post* and an aspiring poet, moved into adjacent studios, they began to host salons that drew from both the creative and university communities. The salons attracted writers like Theodore Dreiser, Carl Sandburg, and Edgar Lee Masters, prominent radicals like the lawyer Clarence Darrow and Eugene Debs, and artists like the painter B.J.O. Nordfelt, who kept his own studio in one of the World's Fair relics. It was at one of these salons that Sherwood Anderson gave his first public reading and met his future wife, Tennessee Mitchell, a sculptor, and where Edgar Lee Masters premiered his "Spoon River" poems. On another evening, a conversation led Margaret Anderson to come up with both the idea and the title of *The Little Review*, which would become one of the most significant literary journals of the period, publishing early work by modernist poets like T. S. Eliot and Ezra Pound and becoming embroiled in a serious obscenity case when it serialized James Joyce's *Ulysses*.[6] It could also be unintentionally Dadaist when Anderson, deciding she'd received no submissions of merit, released an issue consisting entirely of blank pages. Later issues became more politically oriented, the result of her friendship with the anarchist Emma Goldman. Distinguishing the Jackson Park artists from their Little Room forebears was both their work, which tended to be more modernist and experimental, and their politics, which generally

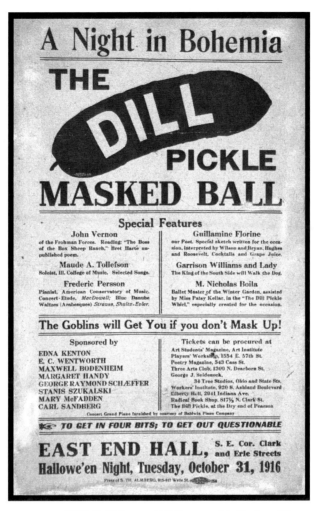

Dil Pickle Club poster, 1916. Courtesy of the Newberry Library.

ranged from socialism to anarchism, with a dash of mainline progressivism. After he left Chicago, Dell would write a sort of aesthetic treatise *Intellectual Vagabondage* (1926) in which one of the guiding tenets was "ostentatious formlessness" as "approved form," but he would also serve as the managing editor of the leftwing publication *The Masses*.[7] Dell became a fixture in New York's Greenwich Village and, with some fellow Midwesterners, would found the influential Provincetown Players.

One by one the artists who read their poems, performed their compositions, or displayed their latest sketches at the Jackson Park salon followed Dell to New York or went the opposite direction toward California. Unlike

CHICAGO ROOTS

the Little Room crowd who either started long-lasting publications like *Poetry* or formed civic arts organizations like the Cliff Dwellers, this younger generation of artists found early success in Chicago and then left—establishing a pattern that lasted for decades. Apart from some university students, the Jackson Park crowd was made up almost entirely of working artists and, in a sense, was as exclusive as the Cliff Dwellers. A curious public had to look north to get a better sight of Chicago's emerging bohemian community.

Towertown took its name from the Chicago Water Tower, one of the few structures left standing after the Great Fire of 1871, and served as Chicago's equivalent to Greenwich Village. In this neighborhood just north of the river, mansions had become boarding houses, with the stables and carriage houses transformed into studios and cafés. The Newberry Library anchored the area and lent it an intellectual gravitas, but it was the small park directly south that was the heart and soul. No one called Washington Square Park by its proper name; it was the Hyde Park of Chicago where anyone could step up on a soapbox and hold forth—thus, it became known as Bughouse Square since most of the speakers could have come straight from an insane asylum. No one took the speakers, regarded as cranks, too seriously, but they drew the crowds, which inspired a former copper miner and radical Jack Jones to open an indoor version in a former stable in an alley just off the park. Visitors to Tooker Alley followed a green light to an orange door upon which was painted the admonition, "Step High, Stoop Low, and Leave Your Dignity Outside." They'd arrived at the Dil Pickle Club whose stated purpose was to "elevate minds to a lower level" through public lectures, plays, and dances.

Unlike Bughouse Square, the Dil Pickle Club managed to recruit University of Chicago and Northwestern University professors as speakers; it hosted debates on Marxism and psychoanalysis and staged plays by Ibsen, Shaw, and O'Neil. The club had a gallery, a woodworking shop, and a printing press—making it a mixed-use arts space slightly ahead of its time. Writers like Ben Hecht and Carl Sandburg hung out in the café, designed by the artist Edgar Miller, and admired the latest sculptures by Stanislaus Szukalski. But the club also attracted a public that was as eclectic as its programming. Writing for the *Chicago Daily News* in 1919, Sherwood Anderson noted that at the Dil Pickle Club the "street car conductor sits on a bench beside the college professor, the literary critic, the earnest young wife who hungers for culture, and the hobo."[8] Towertown had at its height numerous cafés, public forums, and nightspots, but the Dil Pickle Club distinguished itself by the talent of the artists associated with it and its inclusivity. Kenneth Rexroth, the poet, was just a high school student when he frequented it and would take the memories of the club with him west to San Francisco where he became a mentor to the Beats.

22

The Depression effectively brought an end to Chicago's bohemian neighborhood, although by then any members who'd had a measure of success had left for New York or Los Angeles, and it would take a different community and a bit of Works Progress Administration funding to form new creative centers. In 1939 the sociologist Horace Cayton, with the assistance of writers Margaret Walker and Richard Wright, would start the Park Community House, which hosted readings, plays, and art exhibits in the South Side neighborhood of Bronzeville. A year later the South Side Community Art Center would open and nurture the careers of poet Gwendolyn Brooks, painter Archibald Motley, and photographer Gordon Parks, among others. By the early 1940s a new renaissance had begun.

1 Chicago's Newberry Library has a collection of Auditorium Theatre programs spanning the years 1888–1938 in its Modern Manuscript Collections.

2 For more information on Harriet Monroe's early career consult her autobiography *A Poet's Life* (New York: MacMillan, 1938). Lists of early benefactors of *Poetry* can be found in *Poetry: A Magazine of Verse* Records, 1895–1961, at the University of Chicago's Regenstein Library.

3 The script for *Captain Fry's Birthday Party*, an original poster by cartoonist John McCutcheon, and a cast photograph can be found in the Little Room Records, 1898–1931, in the Modern Manuscript Collection at the Newberry Library, Chicago.

4 Alson J. Smith in *Chicago's Left Bank* (Chicago: Henry Regnery Co., 1953) provides a brief history of the Whitechapel Club.

5 See Smith, *Chicago's Left Bank*, 207–215, but also the Cliff Dwellers Records, 1890–2014, in the Modern Manuscript Collection at the Newberry Library, Chicago.

6 For a detailed account of the Jackson Park colony see Harry Hansen's *Midwest Portraits* (New York: Harcourt, Brace, & Co., 1923). Margaret Anderson describes the genesis of *The Little Review* in her autobiography *My Thirty Years' War* (New York: Covici, Friede, 1930).

7 Floyd Dell, *Intellectual Vagabondage: An Apology for the Intelligentsia* (New York: Doran, 1926), 242.

8 Sherwood Anderson, "Jack Jones: Father, Mother, and Ringmaster of the Dil Pickle," *The Rise and Fall of the Dil Pickle Club*, ed. Franklin Rosemont (Chicago: Charles H. Kerr, 2013), 47–48. See also the Dil Pickle Club Records, 1906–41, in the Modern Manuscript Collection at the Newberry Library, Chicago.

Chicago's Alternatives

Lynne Warren

One fact about art that many sense but few actively acknowledge these days is that its practice frankly thrives on adversity. More specifically, it is a particular type of adversity that seems to goad an artist on, cause his vision to be crystallized and his talent to mature, for hunger, poverty, disease, and mental illness can realistically only be hobbling. This adversity is a resistance to the artist put up by his audience—and not necessarily an uninterested, uncultured one. Ironically, this resistance often comes from whence it hurts most, from those artists who have found acceptance by major cultural institutions (museums, collectors, publications, galleries) and, most disheartening to the artist on the outside, by those very cultural entities. Yet the desire to be taken seriously—a universal impulse, but one that is of particular importance to the artist, as the very validity of his calling is often questioned by society-at-large—can be seen as the drive that produces much interesting, and some great, art. It is the resistance of established cultural entities, specifically here in Chicago, that is a fundamental factor in the history of alternative spaces. If the doors of the Art Institute had always stood wide open to all artists of this city, it seems almost certain that few, if any, alternative spaces would have ever been founded, and a unique, varied, and stimulating legacy would have been lost.

In many ways, the history of alternative spaces in Chicago begins in 1948 with the founding of Exhibition Momentum—a series of large exhibitions organized by students from the School of the Art Institute who were not permitted to enter the prestigious, at that time annual, Chicago and Vicinity shows at the Art Institute. From the aptly named Momentum

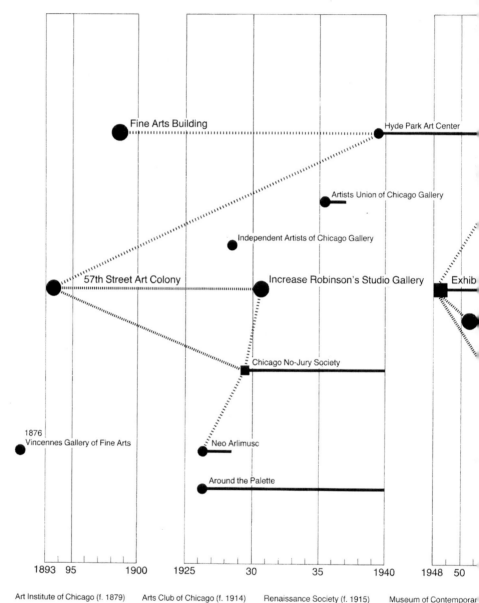

Fine Arts Building

Hyde Park Art Center

Artists Union of Chicago Gallery

Independent Artists of Chicago Gallery

57th Street Art Colony

Increase Robinson's Studio Gallery

Exhib

Chicago No-Jury Society

1876
Vincennes Gallery of Fine Arts

Neo Arlimusc

Around the Palette

1893 95 1900 1925 30 35 1940 1948 50

Art Institute of Chicago (f. 1879) Arts Club of Chicago (f. 1914) Renaissance Society (f. 1915) Museum of Contemporar

WPA/FAP 1934-1939 G.I. Bill begun 1944

ııııı = direct influence
ı ı ı = indirect influence
▌ = spaceless artists' organization seminal to subsequent alternative spaces.

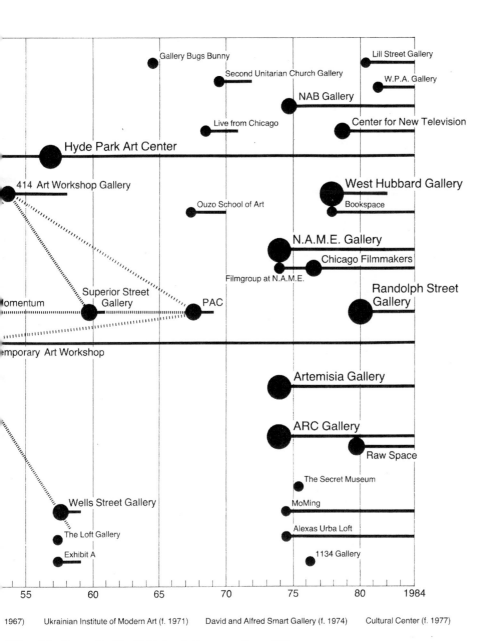

Gallery Bugs Bunny

Lill Street Gallery

Second Unitarian Church Gallery

W.P.A. Gallery

NAB Gallery

Live from Chicago

Center for New Television

Hyde Park Art Center

414 Art Workshop Gallery

West Hubbard Gallery

Ouzo School of Art

Bookspace

N.A.M.E. Gallery

Chicago Filmmakers

Filmgroup at N.A.M.E.

Superior Street
Gallery

Momentum

PAC

Randolph Street
Gallery

Temporary Art Workshop

Artemisia Gallery

ARC Gallery

Raw Space

The Secret Museum

Wells Street Gallery

MoMing

The Loft Gallery

Alexas Urba Loft

Exhibit A

1134 Gallery

| 55 | 60 | 65 | 70 | 75 | 80 | 1984 |

1967) Ukrainian Institute of Modern Art (f. 1971) David and Alfred Smart Gallery (f. 1974) Cultural Center (f. 1977)

NEA Workshop Program (later Visual Artists Organizations program) begun 1972

History of Alternative Spaces diagram, 1984. Design: Jerzy Kucinski and Lynne Warren.
Courtesy of Lynne Warren.

exhibitions, which continued on and off until 1964, a number of true alternative spaces as well as other artists' groups got their impetus. Yet the tradition of artists who found themselves on the outside and banded together to further their aims, which threatened to be thwarted by an uninterested art establishment, is a long one in Chicago, originating in the late nineteenth century. Interestingly enough, equally long is the dialectic that sees the alternative space transforming—very quickly in some cases—into the art establishment. It is this history of rejection by and rebellion against the established art world that has seemed to make Chicago a particularly rich breeding ground for new talent, for alternative spaces are especially good places for young artists to get their start, season themselves, and develop their vision and their ability to express that vision before entering the even more formidable national or international fray. It is interesting and, in the light of history, ironic, that the entity against which virtually all the alternative spaces have worked, The Art Institute of Chicago, was founded in 1866 by a group of artists.

Chicago's early artistic history mirrored the tempestuous mixture of frontier roughness and naïve eagerness for all things "modern" of the city itself. Its rapid growth from a provincial outpost to a major American metropolis provided a wide-open stage for a number of talented and progressive performers—in the visual arts, in music, and especially in architecture. This heady, freewheeling atmosphere allowed for some quite astonishing accomplishments by cultural entrepreneurs looking to their own European experiences as confirmation of art's capacity to uplift and refine: the founding of the Art Institute; the creation in 1893 of the Fine Arts Building,[1] which sought to gather together artists, writers, musicians, craftsmen, and other creative people for the overall advancement of cultural life; and the establishment in 1892 of reasonably priced, comfortable studios by real estate speculator and judge Lambert Tree. These were institutions that contributed greatly to the first period of artistic activity in and growth of the Chicago art world, and the first subsequent period of rebellion by artists against the ossifying of cultural life.

In the early years, art was seen as a means to achieve "social uplift,"[2] and philanthropists such as Edward E. Ayer, Marshall Field, Charles L. Hutchinson, Martin A. Ryerson, and Lambert Tree worked tirelessly to create Chicago's great cultural institutions. The European ideal, defined in large part at this time by the rhapsodic classicism of John Ruskin, served for these men as the model for a cultural life. Thus, for these people, in the final analysis art was nothing to leave in the hands of the provincial native population of artists. Although the Art Institute served as a center and headquarters for a great number of local artists' groups and allowed many exhibitions of these groups' memberships, as it expanded and saw itself more as

an organization to serve the city's general population[3] rather than just those already involved in the arts, many artists felt themselves being locked out.

The Art Institute of Chicago had been founded in 1866 by a group of artists as the Chicago Academy of Design. The intent of the Academy was to create a school and gallery to exhibit members' work. However, the visionary aims of the artist-founders were not sufficient to propagate the school and gallery. A board of directors was created in early 1879 and business and civic leaders appointed in hopes of rescuing the Academy, which was experiencing grave financial setbacks. In May 1879, to effect this rescue, these appointees resigned from the board to incorporate a new organization, the Chicago Academy of Fine Arts, renamed in 1882 The Art Institute of Chicago; the new institution retained the School as an important aspect of its activities but was no longer devoted to showcasing its artist-members.

The artists' organizations of the late 1800s, which initially had worked in close harmony with the Art Institute, including the Chicago League (f. 1880), the Chicago Society of Artists (f. 1888), the Art Students League (f. 1893), the Palette & Chisel Club (f. 1895), reacting by the 1920s to the change in the Art Institute's exhibition and collecting policies—notably to the greater emphasis placed on the development of a historical permanent collection—began providing the impetus for artists to organize exhibition opportunities and spaces on their own. A critical juncture was reached in 1920, when artists, outraged at the exclusive jurying system imposed on the venerable annual Art Institute exhibitions of Chicago and Vicinity art, which systematically rejected the work of "modern" artists,[4] formed a *Salon des Refusées*, which in turn spawned the Chicago No-Jury Society.[5] This precursor to the Exhibition Momentum organization of the late 1940s and 1950s organized large, nonjuried shows that took place in a wide range of venues, from the Garfield Park Museum to the Goldblatt's and Marshall Field's department stores. It was largely the initiative of artists affiliated with the Chicago Society of Artists and of "radical" modern artists (most of them School of the Art Institute of Chicago [SAIC] graduates) such as Rudolph Weisenborn, who held jury systems generally in disdain, and Carl Hoeckner and Raymond Jonson, painters and teachers. These artists had been inspired by SAIC visiting artists such as George Bellows, Randall Davey, and John Sloane. Weisenborn in particular was a whirlwind of anti-Art Institute activity. In 1921 he formed the group Cor Ardens (Ardent Heart), an "international organization of artists dedicated to modern art,"[6] and later, in 1926, the Neo-Arlimusc Society (an acronym derived from the words art, literature, music, and science) which attempted, through wide-ranging activities, to promulgate the development of a certain type of artistic life. Their philosophy held that artists needed not only the support and companionship of their peers, but immersion in a highly cultivated way

of life that included exposure to all art forms. Although neither Cor Ardens nor Neo-Arlimusc opened gallery spaces as such, the latter group showed for two years in Weisenborn's studio—one of the first instances of an artist's studio being opened for alternative exhibitions.

Other support groups of the 1920s that formed in reaction to the Art Institute's prejudice against modern art included the Introspectives, which numbered Weisenborn and Emil Armin among its members; The Ten (Chicago), which showed regularly at the galleries of Marshall Field's; and the Jewish artists' group Around the Palette.[7] The anti-establishment, "bohemian" attitudes of many of these artists derived in large part from the fact that they had lived and worked closely in the 57th Street Art Colony, which sprang up in buildings originally constructed along East 57th Street near Stony Island to house workers at the Columbian Exposition of 1893. This community included writers, poets, art critics, musicians and artists, notably Gertrude Abercrombie and Martyl.[8] The Colony, dating from 1895 but most active during the 1920s and 1930s, provided a haven for the type of artistic life Weisenborn attempted to promote in his organizations, and was instrumental in much of the alternative activity of the era.

As artistic activity increased in the city—now besides the Art Institute, a number of commercial galleries existed, as well as The Renaissance Society at the University of Chicago and The Arts Club of Chicago, both of which devoted themselves to showing the best in international modern art as well as local work—so did the number of artists. Alternative activity, interestingly, died down, as many of the "radical" artists of the 1910s and 1920s found regular exhibition opportunities after their alternative activities had the desired effect of opening the cultural institutions to modern art. The Ten (Chicago) had found a home in Marshall Field's galleries; Around the Palette showed in the Jewish People's Institute building,[9] blurring the line between artist-instigated and establishment activities. Most of these artists were again being admitted to the Chicago and Vicinity shows. Only Increase Robinson, who opened her studio in Diana Square to show artists' work as Weisenborn had done in 1922, and the Chicago Artists Union with their Union Gallery existed as "alternative spaces" in any sense of the term. The Great Depression, of course, also affected the lessening of alternative activity—not in the obvious sense of artists being forced to abandon their profession to survive, but rather because of the vigorous activities of the Federal Works Progress Administration (WPA/FAP), which at one point was employing up to 300 Illinois artists.[10] From 1935 to 1938, the WPA/FAP was in fact headed by Increase Robinson, and employed many of the familiar names of the early era. Interestingly, the true alternative space of the 1930s, The Artists Union, was formed to mediate between artists and the WPA, and had in its origins a connection to the John Reed Society, named

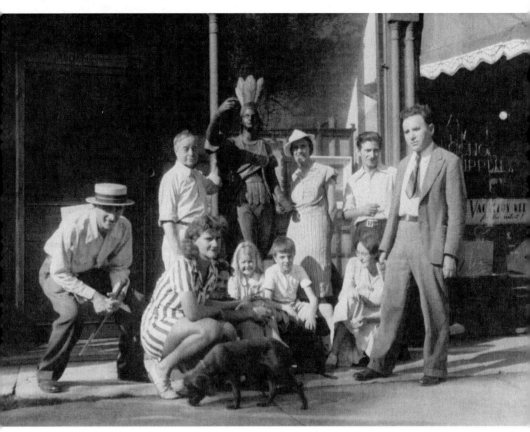

Residents of the 57th Street Art Colony outside Charles Biesel's East 57th Street studio, 1939.
From l. to r.: Emil Armin, Charles Biesel, Gertrude Abercrombie, children unknown,
unknown, Frances Strain Biesel (kneeling), Oscar Van Young, J.Z. Jacobson.
Courtesy of the Illinois State Museum, Springfield.

for the famous American Communist activist and sympathizer of Russian Communism.

The next event of any importance to the history of alternative spaces was the Hyde Park Art Center's opening in 1939. Its seeming aim was to be a place for Chicago artists to gather together, work in its workshops and studios, and exhibit, although it also sponsored an active schedule of children's and adult art classes, as it continues to do today. HPAC's founding members included artists Fred Biesel and Frances Strain, both veterans of the 57th Street Art Colony, although the chief instigator appears to have been Alderman (later Senator) Paul Douglas. It was not until 1956, stimulated in large part by the activities of Exhibition Momentum, that the Hyde Park Art Center began functioning as a true promoter of Chicago's largely neglected local talent.

While the decade of the 1940s, dominated by the government-directed activities of WPA/FAP and World War II was generally a quiet one for Chicago's alternative spaces, the war changed the Chicago art scene forever

in that it introduced a new breed of artists, war veterans educated through the G.I. Bill. Previous to the War, the motivating factor for artists banding together had been the desire to fight against the establishment's refusal to accept modern art. This became a lesser issue immediately after the war, when modern life and all it entailed suddenly was the normal, expected way, having been necessarily adopted to ensure survival and victory by the nation in the face of the war. Although not accepted by the average man in the street, modern art was embraced by cultural leaders including major institutions, collectors and influential intellectuals. Thus in the immediate postwar era, the goal of Chicago's artists was to receive exposure and reviews. Democracy was a major motivating factor—artists felt it was a moral imperative that art not be judged unseen.[11]

The artists involved in forming alternative spaces in the 1950s, including the Contemporary Art Workshop, 414 Art Workshop Gallery, Superior Street Gallery, and Exhibit A, were very interested in self-development through exhibiting their latest works and receiving feedback from artists and others interested in art, with the ultimate goal of refining and perfecting their expressions. The Contemporary Art Workshop, founded in 1950 by John Alquith, Cosmo Campoli, Ray Fink, Leon Golub, and John Kearney, was intended to show members' work and provide workshops and studio space for artists, and survived for many years off the income of these rental spaces. The 414 Art Workshop Gallery functioned as a school and it showed the work of its faculty and invited artists, including H.C. Westermann in his first one-person show. Superior Street Gallery, supported by collector and patron of the arts Joseph Randall Shapiro, included such Momentum veterans as Roland Ginzel, Richard Hunt, Miyoko Ito, Ellen Lanyon, and John Miller. Strategically located on Superior Street, in the gallery district of the time which also boasted Allan Frumkin and Richard Feigen, commercial galleries devoted to showing local as well as New York art, Superior Street featured such artists as painter Bob Thompson and photographer Harry Callahan along with its members.

Reacting to the local prejudice against abstract art, Robert Natkin, a recent SAIC graduate, with Stanley Sourelis, formed the Wells Street Gallery which, after its first year (1957), became a true cooperative, with its members pitching in to cover expenses. Wells Street showed John Chamberlain, a schoolmate of Natkin's, in his first one-person exhibition, as well as a vigorous schedule of other local abstract artists, including photographer Aaron Siskind. Other spaces of the 1950s did not fare so well. Like Wells Street and Superior Street galleries, which suspended operations after experiencing financial difficulties, Exhibit A, an artists' cooperative founded by 24 local artists, including Leopold Segedin, Vicci Sperry, and Angelo Testa, operated for only a short time, showing mostly members'

work, and closed its doors in 1959 after its gallery floor caved in during an opening.[12]

The early to mid-1960s in general were bleak. Many of the artists involved in the alternative spaces of the 1950s, having met with success, had moved to New York. PAC, an outgrowth of Phalanx, a loose organization of over 150 artists, established a gallery devoted to large group exhibitions much in the mold of the Hyde Park Art Center. PAC, which included Roger Brown, Martin Hurtig, and Vera Klement, closed after two years, in 1969. The Second Unitarian Church on Barry Street hosted a gallery for four years (1969-72), instigated by maverick local artist Notley Maddox, who died prematurely in 1980. This space showed a number of artists and photographers, many SAIC students and faculty, in one- and two-person exhibitions. PAC and the Second Unitarian Church Gallery, located as they were on the North Side away from the traditional gallery districts, did not receive the traffic and attention in the art press that the quality of their exhibitions merited.

Also in the late 1960s, the group Live from Chicago, consisting of artists, designers, and architects, opened a space that featured exhibitions weighted heavily toward technologically derived media, such as photography, film, and electronic works. Although some extraordinary exhibitions were mounted, as well as a lively program of music and film, Live from Chicago (its name an attempt to show there was still "life in Chicago" after the brutal events surrounding the 1968 Chicago Democratic Convention), which had opened in the fall of 1968, closed in 1970.

The bright light in the 1960s alternative space landscape was the Hyde Park Art Center. After coming to life in 1956 under the directorship of Don Baum, whose involvement in The Renaissance Society's Student Committee (which sponsored an annual exhibition), as well as experience with the Exhibition Momentum group had well prepared him for such a position, HPAC came into a dominant position in the Chicago art world in the 1960s. Baum organized exhibition after exhibition of extraordinarily lively and innovative group and theme shows of local artists. Out of these exhibitions, and especially the now-legendary Hairy Who shows, Chicago Imagism was born.[13] The tireless activity of Don Baum and the Hyde Park Art Center introduced an impressive list of artists of lasting importance to Chicago's art history.[14]

The moral imperative of artists of the 1950s and 1960s was that work should be shown without regard to, as Leon Golub put it, "the status of its creator or the circumstances implicit in its creation."[15] This imperative had almost vanished by the late 1960s, and is conspicuously absent from the thinking and manifestos of the third and best-known generation of alternative spaces—those, including ARC, Artemisia, and N.A.M.E., founded in the early 1970s.

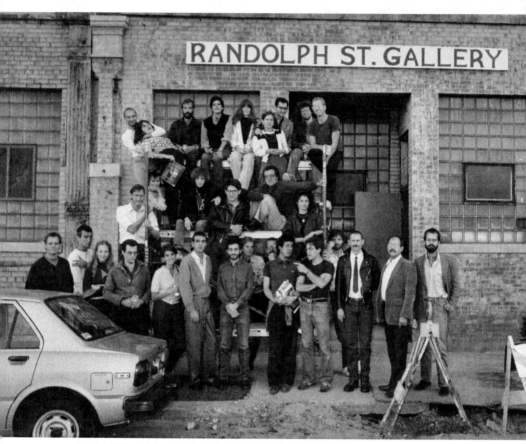

Randolph Street Gallery staff, members of board of directors, and artists from *Opening New Doors* exhibition, October-November 1982. Top row (l. to r.): Hudson, Mary Min, David Helm, Jessica Swift, Cynde Schaupe, Suzi Kunz, Bruce Clearfield, Paul Maurice, Greg Green. Middle row (l. to r.): Greg Knight, Morgan Puett, Nancy Forest Brown, Gary Justis, Dennis Kowalski, L.J. Douglas. Bottom row (l. to r.): Steve Mose, Story Mann, Lynnette Mohill, Frank Garvey, Jennifer Hereth, Marc Giordano, Ted Lowitz, Sarah Schwartz, Robert Pollack, Stephen Lapthisophon, Ron Cohen, Jeffrey Thomas, Michael Hoskins, Lannie Johnston, J. Joseph Little, David Cloud. Courtesy of the Randolph Street Gallery Archives, John M. Flaxman Library, School of the Art Institute of Chicago. Photo: Studio GO.

Some observers of the alternative space phenomenon have denied the existence of true alternative spaces prior to the 1970s, and have remarked on the burgeoning of the spaces in this decade, going so far as to state that the determining characteristic of the 1970s would be the phenomenon of the alternative space.[16] Its history, in fact, is not unlike the histories of the spaces of the 1950s and 1960s: initial vigorous energy generated by the enthusiasm of its founders; the dropping away of members due to the grind of keeping up the space—which cut greatly into personal artistic output; and the subsequent process of financial difficulties, reorganization, discouragement, and closing of the space as its founders, now more established, could afford to go on without it.[17]

For an artist-run organization to be truly artist-run, artists must also

be administrators, which, as it cuts significantly into their artistic output, is something that most artists are understandably reluctant to do. Yet the hiring of administrators ruptures the artist-run identity. Patrons of the arts, curators, and professional administrators may be entirely sympathetic to the desires and aims of artists—having had their consciousness raised by the alternative system's activities—yet they are not artists and ultimately may not do what artists perhaps would. While providing an expanded art context, contemporary alternative spaces may not necessarily provide a more responsive one. As N.A.M.E., ARC, Artemisia, Randolph Street, and other galleries have begun to undertake museum-like activities—retrospectives, mid-career reviews, one-person shows of older and more established but hitherto little-seen artists, etc., the young, untried, unknown artists face tougher competition, both in terms of the amount of physical space available and in the level of maturity and professionalism required to convince the spaces they are worthy of showing. This situation, of course, is exactly the kind that consistently has caused artists to band together and found spaces of their own.

Alternative spaces have enlivened and enriched Chicago's art scene. They have been successful in stretching the local attitudes about art and in discouraging complacency; they have enabled many artists to embark on successful careers. The philosophical debate about their purpose and value will certainly continue. Realistically, as this history shows, alternative spaces can hardly be seen as some fledgling, speculative venture. One would be surprised by the questioning of the validity and contributions of, say, museums or commercial galleries—alternative spaces, by their very definition, seem to invite such basic debate. As the cycle of ossification of established cultural institutions and the emergence of an alternative voice to counter this ossification continues, so will the history of alternative spaces in Chicago.

This essay is excerpted and revised from the essay "Chicago's Alternatives" as originally published in *Alternative Spaces: A History in Chicago*, (Chicago: Museum of Contemporary Art, 1984), 6-23. Exhibition catalog. © 2014 Lynne Warren; used by permission.

1 The Fine Arts Building housed the Little Room and the Little Gallery, frequented by such artistic and literary figures as Margaret Anderson, founder of the avant-garde magazines *Poetry* and *The Little Review*, Lorado Taft, sculptor of heroic, monumental sculpture whose studio was on the tenth floor; and William Denslow, best-known for his illustrations of L. Frank Baum's *Wizard of Oz*. See Percy R. Duis, "Where Is Athens Now?" *Chicago History* 6, (1977): 69-72.

2 Helen Lefkowitz Horowitz, "The Art Institute: The First Forty Years," *Chicago History* 8, (1979): 5.

3 By 1889 the Art Institute was recording attendances of half a million visitors a year.

4 Chicago Society of Artists, *Role & Impact: the Chicago Society of Artists* (Chicago: CSA, 1979), 81. Interestingly, the Art Institute boasted a rather radical, for the time, collection of Impressionism and had hosted the notorious 1913 Armory Show; perhaps the outcry caused by this event had strengthened the already firm conservative instincts of powerful then-director, Charles Hutchinson.

5 Esther Sparks, *A Biographical Dictionary of Painters and Sculptors in Illinois 1808-1945* (Ann Arbor, MI: University Microfilms International, 1972), 677.

6 Ibid., 6.

7 Maureen A. McKenna, *Emil Armin* (Springfield, Illinois State Museum, 1979), 7, 10. Exhibition catalog.

8 Dell's novel *The Briary Bush* is a quaint exposition of pre-1918 life in the Colony.

9 McKenna, *Emil Armin,* 7.

10 Sparks, *A Biographical Dictionary of Painters and Sculptors,* 214-16.

11 John Miller, interview by Paolo Colombo, August 18, 1983, Museum of Contemporary Art Archive, Chicago, IL.

12 Leopold Segedin, interview by Paolo Colombo, November 23, 1983, Museum of Contemporary Art Archive, Chicago, IL.

13 The term "Imagism" was coined by Franz Schulze in *Fantastic Images: Chicago Art Since 1945* (1972), his book on the "Monster Roster" generation, but came to denote the style typified by the Hairy Who and False Image artists.

14 For a complete listing of the artists shown at HPAC, see Goldene Shaw, ed., *History of the Hyde Park Art Center 1939-1976* (Chicago: Hyde Park Art Center, 1976).

15 Leon Golub in the 1948 *Exhibition Momentum* catalogue stated this eloquently: "Exhibition Momentum confirms a fundamental aesthetic ideal; that the ultimate criterion in judging an art object is its inherent value rather than the status of its creator or the circumstances implicit in its creation."

16 Kay Larson, "Rooms with a point of view," *Artnews*, October 1977, 34.

17 Interestingly, Jane Allen and Derek Guthrie raised this issue in a 1974 interview with N.A.M.E.'s founding members, stating it was a "rare organization that can outlast its founding members." N.A.M.E.'s members replied that they took as one of their major responsibilities finding replacements when they left the gallery, stating that the "important thing is that we stay open for good." Jane Allen and Derek Guthrie, "What's In a N.A.M.E.?" *New Art Examiner*, April 1974, 3, 10.

"Do For Self": The AACM and the Chicago Style

Romi Crawford

How does music, and sound experimentation in particular, resonate beyond the context of sonic artistry and also impact other expressive forms, such as visual art? In *A Power Stronger than Itself: The AACM and American Experimental Music*, the composer and musicologist George Lewis recounts how Muhal Richard Abrams, one of the original founders of the Association for the Advancement of Creative Musicians (AACM), forecast that "the AACM's influence would empower other musicians and groups."[1] Might this also suggest its influence beyond musical forms? In fact, the AACM has had an enduring sway on experimental music, locally and internationally, yet its force has impacted other artistic practices as well, in particular Chicago-based visual arts practitioners with "do it yourself" (DIY) inclinations.[2] Upon closer inspection the AACM's DIY tendency emanates from an even earlier history of self-sufficient art making in the region and also resonates today.

The AACM offers a case worth exploring for its connection to groundbreaking black writers' communities that developed in Chicago between 1930 and 1950 and visual arts making in the present era, most notably current manifestations of DIY art that are endemic to the city's aesthetic and artist-cum-organization style. I will focus on two aspects of the AACM's creative experimentation to show the pivotal position this group holds at the fulcrum of then and now. The first is their embrace of locale or region, locating their art in relation to a particular city space, even as the group

attained international status and appeal. The second is the making of an immediate critical locus, what I deem "serious sociality," wherein a society of colleagues or serious audiences support each other and work together in a preter-organizational manner to hone their craft and contour a social agenda. Correlating common methods between the AACM, the societies of black writers that preceded them, and the current wave of DIY practices will, I hope, offer insight into often-ignored continuities that help to identify and explain how local tendencies in art making evolve.

Make Do

The period from 1930 to 1950, referred to as the "Black Chicago Renaissance," offers an important precursor to the types of self-doing evidenced in the organization-inflected work of the AACM. This period was underexplored by scholars prior to Robert Bone's 1986 essay "Richard Wright and the Chicago Renaissance." Bone argues that it had been mistakenly interpreted as an uneventful and dormant period because it was overshadowed—on one side of the history by the Harlem Renaissance and on the other by the Black Arts Movement. "The prevailing wisdom postulates a Harlem Renaissance in the 1920s, and a second literary flowering, associated with the Black Arts Movement of the 1960s. But our sense of the intervening years is at best vague and indistinct."[3] But I contend this assessment has much to do with the make-do processes through which the Chicago writers invented and self-tooled platforms for their work. Lack of respect for these modest, but productive, practices ultimately hindered the reception of this work. It is also a symptom of prejudice within art circles against the Midwest region that extends into much of American art history.

A better understanding of make-do methods might allow for an assessment of work that emerges from this ethos as well as an improved appreciation of it. An account of how young writer, Alice Browning, started the magazine *Negro Story: A Magazine for All Americans* in 1944 is a case in point: borrowing $200 from her husband, purchasing paper stock, making arrangements with a printer, and editing it from her home at 4019 South Vincennes Avenue.[4] In such instances, art forms and their supporting platforms emanate from the project an artist, musician, or writer seeks to give life to and is often homegrown in the most literal sense. The mythology that develops from this story is important because it licenses other, future artists to grow their own work—often sprouting an entrepreneurial endeavor, organization, or platform to support it in the process. The myth in Browning's case is that she started *Negro Story* after having a story rejected from a mainstream journal. In response, she decided to create an outlet for other

black writers who sought to develop their work through publishing.[5] Her magazine, devoted to short stories, had a run of only two years, yet during that time she honed her writing (publishing under the pseudonym Richard Bentley); put in print writings by Richard Wright and Gwendolyn Brooks, among other notable black writers; and garnered both Ralph Ellison and Chester Himes for the advisory board.[6]

Through a friend, Fern Gayden, Browning was able to reprint Richard Wright's "Almos' A Man" in *Negro Story*. Gayden knew Wright, who had published *Native Son* in 1940 and was already a well-respected writer, from their time as members of another writers' cohort—the South Side Writers' Group. In the mid-1930s, authors such as Arna Bontemps, Margaret Walker, Frank Marshall Davis, and Theodore Ward met regularly at the Abraham Lincoln Center in Bronzeville to share stories, workshop writings, experiment with new forms and topics, and encourage each other in their efforts.[7] While this working group grew out of an immediate need to write and find their individual voices, it developed into an environment of shared mentorship that stood in for a formal academic program. Members of the group sought to improve upon their own writing by cultivating a serious social environment. Bone describes it as "a group of Negro writers who, if not Marxists, were at least proponents of the new realism, and champions of a socially committed art."[8] Socially informed art in this sense sought to serve the needs of their self-ordained artistic social circle as much as it attempted to address the wider social dynamics that concerned them, especially race discrimination and class oppression. Founding a club space of their own, instead of a room of their own was a way to also self-authorize a zone or community for critique and feedback, while self-actualizing as individual writers.[9] Not unlike the AACM to come, the South Side Writers' Group created a serious learning environment, where they could teach themselves the rules of the writing profession.

There are other lessons learned from this era's writing factions. They are also instructive when it comes to assessing value. Browning's effort, through *Negro Story*, to provide a forum for black writers to publish during a time when there were few outlets is also important because it helps us to better understand how make-do forms appropriately devolve as their founders evolve new projects and initiatives. Thus we can better appreciate and assess the journal's short life when we take into account that Browning later founded "The International Black Writer's Conference." The annual conference, which she organized from 1970 until 1984, in many ways extended the same project that she brought forth in *Negro Story* magazine. It provided workshops, offered grants, and was equally committed to encouraging black writers. What the short-term life of *Negro Story* implies about make-do forms can be useful to creative individuals or groups. It frees them from the

obligation to continue and persist past the prime of their creative energy and enthusiasm. Normative terms of institutional longevity and financial solvency are not the gauge of success. Instead the make-do approach allows founders to keep their own creativity alive, to continue to develop their own practices, and to continually re-direct their energies to other make-do projects when the urgency or vitality of one has past.[10] Both *Negro Story* and the South Side Writers' Group disclose how make-do approaches take form, through magazines, workshops, clubs, and collectives, as artists come together to make and do the work that they want to.

"Get Knowledge to Help Self"

Founded in Chicago in 1965, the AACM was inextricably linked to a particular phase of art production, the Black Arts Movement, which emerged out of the Black Power and Civil Rights agendas. The Black Arts Movement, spirited by writers and poets, including LeRoi Jones (Amiri Baraka), Don L. Lee (Haki Madhubuti), Sonia Sanchez, and Larry Neal, stressed "sharp views on the black artists' responsibility to black culture."[11] Chicago's instantiation of this was reflected in the work of Jeff Donaldson, Wadsworth Jarrell, Jae Jarrell, Gerald Williams, and Barbara Jones-Hogu, who comprised the AFRICOBRA collective (African Commune of Bad Relevant Artists). Beyond the Black Arts Movement's basic goals of defining a black aesthetic and overtly linking art and politics, AACM co-founder Muhal Richard Abrams regularly endorsed self-reliance and self-help.

When musicians needed to teach, they would teach themselves how to teach. As George Lewis mentions in an interview with musicologist Simon Rentner, self-reliance was a bit of a creed, appearing on fliers and pamphlets on the South Side of Chicago that read, "DO FOR SELF," in giant letters. People would just quote that to each other, "Well, you know brother, you've got to do for self."[12] The mandate to "get knowledge to help self" circulated regularly on the South Side of Chicago. For example, it was routinely relayed in the form of cartoons, essays, and even advertisements in The Nation of Islam's primary media outlet, *Muhammad Speaks*. Often the "do for self" tagline addressed the importance of cultivating one's own food sources, meat and grains alike. In other cases it helped to anchor the significance of education, as evidenced in a 1969 pitch for the University of Islam titled, "Get Knowledge To Help Self." The ad goes on to read: "At the University of Islam in Chicago we have an enrollment of over 600 black boys and girls who are obtaining an educational foundation which will equip them to do for themselves and their people."[13]

The "self" implied here is not super individuated. Rather it simulta-

Joe Jarman at the Wall of Respect, Chicago, 1967.
Courtesy of Bob Crawford.

neously references one's self and the group self. So "doing for self" is also
doing for the community: the self in connection to a particular, semi-con-
tained, social domain, be it a neighborhood, the Nation of Islam, or an artist
collective. This self-reliant approach to communal well-being was evident
in the practices that the AACM deployed to support their art making. Their
grassroots fundraising campaign to finance the training of AACM musi-
cians; programs offering musical instruction to black teenagers; and hum-
ble origins at a kitchen table in a Chicago housing project, all fit within the
context of this dictum which was prevalent on the South Side at the time.[14]

Like the South Side Writers' Group, a fundamental aspect of "doing
for self" included self instruction, exemplified most directly by the AACM
school, "an institution where the teachers are constantly performing the
techniques and ideas being taught to their students."[15] For both the AACM
and the writers' groups in the 1930–1950 period, focus on an individual
artistic expression effectively pulled a group of artists into a social bond,

that reinforced their interest in common societal concerns; for AACM this included Civil Rights, while for the South Side Writers' Group it was socialism. Music scholar, Scott Radano, describes how even the rehearsal process lent to the social function of the AACM: "Together, Abrams, Jarman, Mitchell, Threadgill, and others shaped an improvised art that, through incessant rehearsal, could mimic the design of complex orchestrations. Creating an art that relied on a kind of communal sensitivity, they build "community" into the art itself. Accordingly, community-inspired ideals became a fundamental motivation for the experimental band's interactive musical procedures."[16]

The learning environments in these cases were predicated on a similar spirit of co-learning, where working artists made for themselves and did in service of an inscribed community. Yet the AACM took its educational program a step further than the writers, using the school to construct a committed community of serious colleague-participants and producing a powerful model of inter-generational collectivity. Thus enabling it to continuously absorb the most seriously gifted *students* (self-taught on the AACM aesthetic) into the collective as members. From this a constantly

Lester Bowie at the Wall of Respect, Chicago, 1967.
Courtesy of Bob Crawford.

evolving environment of immersed and serious stakeholders was achieved. In addition, the AACM was also known for conceiving unique settings and locations such as performances at 64th Street beach or in lofts. Members Joe Jarman and Lester Bowie gave impromptu performances in 1967 at the *Wall of Respect,* contributing an important sound layer to the murals and visual art at the 43rd and Langley location. Those who joined them at the site were neither audience nor participants in the conventional sense. Finding association through an artistic experience, at the wall they were at once pulled into a relevant aesthetic and social matter. A scene of "serious sociality" evolved among persons receptive to the free (and often unresolved) form of artwork that aligned with a particular political sensibility and social agenda.[17]

DIY: The Chicago Style

On this score the AACM has been impacting and modeling ways to develop and expand their form so that creative license flows into the political agenda, business methods, exhibition platforms, and educational processes. Its commitment to creative enterprises in general (schools, chapters in various cities, collaborations) reaches beyond music and envelops a much wider province of art and art-related support practices. Thus, the AACM might be considered as a crucial progenitor for the expansionist forms of art that have come to identify the present style of DIY-inflected art making in Chicago. Artist Theaster Gates's work is indicative of this. His art forms, especially those projects under the aegis of Rebuild Foundation that he founded, are flexible enough to inform the civic realm. The Dorchester Art and Housing Collective, where potential artist-residents are informed on the website that they are expected to "give back to the community by teaching workshops, classes or creatively sharing their skills," for example, potentiates the civic need for better urban housing and integration.

It may be useful to hyperbolize for a moment and consider if the AACM and its forerunners have helped to prepare for the Chicago that we now know—with an evident potential for art making and experimentation of this sort that rivals any other city. As early as 1965 the AACM espoused sophisticated community and dialogic methods.[18] Its practices of experimentation—which included grassroots organizing, social networking, practicing self-reliance, using alternative venues, collectivizing and collaboration, teaching, and more—helped to construct, at the very least, the present Chicago art agenda with its DIY cred, its apartment galleries, its poor art forms, its artist-organizers, and its regionalist aesthetic bent. Even given disparate generational and racial, and ethnic circumstances, it is worth con-

necting the "make-do" and "do-for-self" practices of the writers' groups and the AACM, respectively, to characteristics of the heartland aesthetic and Chicago's trenchant DIY ethos, both of which value "resourcefulness, invention, and self-sufficiency."[19]

This is so much a part of Chicago maker-ly protocols that it's the undercurrent or premise, part of the very thought process of artists here, whether they are so-called social practitioners, or not. It is now a recognized aspect of the regional style in non-provincial, yet rooted ways. It is presently even a part of some higher education curricula. At the School of the Art Institute of Chicago, there is a host of offerings along tenets of "self learning" and "hands-on," with entrepreneurial and organizational methods that align with the "do-for-self" and "make-do" strategies of the AACM and earlier black writers' groups. Like those instances from the past, today's academic DIY curricula emphasize emerging venues and evolving platforms through which artists construct specialized contexts, a unique locality, or a serious social context that might lend to and grow their work and practices.[20]

Part of what stands out about the AACM is how persuasively it articulates a local orientation, wherein the locale might have bearing on a form. Even with most of the original members moving to New York City in the 1980s and touring internationally on a regular basis, the AACM maintained a Chicago presence, becoming a non-profit organization "chartered by the State of Illinois."[21] And even without trenchant theorizing of the global-local dynamic, the AACM pushed an agenda that established value for both the idea of home turf and worldwide productivity. This emphasis on locale is one of the ways in which the AACM may have had an effect beyond music forms, and influenced a next wave of art making in Chicago.

The AACM's willingness to make work within the bounds of a particular black neighborhood and its effective identification with the city may have added to the city's reputation as a place for not only experimental and DIY, but also embedded, community-based, immersive, and other modes of everyday art making. In other words, for such forms that derive their force from what art historian and critic Grant Kester states is, "not through the manipulation of representational codes in painting or sculpture, but through processes of dialogue and collaborative production."[22] Even as the city continually struggles and often fails to maintain other types of art capital through blue-chip galleries, auction houses, and the media, these experimental ways of art making are increasingly at the core of its aesthetic and cultural viability. And while the AACM is central and key to this aesthetic temperament, it is not the first or the last instance of "make-do," "do-for-self," or "DIY" tendencies. Rather, it can be contextualized within a wider trajectory of self-doing methods that, over time, have come to distinguish Chicago and its art ways.

1 George E. Lewis, *A Power Stronger Than Itself: The AACM and American Experimental Music* (Chicago: University of Chicago Press, 2008), 507. Founding members included Steve McCall, Phil Cohran, Jodie Christian, and Muhal Richard Abrams. Members have included Roscoe Mitchell, Lester Bowie, Joseph Jarman, Henry Threadgill, Anthony Braxton, and Leroy Jenkins, among others.

2 Lewis addresses the full range of musical artistry in *A Power Stronger Than Itself*.

3 See Robert Bone, "Richard Wright and the Chicago Renaissance," *Callalo*, 28, Summer, 1986 (Baltimore, MD: Johns Hopkins University Press), 466. His essay helped to alter this thinking. Following his lead there has been a shift in interpretation and the Chicago Renaissance and its key writers and artists have been absorbed into the historical record. Most notably there are studies of the Black Chicago Renaissance by Davarian L. Baldwin, Richard Courage and Amritjit Singh, and Darlene Clark Hine and John McCluskey.

4 See Bone, "Richard Wright and the Chicago Renaissance," 465. Fern Gayden was her partner on this project.

5 Notably the magazine focused on the work of black writers but was not exclusionary. White authors also published work in it.

6 The most obvious reason for the pseudonym is that she worked as a teacher at a Chicago public school and did not want the subjects and themes portrayed in her writing to interfere with her teaching career.

7 Bone discusses how they shared drafts and workshopped each other's work.

8 Bone, "Richard Wright and the Chicago Renaissance," 446.

9 Wright was a member of the South Side John Reed Club and the South Side Writers' Group was modeled after this Communist Party faction.

10 Anthony Stepter's notion of "Extinct Entities," which considers the ephemeral traces of art spaces has been helpful to my thinking here.

11 Darby English, *How to See a Work of Art in Total Darkness* (Cambridge: MIT Press, 2007), 64.

12 George Lewis and Scottt Rentner Interview, "Reimaging Africa: From Popular Swing to the Jazz Avant-Garde," *Afropop Worldwide*, http://www.afropop.org/wp/2752/george-lewis-interview.

13 *Muhammad Speaks*, November 7, 1969.

14 See Lewis, in *A Power Stronger Than Itself*, 96; and Ronald M. Radano, "Jazzin' The Classics: The AACM's Challenge to Mainstream Aesthetics," *Black Music Research Journal* 12, no. 1 (1992): 79–95. Both discuss in detail the AACM's grassroots strategies.

15 The school is presently on hiatus.

16 Radano, "Jazzin' The Classics," 83.

17 Serious social realms comprise dedicated readers or viewers. I come to this notion through an interpretation of the reading community that foments around the experience of Frederick Douglass's 1845 *Narrative*. As an ex-slave he is not sanctioned to read and write, but teaches his readers how to read his autobiographical slave narrative. Signal passages routinely clue the reader into a way of making sense, and also deriving pleasure, from the scant information and structured silences that he provides in lieu of pertinent narrative information. Douglass

trains and readies his readers to pay the closest attention to what's not there on the page and one learns from his text how to read against the narrative form and how to mobilize their own relation to the extra-textual methods that influence the reading experience. Douglass's work, like that of the AACM, helps to locate a committed society (mostly abolitionists at the time of its first publication), those able to discern the significance of his discontinuous narrative, and in many cases those who wanted to participate in the effort to emancipate slaves.

18 Sophisticated in that these also take into account the need for individuated artist agency and in that they don't (only) romanticize the notion of community.

19 See Michelle Grabner's description of the *Heartland* exhibit at the Smart Museum, Chicago, in "Heartland Preview," *Artforum* (September 2009).

20 The SAIC course catalog and website define DIY curriculum as follows: "'Do it yourself' practices in art and design evolve when the average individual seeks information and know-how via a self-learning process. Rather than hiring others who have expertise, a DIY-oriented creative would learn then perform the proficiencies required. The first part of the 21st century witnessed a transition from a tradition of centralized manufacturing to a DIY 'maker culture' of dispersed innovations. SAIC offers several classes focused on DIY practices as well as maker culture."

21 In 1982 it was also chartered as a non-profit by the State of New York. See Lewis, *A Power Stronger Than Itself*, 418. In a sense this reinforces its Chicago presence, which endures despite the increased opportunities for the musicians in New York and internationally.

22 Grant Kester, *Conversation Pieces: Community and Communication in Modern Art* (Berkeley, CA: University of California Press, 2004), 153.

Forms of Social Organization: The Association for the Advancement of Creative Musicians

Dieter Roelstraete and Michelle Puetz

In the August 7, 1965 edition of the *Chicago Defender*, the Association for the Advancement of Creative Musicians (AACM) announced its first two concerts in an "open letter to the public." Both performances were held at the South Shore Ballroom on East 79th Street: the Joseph Jarman Quintet on August 16 and Phil Cohran's Artistic Heritage Ensemble on August 23. Beyond this, the letter promulgated the organization's principled aims and goals "to provide an atmosphere that is conducive to serious music and performing new unrecorded compositions" and to "create a spontaneous atmosphere that is unique to our heritage and to the performing artist."[1] The AACM took control of all aspects of concert production and promotion as well as the training of young musicians, and sought to "show how the disadvantaged and disenfranchised can come together and determine their own strategies for political and economic freedom, thereby determining their own destinies. This will not only create a new day for Black Artists but for all Third World inhabitants; a new day of not only participation but control."[2] Concerts were promoted with postcards, both designed and printed, as well as simple typewritten announcements. The AACM's reach quickly expanded far beyond Chicago. By 1969 the Art Ensemble of Chicago—Anthony Braxton, Leroy Jenkins, and Leo Smith—had decamped to France, and AACM musicians were soon

Further Explorations: A Celebration of the AACM program, 1979.
Courtesy of the Museum of Contemporary Art, Chicago.

performing at festivals throughout Europe. By the time most of the AACM musicians returned to the US in 1971, performances were still taking place in Chicago's alternative spaces and venues, but heightened interest in "new black music" [3] meant that area arts institutions started booking AACM musicians, including Muhal Richard Abrams, the Obade Ensemble, Air, Anthony Braxton, and Roscoe Mitchell.

From the outset, the experimental aspirations of the various composers and collectives associated with the AACM sought to push the boundaries of traditional jazz instrumentation. This not only led to a considerable expansion of the existing arsenal of musical instruments (think of the myriad so-called "little instruments" which the Art Ensemble of Chicago in particular availed themselves of during their many memorable live performances), but also to the building of new instruments, such as the hubkaphone (a percussion instrument made up of hubcaps). Henry Threadgill, of Air fame, became an especially proficient player of this marimba-like contraption. As an artwork in its own right, the hubkaphone could also be viewed as a creative repurposing of the flotsam and jetsam of American car culture. Not surprisingly perhaps, given the crisis that the car industry was about to enter in the early 1970s, the hubkaphone's glory days reflected an earlier era. About his short-lived infatuation with the unconventional instrument, Threadgill noted: "in the '60s they were still making things in America that were of quality, but by the end of the '60s, America was on its way downhill in terms of making anything of quality. Radios. Hubcaps. I don't care what it is."

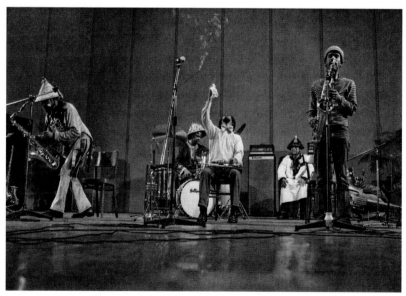

Art Ensemble of Chicago performing at the Bergamo Jazz Festival, Teatro Donizetti, 1974.
© Roberto Masotti.

In addition to a revolution in music and the politics of performance, the founding of the AACM also marked a decisive shift in the development of African American music's visual identity, especially in regard to the theatrical staging of this music's confident new self. Inspired perhaps by the shining example of Sun Ra and his Arkestra, who spent a formative decade-and-a-half on Chicago's South Side before the AACM's founding, as well as by the Afrocentric turn in the broader culture of black America in general, artists such as Phil Cohran and the Art Ensemble of Chicago became known for their extravagant stage costumes, combining elements from African folklore with space-age psychedelia and the like. The concerts of the Art Ensemble of Chicago in particular acquired an operatic quality, conjuring the Wagnerian dream of the total work of art—a musical as well as visual feast for ears and eyes alike.

This text reflects the preliminary research conducted by Museum of Contemporary Art, Chicago curator Dieter Roelstraete and curatorial fellow Michelle Puetz for the exhibition *The Freedom Principle: Experiments in Art and Music, 1965-Now*, co-curated by Roelstraete and Naomi Beckwith.

1 "Creative Musicians Sponsor Artists Concert Showcase," *Chicago Defender*, August 7, 1965, 14.

2 *A.A.C.M. Newsletter* 1, no. 1, October 21, 1973, in the Jamil Figi Papers at the University of Chicago Special Collections Research Center, box 1, folder 1.

3 See Amiri Baraka [Leroi Jones], *Black Music* (New York: William Morrow and Company, 1968).

Women in Action! Feminist Art Networks in Chicago 1970-1980

Joanna Gardner-Huggett

Chicago was a place where women were not discriminated against...We were never separated out; in fact we all won prizes, exhibited. I never even thought about not being a part of the art world.

– Ellen Lanyon[1]

As the painter Ellen Lanyon (1926–2013) explains above, the city of Chicago has long supported the professional lives of women artists. Yet it is frequently not acknowledged that despite a strong tradition of educating women in Chicago and providing opportunities to exhibit and win prizes, there is a parallel narrative of women's networks and organizations creating safe spaces for women to experiment with their art, as well as be mentored and trained in the skills needed to succeed in a professional art world. These collaborations, such as the West-East-Bag (1971–ca.1976), Artemisia Gallery (1973–2003), and ARC Gallery (1973 to the present), would flourish in the early 1970s under the influence of a broader feminist movement taking hold in the United States. Lanyon would become a key player in this history.

Women's collaborative and separatist practices in Chicago during the 1970s finds its roots in the late nineteenth century, beginning with the Woman's Building at the World's Columbian Exposition in 1893, and would continue with the exhibition organization the Women Artists' Salon (1937–ca.1952).[2] It was not these collaborative precedents, however, that lured Lanyon to feminism, but a chance meeting with Lucy Lippard at a

party thrown by collector Lew Manilow in 1971. The noted feminist critic and curator then visited Lanyon's studio and after seeing her painting *The Goddess and the Reptile Illusion,* responded, "Fantastic! What a wonderful image to portray feminism."[3] Lanyon concludes, "I guess I'd been doing this all along and I wasn't really thinking about that but obviously it's all there."[4] Their continued conversations regarding feminism and the art world led Lippard to invite the artist to work with the West-East-Bag (WEB), an international network founded that same year and committed to raising the visibility of women artists, specifically through the establishment of slide registries across the United States and in other countries.[5]

Available statistics regarding women's limited presence in the art world certainly galvanized participation in the WEB and future feminist endeavors in Chicago. For example, in 1971 women comprised 75% of students in art school, yet they would only earn 36% of men's salaries after graduation, and only 17% of grants awarded by the National Endowment for the Arts went to women that same year. Also academia provided few mentors for young female artists, as only 2% of art faculty across the nation comprised women.[6] In 1973 women in Chicago fared better in terms of commercial gallery representation with 29% of its solo exhibitions devoted to women artists in comparison to the 10% average across the nation.[7] During the same year the Museum of Contemporary Art and the Art Institute of Chicago also demonstrated a better record of showing women's work, the former featuring exhibitions dedicated to Diane Arbus and Eva Hesse and the latter photographs by Claire Trotter.[8] Chicago's art world may have held a modest edge for female artists, but the campaigns of activist groups in Chicago, such as the Chicago Women's Liberation Union (CWLU), the Westside Group, and Women's Radical Action Project (WRAP), that were demanding equal treatment for women in the workplace, affordable and accessible child and healthcare, and the right to control one's own body, confirmed that there was serious work to be done.[9]

In addition to creating slide registries for women artists, the major political networking tool utilized by the WEB was its newsletter; Chicago members took turns with participants in New York and Los Angeles composing the roughly quarterly publication, as well as circulating it in the Midwest. The newsletter included practical information, such as announcements of local exhibitions and gallery talks addressing women's interests, but more importantly it provided examples of how to organize protests against museums and educational institutions.[10] In the first Chicago issue published in October 1972 Johnnie Johnson outlined the Museum of Contemporary Art's poor record of showing women with Louise Nevelson as the only female artist featured that year. Johnson simultaneously condemned Chicago collectors of contemporary art as equally responsible for

women's marginalization.[11] Editors also offered statistics regarding gender discrimination in art schools as a way to encourage women to engage in protest in their own cities. Further, in the same issue editors provided a sample letter demanding art departments implement women's studies courses or they would find themselves the subject of protests that could be easily duplicated and sent out to institutions across the country.[12]

The WEB newsletter was cheap to produce and easy to distribute, while the public events WEB organized were instrumental to women taking action in Chicago. To introduce the WEB to Chicago, Lanyon sent letters to fifty women artists in the area inviting them to a meeting at the School of the Art Institute of Chicago where she was teaching. More than 300 women attended, making clear that despite the relatively supportive atmosphere of the city, a feminist agenda was still necessary. Soon afterwards Whitney Museum of American Art curator Marcia Tucker came to Chicago, met with female artists at Sara Canwright's loft on the West Side, and described the practice of consciousness-raising and how it is essential to feminist organizing. According to Lanyon, numerous consciousness-raising groups emerged from that session.[13]

These successful, but fairly informal events, organized by WEB prompted the group to coordinate the first annual Midwest Conference of Women Artists in 1973. Held at the Wabash Transit Gallery at the School of the Art Institute of Chicago, panels offered both legal and professional advice in such sessions as "Legal Recourses in Cases of Sex Discrimination in Hiring Practices" and "Galleries, Grants, and Commissions," in which women were taught how to navigate the processes of applying for grants and finding representation with a commercial gallery. In addition the feminist art historian Ann Sutherland Harris lectured on "Images of Women and Women Artists in 17th- and 18th-century Italy," and Carolee Schneemann screened her films *Fuses* (1965) and *Plumb Line* (1971).[14] An exhibition, *Women Choose Women*, opened the Friday evening of the conference, giving participants the opportunity to see works by Chicago-based women artists selected by their peers.[15] While intended to be a local conference, there was a large out-of-town presence, which led the WEB to hold a second Midwest conference in 1975 at Ox-Bow Summer School of Painting in Saugatuck, Michigan, which would cover much of the same content addressed in the first.[16] However, the slide-sharing sessions proved to be most powerful to attendees. New York–based artist Debbie Jones recalls, "viewing others' slides gave me a strong sense of validation for my own imagery and struggle."[17]

Significantly for Chicago, the WEB's first conference helped catalyze the formation of two women artists' cooperatives founded in September 1973: Artemisia Gallery and ARC Gallery. Joy Poe, a founding member of

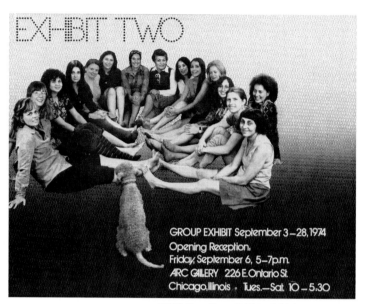

EXHIBIT TWO

GROUP EXHIBIT September 3 – 28, 1974
Opening Reception.
Friday, September 6, 5–7p.m.
ARC GALLERY 226 E. Ontario St.
Chicago, Illinois • Tues.—Sat. 10 – 5.30

ARC Gallery, *Group Exhibit* exhibition poster, 1974.
Courtesy of ARC Gallery and Educational Foundation.

Artemisia, attended the session at the first WEB conference in which art-
ist Harmony Hammond showed a video about A.I.R. Gallery that formed a
year earlier in New York.[18] Then a graduate student at the School of the Art
Institute of Chicago, Poe visited A.I.R. that May and concluded that the same
model could be realized in Chicago.[19] After the initial summer meetings, at
a subsequent meeting of forty women, five core members were chosen (Joy
Poe, Barbara Grad, Margaret Harper Wharton, Emily Pinkowski, and Phyllis
MacDonald) and later they chose fifteen more members: Phyllis Bramson,
Shirley Federow, Sandra Gierke, Carole Harmel, Vera Klement, Linda
Kramer, Susan Michod, Sandra Perlow, Claire Prussian, Nancy Redmond,
Christine Rojek, Heidi Seidelhuber, Alice Shaddle, Mary Stoppert, and Carol
Turchan. Taking their name from the seventeenth-century Italian Baroque
painter Artemisia Gentileschi (1597–c.1651) "whose best work had been
credited to her father" and whose work had been introduced to Poe during
Sutherland Harris's lecture, these women were determined to make their
own names known to the art world of Chicago and beyond.[20]

The inspiration for ARC Gallery also had connections to A.I.R. Nancy
Spero, one of its founders, along with her husband Leon Golub had stud-
ied at the School of the Art Institute of Chicago. Together they encouraged
Gerda Meyer Bernstein, a close friend from their time in Chicago, to start a
women's collective in order to encourage younger women artists. Bernstein
enlisted the help of her friend Frances Schoenwetter and between them

they sought slides of the best women artists in the area. Eventually Johnnie Johnson and Kay Rosen joined a working committee and the group selected an additional thirteen members: Dalia Alekna, Jan Arnow, Judy Lerner Brice, Ellen Ferar, Irmfriede Hogan Lagerkvist, Maxine Lowe, Mary Min, Civia Rosenberg, Regina Rosenblum, Laurel Ross, Sara Skolnik Rosenbluth, Myra Toth, and Monika Wulfers.[21] While Artemisia envisioned itself as a feminist-oriented space, Johnson notes, ARC chose to "concentrate principally on more pragmatic concerns, technical workshops, and the 'business of being an artist.'"[22] The name ARC—Artists, Residents, Chicago—suggested the practical intent; and, like Artemisia, it also started with "A" and as Bernstein observed, this ensured a top listing in any gallery guide.[23]

Central to both Artemisia and ARC was a non-hierarchical form of governance. Like many feminist organizations of the early 1970s, a bureaucratic, hierarchical structure was viewed as a masculine ethic that failed to reflect women's own values and experience. Rather Artemisia and ARC distributed authority among all members; it implemented a rotating leadership and made all decisions through a participatory process.[24] Being exclusively female was also critical to the success of this mode of governance for both Artemisia and ARC because it allowed women to meet without the presence of male interference and ensured that their concerns and needs would finally be heard and addressed in a nurturing environment.[25] In addition to offering each member of Artemisia and ARC an annual solo show and a supportive atmosphere in which to develop a strong body of work, both galleries also extended its concept of community by establishing educational non-profit counterparts: the Artemisia Fund and the ARC Educational Foundation, respectively. As a result, these spaces began to replace the outreach programs of the WEB. Domenica Thompson writes in 1976, "The ARC Foundation and Artemisia Fund have taken on the burden [of] bringing meaningful programs to the public so the WEB sees no need to strive in that area, but WEB members should support the cooperatives."[26]

In its programming, the Artemisia Fund placed an emphasis on feminist issues and artists. As early as 1974 they hosted Judy Chicago as a visiting artist at a moment when she was also commencing the *Dinner Party* (1975–1979), as well as Cindy Nemser, editor of the *Feminist Art Journal* and author of *Art Talk: Conversations with 15 Women Artists*.[27] During the 1976–1977 season Artemisia offered two workshops to the wider community: Feminist Art Workers and Feminist Educational Methodology,[28] the latter was conducted by Ruth Iskin and Arlene Raven, both key figures in feminist art history and collective practices in Los Angeles, including Womanspace and the Woman's Building, founded in 1972 and 1973 respectively. Artemisia also coordinated thematic exhibitions that confronted the position of women in society, such as *Both Sides Now: An International*

Exhibition Integrating Feminism, and Leftist Politics (1978), guest curated by Lippard.

The extensive programming of the ARC Educational Foundation, while motivated and concerned by feminist issues, was more focused on more practical and general approaches to art, as was its overall mission. In its first ten years events ranged from evenings with the art historian Anne Rorimer (1975) known for her scholarship dedicated to minimalism and conceptual art, to Chicago collector Joseph R. Shapiro (1975), and artists Barbara Crane (1975) and Leon Golub (1979).[29] ARC also sponsored panels, such as "Hazards in Art," which included a number of experts on how to prevent illness and injury caused by various hazardous methods of art production (1975); "Women's Coop Galleries (1980)," featuring the artist Barbara Aubin, performance artist and feminist critic Joanna Frueh, and critic C.L. Morrison; and "Use and Place of Photography in Contemporary Art" (1981). Furthermore, in 1979 ARC implemented the program "RAW Space," which dedicated its basement gallery to sculpture, installation, and electronic art—a feature that distinguished the gallery from many other women artists' cooperatives and alternative galleries and proved to be an important experimental space. Thus, ARC and Artemisia's programming was not intended solely to serve its membership, but to foster dialogues about both feminist and contemporary art issues within the wider Chicago art community.

Lanyon explains that overall feminist art activism in the Midwest was "softer, slower," and "not as rigorous as those in the more competitive coastal cities..."[30] Historian Michelle Moravec rightly asserts that Chicago women did not actively follow the WEB's call to contest the policies of mainstream museums and commercial galleries.[31] While these feminist networks may have remained internal to the art world, WEB, Artemisia, and ARC contributed greatly to the alternative art scene of Chicago and became part of a rich community of collective spaces. Taking their place along with Chicago Filmmakers, N.A.M.E. Gallery, and Randolph Street Gallery, with which they frequently collaborated on exhibitions and initiatives, they ensured that succeeding generations of female artists would have the opportunity to feel, as Lanyon said, that they were "never separated out" or "discriminated against."[32]

1 Joanna Gardner-Huggett, "Interview with Ellen Lanyon," in *1968: Art and Politics in Chicago* (Chicago: DePaul University, 2008), 41. Exhibition catalog.

2 For further history, see Wanda Corn, *Women Building History: Public Art at the 1893 Columbian Exposition* (Berkeley, CA: University of California Press, 2011). For a history of

the Women Artists' Salon, see Joanna Gardner-Huggett, *Julia Thecla: Undiscovered Worlds*, (Chicago: DePaul University, 2006). Exhibition catalog.

3 Gardner-Huggett, "Interview with Ellen Lanyon," 40.

4 Ibid.

5 For a much more comprehensive history of the West-East-Bag, see Michelle Moravec, "Towards a History of Feminism, Art and Social Movements in the United States," *Frontiers, A Journal of Women Studies* 33, 2 (2012), 22–54.

6 Eleanor Dickinson, *Gender Discrimination in the Art Field*, 1999, 4–13.

7 Ferris Olin and Catherine C. Brower, "Career Markers," *Women Making Their Mark, Women Moving into the Mainstream 1970–85*, ed. Ellen Landau (New York: Abbeville Press, 1989), 4–13.

8 Ibid., 212.

9 For an account of the formation and activities of the Westside Group see Amy Kesselman, with Heather Booth, Vivian Rothstein, and Naomi Weisstein, "Our Gang of Four: Friendship and Women's Liberation," in Rachel Blau DuPlessis and Ann Snitow, eds. *The Feminist Memoir Project Voices from Women's Liberation* (New York: Three Rivers Press, 1998), 25-53. See Jo Freeman, "The Revolution is Happening in Our Minds," in *The New Feminism in Twentieth Century America*, ed. June Sochen (Lexington, MA: D.C. Heath and Co., 1971), 149-160 for a discussion of the Women's Radical Action Project. For a history of the Chicago Women's Liberation Union see: http://cwluherstory.com, which contains a history of the group, memoirs, historical archive, and articles written about CWLU.

10 "W.E.B., An International Liaison Network of Women Artists," (October 1972), 1.

11 Before publishing this issue, WEB representatives put together two local newsletters that were circulated only in the Midwest and not at the national level. Ibid.

12 Ibid., 4.

13 Gardner-Huggett, "Interview with Ellen Lanyon," 40.

14 A copy of the conference program is available in the Joy Poe Papers, Artemisia Gallery Records, Ryerson and Burnham Libraries, Art Institute of Chicago, Chicago, Illinois.

15 This exhibition was likely based on the exhibition model *Women Choose Women*, organized by the activist group Women in the Arts (WIA) and held at the New York Cultural Center in January 1973. An all-female jury selected 109 artists from the membership of the WIA as a way to highlight the wide array of art made by women at that date. See Mary Birmingham, "Choices and Connections," in *Women Choose Women* (Summit, NJ: New Jersey Visual Arts Center, 2014), 7–15. Exhibition catalog.

16 Linn Hardenburgh and Susan Duchon, "In Retrospect—The Midwest Women Artists' Conference," *Art Journal* (Summer 1976), 386, 388.

17 Ibid., 387.

18 Devonna Pieszak and Bonnie MacLeod, "Consciousness Raising on Ontario St.? Chicago Women's Galleries and the Women's Movement," *New Art Examiner* (November 1973), 3.

19 Joy Poe, "Artemisia Gallery," 1979. Artemisia Gallery Records, Ryerson and Burnham Libraries, Art Institute of Chicago, Chicago, Illinois.

20 Virginia Holbert, *Artemisia X: Ten Years*. (Chicago: Artemisia Gallery, 1983).

21 Interview with Gerda Meyer Bernstein, July 5, 2007.

22 Pieszak and MacLeod, "Consciousness Raising," 3.

23 Interview with author, July 5, 2007.

24 Rebecca L. Bordt, *The Structure of Women's Non-Profit Organizations* (Bloomington, IN: Indiana University Press, 1997). Bordt focused on organizations in New York City, but the results of this study easily can be applied to alternative women's groups across the country.

25 Dana Shugar, *Separatism and Women's Community.* (Lincoln, NE: University of Nebraska Press, 1995), 12–15.

26 Domenica Thompson, *Chicago Newsletter,* sponsored by the Chicago WEB, ARC Foundation, and Artemisia Fund, October 1976.

27 Cindy Nemser, *Art Talk: Conversations with 15 Women* Artists (New York: Scribner, 1975). Video documentation of Chicago's talk is available in the Artemisia Gallery Records, Ryerson and Burnham Libraries, Art Institute of Chicago, Chicago, Illinois.

28 Video documentation of an interview with Ruth Iskin and Arlene Raven conducted during their workshop is available in the Artemisia Gallery Records, Ryerson and Burnham Libraries, Art Institute of Chicago, Chicago, Illinois.

29 Audio recordings of the lectures delivered by Barbara Crane, Leon Golub and Joseph R. Shapiro at ARC are available in the ARC Gallery Records, Ryerson and Burnham Libraries, Art Institute of Chicago, Chicago, Illinois.

30 Lanyon quoted in Hardenburgh and Duchon, "In Retrospect," 388.

31 Moravec, "Toward a History of Feminism," 30.

32 For a history of alternative spaces in Chicago see Lynne Warren, *Alternative Spaces: A History in Chicago* (Chicago: Museum of Contemporary Art, 1984). Gardner-Huggett, "Interview with Ellen Lanyon," 41. Exhibition catalog.

Vision for a Culturally Grounded Institution

Encarnación M. Teruel
Interviewed by Abigail Satinsky and ESCAPE GROUP

Abigail Satinsky: *We wanted to speak with you because of your wide-ranging experience in Chicago—from the Chicago Park District, the Field Museum of Natural History, and now the Illinois Arts Council, but especially your time at the Mexican Fine Arts Center Museum in the late 1980s when you started the organization's Performing Arts Department. Anthony Romero and J. Soto—artists working under the name ESCAPE GROUP—are also here. They have been researching the history and expression of what, as natives of the Southwest, they know as the Chicano civil rights movement, and are interested in its iterations in the Midwest. With this in mind and your experience in culturally grounded institutions, as well as background as a performance artist, we wanted to have a conversation about your experiences in Chicago and common concerns.*

Encarnación Teruel: I'm first-generation Mexican American conceived in Mexico and born in Chicago. My parents and two older brothers who passed away were born in Mexico, and I was the first of five to be born in the US. My dad came to Chicago in the early 1950s and worked in the steel mills on the Southeast Side of Chicago, which is where the first Mexican community of note was. In the 1960s, he moved the family to Pilsen where the immigrant Mexican community, as we know it now, was establishing itself. Like true immigrants to the United States my parents wanted their children to assimilate, so we moved from Pilsen to Lakeview with the point of not living in a Latino/Mexican community.

I went to school in the 1960s as a first-generation Mexican-American trying to assimilate—back then the seeds of one's own cultural amnesia and rejection were planted early. When I was held back in first grade because I couldn't speak English well enough it made me think Spanish was bad. Back then, as a Mexican, my educational experience about my heritage essentially was that Pancho Villa was a bandito and that the Louisiana Purchase was a great deal for the US. As a person of color you were not exposed to any role models in history or culture, so it made you feel like you were part of a people that never accomplished anything. You would see everything in relation to a white society. The human rights movements in the 1960s and 1970s were influential to me, even though I didn't grow up in the Latino community and also wasn't involved in the Chicano movement directly, which took place primarily on the West Coast and the Southwest, but I'm Mexican and my family and friends were Mexican. As the demographics of the country shifted and the Latino population grew, our society changed. Suddenly rather than seeing speaking Spanish as a detriment, I recognized that I'm bilingual!

Early on I wanted to be an artist. Even prior to going to the School of the Art Institute of Chicago (SAIC) for my BFA, I went to Chicago Public High School for Metropolitan Studies; I was among the first group of 150 students who went to that school and whose makeup demographically reflected the city's population. It was an experimental high school that used the city and its institutions as a classroom. We would go to the Field Museum for history classes, the Art Institute museum for art, and a typewriter factory on the West Side that no longer exists for our typewriting classes. This gave me a sense of the historical and cultural connectivity between the communities throughout the city and reconnected me to my own family's journey through Chicago.

After I graduated, I spent two years working; my plan was to go back to Mexico to reconnect with my roots. By that time, my family lived in Uptown and I had a Jewish girlfriend who lived in Albany Park. We saved our money and rode our bikes from Chicago to the Mexican border with the romantic intention to live in Mexico for a year in a little adobe house. I was going to study surrealist painting and be like an experimental Diego Rivera, and she was going to study writing; we were both going to study Spanish. That didn't actually happen that way. We did ride our bikes down there and we did spend about nine months in Mexico, mostly in San Miguel Allende, which is kind of like an artists' colony with a lot of ex-patriots from the United States and Canada, after which I came back to Chicago. I entered SAIC with a ceramic portfolio intending to be a psychedelic muralist. When I applied to SAIC I thought that I had a good chance of being accepted because as far as I knew they had no Mexican students and they definitely needed some! No one ever

tells you that, though I did get in. At that time the curriculum was mostly Eurocentric arts based on and dominated by a prism of Anglo culture.

This is 1976 and I ended up in the basement floor of the Columbus building at the Art Institute. I guess the basement was where all the freaky experimental stuff was happening. Generative systems, which meant art and technology, performance art, filmmaking, and audio works were all happening down there and are still kind of happening down there. After some time at the school, I met Marcia Tucker who was in residence at SAIC where she mentioned that she had opened a museum in New York called the New Museum focused on contemporary art. I ended up going to New York to do a curatorial internship there, and since the museum was only about three years old at the time and run on a shoe-string budget; I was able to work in all of its varied facets. While in New York I also worked at Creative Time as the head preparator and performance coordinator for *Art on the Beach*,[1] which included public art installations by Alice Aycock and Nancy Rubin, and performances by Jon Gibson and the Bill T. Jones and Arnie Zane Dance Company, among others. And it was a great summer—getting high, going out, sitting on the beach, and working with these artists to build these huge sculptures out there on the sand. This was during the whole New York Lower East Side cultural punk explosion and I lived there for about three years, going to the Mudd Club, becoming involved with projects like the *Real Estate Show* and the *Times Square Show*, which were illegal exhibitions in city-owned buildings around issues of gentrification.

Afterwards, I returned to Chicago and SAIC to try and finish my education, though Chicago felt pretty dead to me artistically. I ended up doing performance art in discreet places throughout the city and in clubs like Metro and Medusa's. This culminated in a co-curated project with Violet Banks called *SEX SHOW: Cultural Perspectives on Sexuality in Society*, which by day was a gallery space with art centered on sexuality, in the evening a sex information center featuring the services of the Howard Brown Clinic, and then at night would re-open as a "sex club" with sexually themed poets, performance artists, and bands. This was a response to the conservatism of the Reagan era and at the beginning of the culture wars and the AIDS pandemic. Incidentally the *SEX SHOW* became infamous because it was closed down with a Chicago police raid. By the end the 1980s, even though I was presenting my work in clubs and galleries and had received a National Endowment for the Arts grant, I was really starving. Then the culture wars happened, and NEA stopped funding individual artists, so there were fewer options than even before.

My own art at this time had shifted from sexually oriented to culturally grounded work, and I started getting interested in cultural preservation on a personal and also societal level. That's when I met the people who started

the Mexican Fine Arts Center Museum (MFACM) through my brother, who is a composer and runs the Latino American Recruitment and Educational Services office at the University of Illinois. So we went down and talked to Carlos Tortolero and Helen Valdez, both schoolteachers, and who had just started the museum three years prior. They were seeking positive role models and felt a deep need to educate and serve Chicago's Mexican community because they didn't see that happening in the educational system here. With such a sizeable community of Mexican Americans being underserved, they felt there was a real need for a Mexican museum.

The MFACM began in 1982 with a budget of $900 in half of the field house in Harrison Park when Harold Washington was mayor. He had begun dismantling the Democratic political machine through which a lot of patronage came to exist in the Park District. The Mexican Museum was one of those things that, for Washington, would help make the parks more accessible. The Mexican Museum did create some tension with the Chicano cultural arts movement that preceded it in Chicago because it came from a different philosophical perspective and a new understanding of community work. Even though there were commonalities in terms of education, human rights, and first voice issues, it was distinctly different.

When I came to the museum and saw what they were doing, it was kind of familiar to me. At the time I went to the New Museum, "museum" made me expect something that looked like the Art Institute, but when I got there it was a 5,000-square-foot gallery at the New School's Center for Social Research—basically a gallery and a small office with five people crammed in. So that was an education for me: all things start small and then grow. I saw the same potential in the Mexican Fine Arts Center Museum. They had the vision of making an institution equal to the Art Institute and beyond. I thought I could help establish it as a museum by establishing an infrastructure to actually function as a museum. They didn't really take me seriously because they really saw me as a freaky performance artist and not at all what they were envisioning, but I started as the education assistant for maybe three months, and then became the "museum specialist" because I had museum preparator experience and we wanted to achieve museum standards. In those days everyone at the museum had a title—director of something—even though we were maybe eleven people. Again this was part of the strategy of establishing the museum. So when we went somewhere else we'd say, "I'm the Director of Education." "Oh, really? How big is your staff?" "It's just me."

AS: *What were some of the guiding principles of the Mexican Fine Arts Center Museum at the time?*

ET: As it was originally called, museum and center were really important parts of the name: museum to establish it, as I said, and give it some offi-

cial cultural credence; and center, connecting to community accessibility, like El Centro de la Causa or Casa Aztlan, where people are *meant* to be able to come and not feel so alienated. Large institutions like the Art Institute museum can feel alienating and overwhelming for an immigrant, especially if you are a Latino or person of color and most of the art is Eurocentric—it can seem very unwelcoming. The Mexican Museum was to be really different. That's why it was based in a community. It really did serve as a model nationally in terms of how you could establish a culturally-grounded contemporary institution in a community. Carlos Tortolero tells the story of once we had some Meso-American artifacts on display in the museum and there's a father with a kid standing there, and the kid says, "Why is this stuff here?" And the dad says, "Because you're here." It's really important that someone can step out of their house and walk across the street and have that experience of a museum with contemporary art exhibitions and Meso-American artifacts that reflect your cultural heritage.

AS: *As an artist, what do you think you brought to the museum? How did the performance program get started?*

ET: The founders were educators without either a museum or an arts background. They made educated decisions that had nothing to do with the arts, but they were really good at the philosophy and concepts of the museum. My feeling was that the museum was in danger of propagating cultural stereotypes. Exhibitions like the *Day of the Dead* show are great but they can perpetuate a one-dimensional view and can be too focused on the folkloric aspects of the Mexican cultural experience. Folkloric groups in Chicago are usually started by families that want to make sure their kids have a traditional cultural grounding, dressing them up in mariachi outfits or other kinds of regional types of dress, and dance the dances in the way that they were traditionally taught. What happens is that they tend to freeze a cultural entity without realizing that it's an art form that keeps living and changing. If you go to Mexico and look at folkloric groups, they might have some salsa in it or even hip-hop culture, but here it's got to be traditional folkloric in the way it was presented fifty years ago.

Once the performing arts space opened, I started to present work that I thought was the best Mexican-based, Mexican American, or Latino. Art that was culturally grounded, while also universally accessible or universally beautiful in some kind of way. I took myself as an example: I'm Mexican and I do performance work, but it's not always Latino-based.

We'd go down to Mexico to do research for work to bring to the museum, and I'd get into these conversations with Mexican artists and they would say, "You know, you Chicanos..." and I'd say, "I'm not a Chicano." "Okay, whatever. But you guys, the Chicanos up in the United States, are fascinated with the Virgin of Guadalupe, Frida Kahlo, and sombreros and all this stuff." And I'd

say, "well, it's political; it's political artwork." They go, "Yeah, but you know how we see that stuff? That's kitsch. To us, when we go and see that artwork, it doesn't have the same resonance to us that it has to you guys." This awakened me to an idea of how culture is seen differently and fits in different migrant and immigrant communities in different kinds of ways and how I could bring that perspective to the museum.

Back to the folkloric thing, if you leave your country and go to another country—it doesn't even matter if it's Mexico and the US but just anywhere—you long for your culturally grounded connectors. It's just like when you're traveling and you crave those back-home connections—cheeseburgers, Chicago style pizza, Hollywood movies, or even folkloric traditions.

I had this vision to do an interdisciplinary performing arts festival and not replicate what often happens in Eurocentric museums where there is a separation between the visual arts and the performing arts. I also thought it would be important to establish the Performing Arts program as an essential part of the museum, not as ancillary, which is often the case with other similar institutions. In terms of connecting with the local community, it was also a way of having the museum become more noticed, because when you're doing performing arts, there is much more of a media presence with performer interviews and dance and concert reviews and the audience sees it as an enlivened, living institution. The first festival was called the *Del Corazón Mexican Performing Arts Festival*, which included Carlos Fuentes, Octavio Paz, and Isabel Allende (who's not Mexican). We were bringing in artists who were doing different kinds of things, and not necessarily because it was Mexican artwork but because it was important artwork. In later festivals, we brought people like James Luna, who says he's got some Mexican in him but is a Native American from the rez. Those program choices were very important in terms of expanding the idea of the concept of what Mexican and Latino art was about, and I think in many ways they impacted the cultural art scene here in Chicago.

J. Soto: *This makes me think, where is all that now? Where is the contemporary Latino/a art happening now in Chicago? Because I'll be honest and say that I feel out of touch with it, that I feel like I don't know where to go to find those representations and it doesn't feel centrally located. When I was coming over to this interview I was thinking about the importance of those representations. In 2006 I saw* Chicano Visions *at the de Young Museum in San Francisco and I remember feeling blown away by having access to those artworks. It has taken until just now for me to realize that was when I really began to consider getting an MFA and began to commit to a studio practice. So being here in Chicago, I think Anthony and I are both interested in crossing these boundaries or skirting simplified identities and trying to really make room for the complexity that is being Latinos right now—each with these back-*

grounds that are both very similar but also different, and wanting to remain agile within those representations.

ET: I can relate to that. My work wasn't necessarily culturally grounded, but I knew that I was Mexican and I knew that had something to do with it. It didn't always necessarily have Latino or Mexican themes as touchstones, but I felt that it definitely came from my experience—which wasn't Mexican in its totality, was not one thing or the other. And so you want to remain agile in that regard; you want to be able to create work that is going to be whatever it is you're trying to do, that is going to be universal in some way.

When I started working at the museum, I wasn't seen as a true Mexican. I was one of the first people to work there who wasn't born in Mexico, and who had received an extensive arts education and museum experience here in the US. I was seen more as a Pocho, disconnected to my heritage, who did not know about Mexican culture. In a certain sense it was true; I had a different kind of "Mexican" perspective than others did. But this experience opened my eyes and made me realize I could take ownership of that position because it's not about being closed; it's about being open. As artists, that's really important because most of the time you want to be open to as many things as possible, to be able to digest varying perspectives and do something with it. So there is that tension when you're creating around questions of what am I making and to whom am I speaking? The best art speaks to all of that, while not necessarily needing to speak to any of it.

I left the museum partially because I got tired of being the Mexican performance art expert in Chicago. I got tired of people saying, "Oh, if you want to talk about Latino art, call Encarnación. He's cool because he understands the traditional folkloric stuff, but he's got friends all over the world who are doing great artwork, like Guillermo Gómez-Peña or Jesusa Rodriguez." After a while as a curator and presenter I began to feel constrained and limited versus my interest of discovery.

As I've grown older and worked in different institutions, I try to keep that spirit of discovery alive. Culture is always moving, so it's impossible to always be part of the new. But that doesn't mean that there isn't a certain sensibility you can have, to be open and agile, and able to admit that while you don't understand where something is coming from, you can recognize it is a voice that touches certain things, and needs the attention to see where it is going.

Anthony Romero: *I want to circle back to this idea of the representation of brown artists in contemporary art and the ways in which future generations might look to these kinds of role models in order to aspire to something other than a kind of folk tradition. So that you could be brown and a minimalist or conceptualist—that you wouldn't have to be pegged as a muralist. I'm very interested in creating the kind of openness like you were saying—to open*

up possibilities to think about cultural experience in these communities so that they could have more possibilities themselves. It seems like your work is very much in line with that.

I also want your opinion about your cultural experience with various Latino communities in Chicago in relationship to contemporary social practice. Does something like free health clinics that popped up in the cultural centers in Pilsen have a direct relationship to things that are happening in social practice now, because social needs and experiences are now more represented in contemporary art institutions?

ET: I really believe in the interconnectivity of things and I look at my life that way. I don't know if that is necessarily a model, but I do question, in response, how activism is connected with free clinics and the clinics are connected to social activism, to social practice, to contemporary art. How do you map a societal footprint for that? I don't necessarily know that there's an answer that lets us create a diagram or an equation for that. But social practice artwork now, cultural artwork, and public artwork are all interconnected, just like the Mexican Museum is connected to what came before it like the Latino Cultural Center and the Latino Progressive Institute. The museum became successful and more people in Chicago started to look at the museum as the Latino center of the city, and these other groups that weren't as organized or as established but were just as important in the community had this professional tension between what they were doing and what the Mexican Museum was doing. One of the reasons the museum exists is because in Chicago, Latinos weren't being taught their history, and in order to know where you're going you have to know where you're coming from. Moving forward, what does that become? That's a really marvelous problem to look at and try to figure out how that manifests itself. Things that were exposed at the Mexican Museum to the Mexican American or Latino and the general population of Chicago offered possibilities of what could be done and new cultural paradigms, though built on other activities already underway. It's kind of like what you were saying before about when you went to see the Cheech Marin show and how that inspired you. I see my work as doing that.

I guess you start with individual activism, an individual sense of connectivity, and the desire to make a difference. I've never run an organization because I don't want that responsibility, but as an artist, is it your artwork? And as an activist, is it what you organize and activate? Part of it, I think, does come from what you're saying: that you don't see something there. So as an artist or an activist, what's your responsibility? If you don't see it, then should you make it happen? Then there are questions of resources, what can you do, and what is it that you're going to make happen? I think that artists do that a lot, whether it's creating an artwork or creating artwork that

has a larger interactive societal impact. At the Mexican Fine Arts Center Museum I had the arts background and artistic eye instead of the educator's eye or even a museum professional's. I was an artist. That's how I ended up there. And I was one of those artists, kind of like you two, who could make those connections and see how these things can manifest themselves in other ways.

AR: *Yes, I really connect with becoming interested in cultural preservation and culturally grounded institutions. The trajectory feels very similar, too. I never thought about being brown because I was surrounded by brown people. That had never occurred to me until I came to Chicago from south Texas, and I decided not to live in Pilsen but in Wicker Park, and then realized: oh, I'm in a completely different place. What is this thing I'm experiencing? I've been in Chicago for about five years now, and it's really in these last five years that this interest in history and being culturally grounded has manifested itself. Where I grew up eight hours from the border, you're in it; you don't have to think about it because it's just there. Everyone looks like you, so there's really no difference to account for. Then I come here and, like you, I'm practicing performance in that same basement of SAIC, and everything is just turned on its head.*

The interview was conducted on April 26, 2014 in Chicago.

1 Between 1978 and 1985, Creative Time, a public art organization based in New York City, held seven *Art on the Beach* exhibitions at the Battery Park Landfill, an undeveloped strip of beach created by the excavation and construction debris of the World Trade Center. Creative Time commissioned large-scale, experimental public sculptures and performances, featuring more than 180 artists, performers, architects, musicians, and dancers. More at *Creative Time: The Book, 33 Years of Public Art in New York City* (New York: Princeton Architectural Press, 2007), 60–67.

Until It's Gone: Taking Stock of Chicago's Multi-Use Centers

Nato Thompson

In the early hours of April 25, 2001, a three-alarm fire broke out at Chicago artist Dan Peterman's complex at 6100 South Blackstone Drive. Starting from the northeast corner in the Big Fish Furniture shop, the blaze spread across the roof and tore through the entire building. Firefighters arrived and blasted the complex with high-powered hoses, the sheer force of which put holes in the sheetrock walls and drenched a deteriorating stock of *The Baffler* magazines. The fire practically decimated the building. Ten years of Peterman's recycled works had turned to hardened blobs. *The Baffler,* one of the nation's greatest muckraking journals, lost most of their archives and their whole office. Blackstone Bicycle Works lost their store. By the end of the blaze, the city of Chicago was dramatically close to losing one of its most unique and utopic alternative art centers.

Approximately a week later, DePaul art professor and artist Jim Duignan received what amounted to an eviction notice. His project called the Stockyard Institute was to have its rent raised from zero to $2,500 a month with a severe decrease in square footage. The Stockyard Institute, located at 4741 South Damen Avenue, was just coming into its own as a particularly idiosyncratic and socially radical art center. Chicago artist collective Temporary Services had begun to move in. The South Side's University of Hip Hop had just painted the walls with murals depicting elephants plowing through the streets of the downtown Loop. A roof garden was being developed and Duignan's high-school students were regularly meeting there.

Duignan envisioned a space for artists whose practice incorporated everyday life. Now everyday life was sending him packing.

The confluence of these two tragedies had many Chicago artists, activists, teachers, and neighbors talking (and paranoid). What had been lost? How could this happen? It wasn't simply that these spaces provided noncommercial venues for art, but in a more beguiling manner, there was a sense that each space was endearingly odd. Not simply venues for noncommercial art, they were multi-use centers that strategically bridged disparate practices and communities. They were lacunae in a laundry list of predictability. Globally such polymorphous venues are on the rise, and under the noses of most Midwest residents, Chicago has been the leading city in the organic development of these models. A fire and an eviction hadn't simply caused a void; they had induced an urgent need for reflection. What is it these spaces were doing and how can we build on them? Looking at the broad scheme of alternative centers globally and concentrating on these two spaces locally, many possibilities reveal themselves.

Introducing the Multi-Use Center

One could easily imagine an artist working with a literary magazine or a carpentry shop working with a bike shop, but how would a bike shop and a literary magazine collaborate? Or a carpentry shop and a writer's studio? The answer is that they did, in many varied ways and on many levels.

— Greg Lane, *The Baffler* publisher

I use the term "multi-use center" to describe the activities of these idiosyncratic exhibition spaces. It's a working term and possibly used to compensate for a rather dysfunctional methodology. Moving from bicycle repair to collective kitchen to conceptual art isn't always the smoothest of journeys. But if one can get past the white-cube stigmas, the physical proximity and conceptual disparity of the various enterprises create a veritable social catalyst. This multi-use sociability is the same catalyst that pushes the rhetoric of much contemporary art and postmodernism.

Nicolas Bourriaud coined the term "relational aesthetics" to describe the art of the late 1990s. Artists like Liam Gillick, Superflex, and Rirkrit Tiravanija produce context-specific work that allows the viewer many points of entry and is fundamentally contingent, existing between discourses. It is no wonder that terms like "generosity" and "relational" came into vogue as artworks became dialogues and not objects. But as cultural critic/political theorist Tom Frank and friends at *The Baffler* would happily point out, such approaches don't move away from the constraints of capi-

tal, but tend to reflect it. The move in late capitalism from manufacturing to service has created information as the new commodity, in all its decentered forms. What is different about multi-use centers, and what allows them to break from these molds is that their production and site are linked within a process that evades, in spirit as well as economics, the logic of capital. For spaces like Peterman's studio building and the Stockyard Institute, their art practice is embodied in the site itself and the day-to-day operation of the site is engaged in a radical dislocation from that capitalist sensibility.

On my first visit to Peterman's complex in 1999, I was quickly reminded that mixing art and life isn't always pretty. The term "organic" seemed a bit passive to describe the space, which was mazelike and chock full of contraptions. Peterman's recycled minimalist bricks were laying around, refried beans and tofu were being prepared in the central kitchen, *The Baffler* magazines were piled up everywhere, a motley assemblage of people of all ages were milling about, and ramshackle bicycles were hanging from the ceiling. Everyone seemed quite comfortable in the mayhem and I hoped, one day, I would as well. Various discourses and modes of living were mixing in every nook and cranny, and I knew it was necessary to decenter my outlook.

In 1996 Peterman bought the Blackstone building from the Resource Center (a do-it-yourself recycling center that is currently imperiled as well). Many of the inhabitants, including Peterman, occupied the premises before this transition in ownership. *The Baffler,* Big Fish Furniture (which will become Big School Furniture), Peterman's studio, Monk Parakeet (a gallery), a beautiful community garden, and Blackstone Bicycle Works all operated out of the facility.

Blackstone Bicycle Works (BBW) grew out of the recycling center that previously operated at the site. As recycled bicycles began to collect on the premises, the feeling that something a little more productive should happen to them was hard to ignore. At least that is how founder Andy Gregg saw it. Now BBW is a non-profit that gets local youth involved in small business practices, fixing bikes in exchange for bike parts.

Amongst the din of repair and reuse, one can hear the witticisms of *The Baffler.* As producers of a muckraking journal committed to reinvigorating the left, publisher Greg Lane and editor Tom Frank have found 6100 South Blackstone to be a most convivial operating center. Since 1988, they have become the bastion of true American essayists in the vein of H.L. Mencken and Studs Terkel. Their satiric voices tear into everything holy, from punk rock to longhaired dot-commers. Not impressed by a contemporary confluence of 1960s counterculture and 1990s corporate culture, their perceptive criticism has shed light on the dark side of the information revolution. "Our society is blessed with a great profusion of self-proclaimed subversives, few of which have any problem with the terrifying economic-cultural order into

their millennium," states the introduction on their website. Their important conviction that their culture industry is, in large part, the dubious outgrowth of late capitalism is a necessary ingredient in any critically informed cultural diet. For an art culture that has mostly reverted to commercial models for its sustenance, such lessons are sorely needed.

South Blackstone is home to a massive community garden growing tomatoes, corn, lettuce, and cilantro. Big Fish Furniture produces high-end furniture from their collective woodshop. Peterman utilized the facilities for his own art production. The Monk Parakeet gallery space housed exhibitions from guest curators as well as those involved in the residency program, which basically entails a free place to live and work at the complex and may be one of the best kept secrets in Chicago. In its recent history, it has hosted a stunning array of international artists and become known as a sort of global crash pad. A quick survey of the artists who have worked out of the space includes Tiravanija, Christian Wittenberg, Hubert Duprat, PTTR (paint the town red) with Hans Winker and Stephan Michael, Slovenian collaborative NSK, Superflex, documentary film artist Gitte Villesen, French artist Nicolas Floch, Danish collective N55, and Swiss artist Christoph Büchel in collaboration with Thomas Blackman Associates.

The Stockyard Institute (SYI) had neither the history nor the resources of 6100 South Blackstone. The unforeseen rent hike sent Jim Duignan's project right out of the building located at 48th Street and Damen Avenue. SYI was to be home to a bunch of different groups, all of whom approached the world in an integrated manner. San Miguel School, a privately funded alternative school that brought Duignan in to initiate an alternative arts/education program, operated out of the building next door. The University of Hip Hop, founded by Chicago graffiti artist and poet Lavie Raven, specializes in graffiti, rapping, breakdancing, and deejaying. These four subjects are the cornerstones from which the University of Hip Hop engages everyday life. Recently, after some camping trips, many of the students at the University of Hip Hop began painting murals of wolves and elephants, some of which ended up all over the interior of SYI. Temporary Services (TS) had been looking to station an outpost at the site as well. Temporary Services, in my opinion the most influential and groundbreaking collective operating in Chicago, has been investigating social approaches to aesthetics for almost four years. TS member Nance Klehm devoted long hours to providing a garden in which SYI students could work. And (full disclosure) the Department of Space and Land Reclamation, a group with which I am involved, was looking to instigate some projects there as well. Formerly an early-twentieth-century Ukrainian men's club, the building consisted of three floors with ample space. Duignan moved quickly to transform the center into what he saw as a "reasonable, critical place for the pursuit of ideas, experimentation, and change."[1]

His work with kids in the violent neighborhood, Back of the Yards in Southwest Chicago, is an example of art production that is inherently "relational," but with more radical implications. Using pedagogical practice inspired by Brazilian Marxist educator Paolo Freire, Duignan sees education as a shared experience. Listening to his eighth- and ninth-grade students' concerns, and the students in turn listening to his, they are able collectively to create meaningful projects. *Designing a Gang Proof Suit,* a project initiated in spring 2000, came out of discussions regarding the kids' experiences in the neighborhood. In response, students designed gang-proof suits that would allow them to feel comfortable when strolling around. Standing four-feet-ten-inches-tall (the average height of a sixth grader) and equipped with fur-lined boots and bulletproof shielding, the conceptualized suits physically embody the creative brilliance and pragmatic fears of the students. I am told a welder is working on bringing them into reality.

The *Designing a Gang Proof Suit* project truly embodies the praxis of multi-use centers. It is a result of a successful dialogue between disparate groups. And it is at this point that a remarkable piece of knowledge comes to bear: it is hard, if not impossible, to untangle the space from the practice. For both Peterman and Duignan, as well as for the groups that work out of their spaces, their practice necessitates a radical, hybrid space out of which to work. The cross-fertilizing, reflexive methodologies can be felt in the simple fact that they both privilege collective dinners as moments of connection between groups, thereby mixing everyday experiences with their artistic practices.

It is this praxis that, in fact, is at the root of groups and spaces discussed here. The combination of a collective transformation or becoming and resistance to capital are able to hurdle some of the great barriers that have faced much contemporary art. The hermetic qualities and insulated creative practices of these hybrid places are able to flourish in direct relationship to a safe, relevant, and practical terrain. The ebullient realm of urban geography, social ecology, mechanical engineering, journalism, biodiversity, sustainable living, and interior design are sewn together in a compelling aesthetic strategy. Unlike the modus operandi of capital, the process is organic, nonhierarchical, and open-ended.

Strategies of Engagement

These practices and many more different but related experiments are where I believe the possibilities for art lie. They are positioned in the territory between active political engagement and autonomous experimentation, in that enclosure that is now marked out for contemporary art.

— Charles Esche, referencing 6100 S. Blackstone Ave.[2]

In art institutions (museums, galleries, art schools, alternative spaces, etc.),
the Habermas thesis, that Modernity never died, finds its practical applica-
tion. In spite of all the critical fulminations about the death of originality, the
artist, and the rest of the entities named on the tombstones in the Modernist
cemetery, these notions persist, protected by an entrenched bureaucracy
geared to resist rapid change.

— Critical Art Ensemble, *Digital Resistance*[3]

Everything has changed and nothing has changed. While we have osten-
sibly moved past heroicizing the individual artist toward a collective *becoming*,
the art world has never looked more conservative and more focused on the
individual. There is a great disparity out there between theory and art practice,
and multi-use centers are definite clues if not outright solutions to this vexing
divide. In the graveyard of modernity (to follow up on Critical Art Ensemble's
macabre intonations), practice and site are intertwined in this new terrain
where art is simply a strategy. While much of the art world is giddy with the
theoretical amnesia and modernist gumption that cause people to think they
invented what they are doing, there are offshoots of practice that reflect an
engaged strategic approach. For example, pedagogical approaches influenced
by Freire, such as Duignan's, are socially grounded. Many progressive educa-
tion departments, and artists influenced by them, have taken advantage of
an approach where the student/subject participates in his or her own devel-
opment. This movement from a subject of study to a practice of becoming is
the type of transition that the artists discussed in this essay are investigating.

In technology, some practitioners have coined the term "tactical media"
to describe "a critical usage and theorization of media practices that draw
on all forms of old and new, both lucid and sophisticated media, for achiev-
ing a variety of specific noncommercial goals and pushing all kinds of poten-
tially subversive political issues."[4] Tactical media is interesting in that it
preferences the mode of engagement over the subject matter, where the
approach overrides the medium. There are many other fields, such as med-
icine, architecture, and anthropology, where the collapse of Modernism has
developed more interdisciplinary offshoots. I mention these to provide a
brief, and hopefully exciting, sense of a new practice that is opening itself up.

As the practice of multi-use centers is more of a tenor than a full-fledged
terrain, the differences between various examples might be more striking
than their similarities. What is most important are these groups' hybridity
and critical perspectives. Across Italy, a phenomenon known as the social
center has become ubiquitous. There are now roughly 150 and the number
is growing. These anarcho-communist multi-use centers house cooperative
gardens, places for travelers to sleep, do-it-yourself concerts, and ad-hoc art
exhibitions. They are somewhat shrouded in mystique, but they have been

home to some of the more compelling and resistant strains of the global anarchist movement. Elsewhere in Europe, N55, a collective based in Denmark, have designed Buckminster Fuller–inspired housing, where they currently reside. They produce a diverse range of utopian living devices, including a floating platform that acts as a foundation for their home, clean-air machines, soil factories, and hydroponic units. Here in the States there is the Center for Land Use Interpretation (CLUI) in Los Angeles. CLUI conducts alternative tours and studies of Los Angeles land-use issues. Investigating waste centers, dams, power supplies, complicated histories of film sets, and even land art, their projects tend to resemble geological research. But their approach is more beguiling than that of a university survey team. Equipped with field-study outposts, an extensive archive, tour buses, and a good sense of museological display, CLUI presents empirical knowledge in an alluring, if not ambiguous, manner. Their general appreciation for the problems of representation allows them to employ the tools of display cleverly in order to present a clearer picture of an extremely complicated landscape.

Sharing the same building with CLUI is the Museum of Jurassic Technology. Its founder David Wilson has been heralded for his museological, postmodern plays on truth, but in fact, it is the strategic destabilization of discourse that makes this museum such a gem. Wilson's historical curiosities have paved the way for other spaces that live in a vertigo of allegiances and nonallegiances to established fields of study. In Rotterdam, an entire enclave by artist Joep van Lieshout has gained momentum. In his artist compound, he developed Atelier van Lieshout (AVL), an awkward and functional free state. With almost thirty co-workers, AVL produces compost, medicine, alcohol, weapons, residencies, and furniture for poly amorous practices. It is a more libertarian blend of alternative public works and happenings (in the Allan Kaprow sense). Once again, the blurring of civic fields such as plumbing or furniture are enmeshed in strategies of alternative living.

Within the tactical media field there is a tremendous array of collectives: Critical Art Ensemble, Institute for Applied Autonomy (IAA), ®™ark, Hactivist, and subRosa to name a few. Each of these groups uses technology to interact with, disrupt, and reconfigure traditional relationships to a given medium in order to expose underlying relationships of power. Their projects are strategically positioned to live in a nexus between various discourses and to examine them critically. For example, IAA has recently created a sort of Mapquest-like software at their website http://www.appliedautonomy.com that conveniently maps out a journey from point A to point B in Manhattan with no surveillance cameras along the path, quite a trick. This software is available to the general public and isn't particularly geared toward the art world. It provides a strategic tool that complicates and reveals the dominant flow of power relations in an urban environment.

Multi-use centers are appearing everywhere. An inspiring example is the MS Stubnitz located in the harbor of Rostock, Germany. This 80-meter sailing vessel was purchased by a government cultural initiative to become a maritime' cultural center that operates along the coast of the Baltic and North Seas exhibiting experimental art and music. Since its purchase in 1992, the MS Stubnitz has sailed to Stockholm, Hamburg, and Rotterdam entertaining audiences in its massive music venues and a dedicated 30-person crew. The crew lives in the cabins and the trawler is home to metal, carpentry, and electrical workshops, a print shop, a photolab, a graphic design studio, and an at-risk-youth program. Like 6100 South Blackstone, the boat provides youth social programming and production facilities.

Red, Red Tape

Strategically engaging the contemporary social terrain does not come without major complications. Myopic bureaucracies and scant public funding tend to reduce the social landscape to a visionless urbanity that runs on donated time. Unlike the more heavily funded artistic and social spheres of Western Europe, the United States has traditionally been reluctant to support open-ended strategies for social engagement. Just try to imagine the US government paying for a Lake Michigan–based aircraft carrier that hosts raves and collectivist meetings. And still after the 1970s "out of the galleries" movement, art venues by and large are synonymous with commercial galleries. For Peterman and Duignan, the city of Chicago has been a particularly arduous community in which to participate.

"I realized that the complex needed greater visibility," said Peterman. "Many people in the city found it difficult to grasp what it is we are doing here. Centers like this, with organic models of organization, that are more open-ended with their goals, are complete mysteries to most people. They look at this place as an old shack with strange people hanging out." For Peterman, the constant pressure from various sectors that wanted to take the land from him was extremely draining. While it was bad enough to have his entire dream burn down, it was worse to have so many opportunists racing to court so soon afterwards to lay claim to the property. "If I lost this place, I doubt I would stay in Chicago," said Peterman. "I have put a lot of years into the complex. It anchors me here. Without it, I would probably join the global community."

For Duignan, born and raised in Chicago, the adversity is nothing new. "These kids live in some of the toughest areas in the country," he says. "I've been here my whole life. No matter what happens, I will keep working with them." His commitment, while admirable, need not justify such a difficult working environment. With little funding and no commercial support, these spaces rely on perseverance.

Regionalist Strategies: Taking the Midwest Alternative

Fortunately, Peterman's complex is to be reborn as the Experimental Station. With insurance money paying for renovation, in a year's time 6100 South Blackstone will became home to the city's first alternative-living incubator. The name Experimental Station is borrowed from a speech Frank Lloyd Wright gave at Hull-House, in which he expressed a desire for a place where art, technology, and design could interact. The Experimental Station will become a non-profit as a method to gain more public support and will continue to house the organizations that have made it such a vital part of the Chicago community. Peterman intends to increase the residencies at the space for those creatively investigating the fields of ecology, cultural criticism, independent publishing, and alternative education.

Jim Duignan and the Stockyard Institute have relocated to 836 North Leamington Avenue in the Austin neighborhood of Chicago. For many months, the future of SYI's physical locale was in doubt, but with the assistance of San Miguel School, Duignan was able to move his operation. In the interim, he never doubted that he would continue his work with students, but he did not relish the possibility of becoming nomadic. His situation is not unfamiliar. Many other spaces are perpetually on the move in a forced nomadism that is culturally and personally draining. Given this crisis in multi-use centers (as well as gentrification in general), the rush to embrace nomadism in contemporary discourse appears in bad taste.

With cities like New York, San Francisco, and Los Angeles all rushing to evict their cultural producers, it is a shame that the Midwest follows their lead. Providing space for a regional breed of multi-use centers will not only further establish this compelling new sphere of practice, it will anchor an already vibrant cultural sphere. Seeing beyond the traditional exhibition space isn't just utopian, it is quite simply strategic and practical.

This text was originally published in *New Art Examiner*, (March/April 2002), 47–53.

1 From website: http://www.stockyardinstitute.org

2 Charles Esche, "Modest proposals or why 'the choice is limited to how the wealth is to be squandered,'" in *Berlin Biennale 2* (Berlin: Oktagon, 2001), 22–27.

3 Critical Art Ensemble, *Digital Resistance* (New York: Autonomedia, 2000), 59.

4 Ibid., 5.

Department of Space and Land Reclamation exhibition catalog cover (detail).

THE ARTIST ORGANIZER

The Artist Organizer

In 1997 the Illinois Arts Council hosted a conference entitled *Artists as Cultural Workers: Collaborating with Communities,* which brought together more than 150 artists, representatives from arts organizations and community service groups, such as Casa Aztlan, Guild Literary Complex, Chicago Public Art Group, Community Film Workshop, and Street-Level Youth Media, an organization originally founded as part of Iñigo Manglano-Ovalle's contribution to *Culture in Action,* and included a keynote by Rick Lowe of Project Row Houses in Houston.[1] The conference guide stated: "Is a cultural worker typified by individuals who bring an artistic sensibility to the table of community issues? Must artists draw a line between art and life? Is there an implicit compromise when an artist collaborates with a community? Must an artist always divest from the product when doing public art? Is an artist who works for an arts organization still a voice for the individual artist?" Conference discussions posed various guiding questions of their own, including "How do we define 'Community?' and "What defines Good Cultural Work?"

To put this gathering in some context, *Culture in Action,* the seminal public art exhibition curated by Mary Jane Jacob, happened in Chicago in 1993, just four years prior. It was around that time that influential texts also began to emerge, such as Suzanne Lacy's *Mapping the Terrain: New Genre Public Art* in 1994 and Nina Felshin's *But is it Art? The Spirit of Art as Activism* in 1995, which each argued for and traced the legacies of a socially responsible and socially responsive public art. Community artists and organizations making "cultural work" were seeing their work reflected in trends in contemporary art discourse which were shining a light on com-

munity-based art and directing institutional attention and resources to its production. The discussion topics in 1997 could just as well be the same as those at the Creative Time Summit or Open Engagement today. The tension between community arts organizations with explicit social justice missions and contemporary artists who work with communities of people while retaining authorship and cultural capital, is still one of the most pressing concerns when it comes to social practice. At stake are also significant resources, evidenced today in what is called creative placemaking, which references a broad set of funding initiatives, most notably through the National Endowment for the Arts, that forge public-private partnerships between arts organizations and business interests to "revitalize" neighborhoods through community-engagement strategies, which also can threaten to not recognize the histories and communities which are already there. What are artists' visions for how to navigate the prevailing discourses and move ahead on their own terms?

The focus of this section is on those who creatively transform the role of artists as social organizers, making frameworks for more equitable institutions, public spaces, and social conditions and experimenting with radical formats to produce their own art systems. Dr. Margaret Burroughs—iconic artist, advocate, and educator who sat at the center of the Black Arts Movement in Chicago and co-founded the South Side Community Art Center and DuSable Museum, the first and oldest museum dedicated to African American history, culture, and art—lays out her charge in a poem for artists as institution builders. Axe Street Arena, an artist collective and multi-purpose art space in operation from 1985 to 1989 in the Logan Square neighborhood, and Mess Hall, open from 2003 to 2013 in Rogers Park, were both hubs for critical thought and praxis; here are expressed through their respective visions for artist spaces to reimagine the economies and political systems in which art operates. *White Walls* was an experimental format created to share the writings and text-based artworks by pioneering conceptual artists as well as many of the artists participating in these spaces. Meanwhile Ryan Griffis writes of the tactical media interventions of Pilot TV, Version Fest, and Department of Space and Land Reclamation that organized "by any media necessary" to call into being communities to reclaim public space. This happens as well in the funding practices detailed in Bryce Dwyer's "Alternative Arts Funding in Chicago," in which Chances Dances, Co-op Sauce, Fire This Time Fund, Sunday Soup, and Maria's each take on the role of a granting body in order to create public conversations about the value and redistribution of resources.

This variety of tools and approaches are examples of the ways artists define their own ethos and can construct systems of representation and sustainability. As Shannon Stratton, Executive Director and Founder of

Threewalls, states: "Given the decay of today's social structures, artists are forced to design their own safety nets, and they recognize that in designing them for their immediate communities, as a group they test ideas, accrue skills, edit process, and have the potential for modeling best practices back to the institutions who claim to support artists and culture, but whose practices are somewhat calcified. Is it possible for artists to redefine the field for themselves?"[2]

—AS

1 Thanks to Rose Parisi, Director of Programs, Illinois Arts Council, who organized this conference along with Joanne Vena, then Director of Arts-in-Education Programs, for directing me to this in my research.

2 Shannon Stratton, "As Form," lecture at Cranbrook Academy of Art, delivered October 1, 2012.

A Poem for the Artists

Margaret Burroughs

We are the artists
We are the image makers
We are the creators
We are the makers of magic
We are the makers of illusion
We are the creators of reality
We are the creators of the unreal
We make things to seem what they are not.
We make things to see what they are.
We have the power to produce
Both to seen and the unseen.

We are the artists
We are the recorders
We are the historians
We are the story tellers
We are the dreamers
We are the artists
We are the children of the Universe.
We are the children of the Cosmos.

We are the communicants
We are the celebrators
Our subject matter is the essence of humanity.
Our medias are lines, forms, colors, and textures.
Our medias are words, rhymes, verses, and paragraphs.
Our medias are tones, rhythms, melodies, and movements
Our instruments are sound and sight and feeling

We are the artists
We are the creators
Our art is a time capsule
What we set down today is for the future
Those unborn and generations hence
Will learn from and build on what we have done
We are the artists we are the creators.
We are the architects and the builders
We are the enemies of destruction
We are the cleansers and the purifiers
We are the enemies of pollution
We are the artists.
We are the priests and the priestesses
To the people.

This poem was originally printed by MAAH Press, 1976, and is reprinted with permision of the DuSable Museum of African American History.

"We reject a world in which education and information are touted as the answers to all our problems, while in reality they are seen as other mechanisms to intimidate and control. We also reject an art which panders either to the investment-minded art collector and careerist art-maker, or the narrowly propagandist left. Instead, we desire to indulge ourselves in such forbidden activities as dreaming and conversation, principled action and determined inaction. From these things, real art, that strange fruit of mysterious intuitions and indefinable connotations may, we hope, be encouraged to participate in our futures."

 AXE ST. ARENA

Axe Street Arena statement in *Panic* 1, no. 1, March 1986. Courtesy of Bertha Husband.

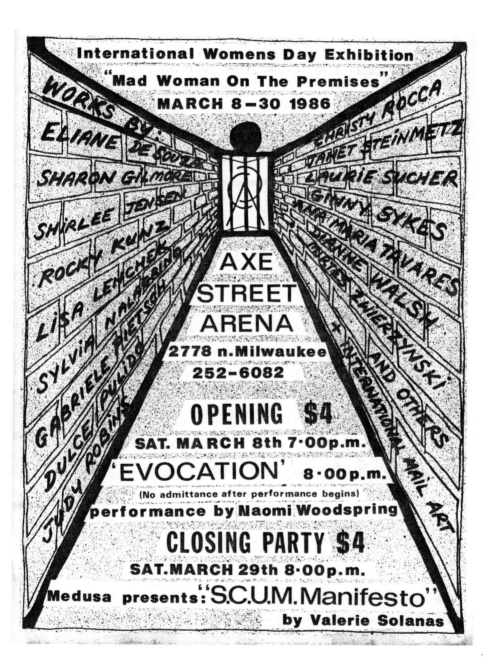

Axe Street Arena, *International Women's Day* exhibition poster, 1986. Courtesy of Bertha Husband.

Mess Hall, *Ten-Point Statement* poster, 2007.

WE DEMAND CULTURAL SPACES RUN BY THE PEOPLE WHO USE THEM.

WE CREATE THE SPACE TO REMIX CATEGORIES, EXPERIMENT, AND LEARN WHAT WE DO NOT ALREADY KNOW.

MESS HALL EXPLODES THE MYTH OF SCARCITY. EVERYONE IS CAPABLE OF SHARING SOMETHING.

THE SURPLUS OF OUR SOCIETIES SHOULD BE CREATIVELY REDISTRIBUTED AT EVERY LEVEL OF PRODUCTION AND CONSUMPTION.

SOCIAL INTERACTION GENERATES CULTURE!

WE EMBRACE CREATIVITY AS AN ACTION WITHOUT THOUGHT OF PROFIT.

WE DEMAND SPACES THAT PROMOTE GENEROSITY.

MESS HALL INSISTS ON A CLIMATE OF MUTUAL TRUST AND RESPECT – FOR OURSELVES AND THOSE WHO ENTER OUR SPACE.

NO MONEY IS EXCHANGED INSIDE MESS HALL. SURFING ON SURPLUS, WE DO NOT CHARGE ADMISSION OR ASK FOR DONATIONS.

MESS HALL FUNCTIONS WITHOUT HIERARCHY OR FORCED UNITY.

MESS HALL, 2007

Notes on "An experiment in synthesizing word-related interests of artists and poets"

Buzz Spector

The idea for the journal that became *White Walls* arose in a conversation with Reagan Upshaw in January 1977. This was midway through my first year in the MFA program at the University of Chicago. A few days earlier one of my studio mates, Robert Gottlieb, had told me about an art history grad student who was also a poet, and I called Upshaw to introduce myself. He invited me to meet him in the lobby of the campus art museum, at that time called the David and Alfred Smart Gallery, where he worked as registrar. Since I wrote poetry as well as made art, I was happy to hear about someone else on campus who shared these two interests.

We sat in the empty lobby (the Smart was then a great place to be alone with art) and dropped the names of poets we admired. He liked Auden, Philip Larkin, Ted Berrigan (a good sign); I liked Robert Creeley, Charles Olson, the concrete poets. ("But imagine a reading," Upshaw responded, and made funny clicking noises in oral approximation of that poetic style's repetitive letters and nonsense words.) After our obligatory citing of various old masters, we discussed our favorite artists—Richard Diebenkorn's cool abstractions for him, Brice Marden's even cooler monochromes for me, and Robert Ryman whose white paintings I had in mind as I made the large black graphite drawings of my graduate school days. Then we began

talking about various little magazines and journals in which we'd published (or hoped to publish) our writing.

A few years before I'd briefly done freelance keyline and paste-up work for Laurence Levy, a graphic designer in the Chicago suburb of Evanston. Levy earned his living doing design work for various corporate and institutional clients, but his favorite role was as the art editor for *TriQuarterly*, Northwestern University's literary magazine. In the summer of 1974 Levy gave me the paste-up assignment for a special issue of *TriQuarterly*, guest-edited by art critic John Perreault, which was titled "Anti-Object Art." The contributions were conceptual and language art of a sort I was then not much acquainted with, including submissions by Joseph Beuys, Christo, Les Levine, Adrian Piper, Joseph Kosuth, Robert Barry, Lawrence Weiner, and Eleanor Antin, among others. Perreault's introduction made a case for art in which "the idea [was] more important than, or as important as, the physical or visible expression of that idea." He confessed that he used to think conceptual art was a kind of "art and literature hybrid," but then decided it had only narrative rather than literary value. I thought Perreault was wrong about this as I had been writing a kind of minimal poetry engaged with laconic phrasing similar to what I'd seen in some of the writing in "Anti-Object Art." I told Upshaw about my work on *TriQuarterly*, and he in turn told me about various anthologies of experimental poetry he'd read that seemed similar in intent to what I'd described.

A week later I rang the bell at the Drexel Avenue apartment where Reagan and his wife Roberta lived. They'd converted their second bedroom into an office/library, and browsing through their books I found many of the same titles as those sitting on my own shelves. This overlapping taste in reading cemented our friendship. It might have been during that first after-dinner conversation that our hazy notions of publishing poetry and language art coalesced into a magazine of writings by artists, but it wasn't until the fall of 1977 that we set to work. Over another dinner at the Upshaw apartment we wrote out a list of names. *Big Shoulders*, taken from the Carl Sandburg homage to Chicago, was the early favorite, but *White Walls* (*WW*), alluding both to tires and gallery spaces, was more to the point of the discipline-merging we had in mind. With a name, we could order a rubber stamp, which we used to make the "letterhead" on which we invited some forty or so artists and poets to contribute to a premiere issue. We casually mentioned that we were starting our magazine "at" the University of Chicago (leaving out our grad student status), in hopes that institutional prestige might sway one or another of our potential contributors. On those letters we listed my apartment on Ingleside Avenue as the magazine's office, but by the time the first issue saw print we'd rented the PO Box that served as the *White Walls* mailing address for the next thirty years.

What we were inviting people to contribute to evolved out of many, sometimes heated, discussions of how our publication would represent the disparate branches of writing by "writers" about art and "artists'" writings. We all saw relationships between the kind of poetry being written by such figures as Ian Hamilton Finlay or Jean-Francois Bory and the texts accompanying (or as) work by Richard Long, Hamish Fulton, or Agnes Martin. We were also aware of the cross-disciplinary activities of Fluxus and, among its predecessors, the Lettrists. To be sure, there was also a substantial history of poets and artists writing art criticism—Frank O'Hara and Fairfield Porter were favorites of ours—and of writers trying their hands at art making, but our shared editorial interest was in the zone where art as idea and creative writing seemed most to overlap rather than in more conventional texts about art by identifiable artists or writers. We were unable to agree on a single set of parameters for the magazine and the first issue went out with separate editorial comments by Reagan and myself; me calling *WW* "an experiment in synthesizing art-related interests of artists and poets," and Upshaw pointing out that "the use of words in the work of visual and conceptual artists may provide some interesting suggestions for poets." Upshaw went on to note that, "if we can provide some useful ideas for artists and writers to steal from each other, *White Walls* will have served its purpose."

From our list of solicitations we received ten responses, including text/image works from Agnes Denes and Mike Crane, both of whom had contributed to "Anti-Object Art," and from John Perreault himself, who contributed an extraordinary short fiction, "The Missing Letter," written without using the letter "a." The projects of visual artists appeared alongside poetry by such figures as Ron Padgett, Barbara Guest, Lewis Warsh, and Dick Higgins, a major figure in Fluxus and coiner of the term "intermedia," which characterized much of the work we would subsequently publish. The peripatetic writer/editor, Richard Kostelanetz, sent us a suite of concrete poems, while Ken Friedman, another Fluxus figure (he would later guest edit *WW* #16, the Fluxus issue) submitted his "Notes from a continuing Existential Western," and Peter Hunt Thompson gave us an excerpt from "The Book of Signatures." We added an eleventh contribution after seeing Jim Melchert's series of exquisite graphite drawings at a local gallery. These were outlined rubbings of envelopes, photographs, or scraps of paper beneath which the artist had penciled in narratives of the artifacts and images from which he'd made those ghostly outlines. Our first cover, a wraparound photo reproduction of a white wall, was a gift from Conrad Gleber, an artist/printer who used offset lithography to make art and who ran the offset printing presses at the School of the Art Institute of Chicago.

THE ARTIST ORGANIZER



I had a key to the *New Art Examiner* offices, having recently served as guest editor for their January 1978 issue, and we were thus able to "borrow" the *Examiner*'s typesetting equipment (from midnight on) to compose our own pages for the first four issues. Such late night typography was a contributing factor to some unfortunate errata later on, but we were error-free our first time in print. While our magazine lacked anything like office space, my kitchen table worked well enough for layout and paste-up. Paying the printer was a matter of redirecting scholarship and student loan monies, although this financial strategy left me several months behind in my rent. Fortunately I was living in student housing at the time and so wasn't evicted. The University would eventually withhold my degree until I paid those bills, which I was able to do by taking a job editing publications for the Graduate School of Business in order that the housing office could garnish my wages.

In the first issue only Reagan and I are listed as editors, even though Roberta Upshaw had worked alongside us, but she joined the *White Walls* masthead for *WW* #2. From the beginning we considered the publication to be a form of curatorship on pages. In February 1981 the editors served as guest curators of the exhibit, *Words as Images*, at the Renaissance Society.[1] *WW* #5 served as the catalog, which also featured a lecture by artist Rosemary Mayer. The participating artists in *Words as Images* also submitted separate writings for publication in the magazine. While the exhibit was well attended, some local visitors noted that there weren't any Chicago artists in our selection. Taking the criticism to heart, the magazine's next event sponsorship in October 1981 was *Inventions*, an evening of collaborative works by Chicago dancer/choreographer Jill Kellner at Links Hall Performing Studio. I was a performer in Kellner's *Black on White with Bells*, which also featured music by Chicago pianist and composer Fred Simon. *Passing Over/Gulp* utilized dance and text performed with choreographer Pamela Harling, and *A Song* was performed to music by Fred Simon, using Robert Creeley's title poem as read by guest artist Kate Kuper.

Reagan and Roberta left the magazine in 1981, after we'd produced six issues, when Reagan took a job in New York. I was not ready to give up publishing the magazine at that point and invited Timothy Porges, another friend who was also both an artist and a writer (he'd contributed the cover drawing to *WW* #6) to join me as co-editor.

Tim and I expanded *White Walls*'s editorial commitment to publishing writings by Chicago artists, but we also continued to seek unique opportunities to collaborate with other not-for-profit art organizations. In *WW* #8, issued in summer 1983, we published selections from an exhibit at Franklin Furnace, New York that took place earlier that year. *Artists' Use of Language* was curated by Barbara Kruger, and she made a selection of works for our

pages. In her editorial statement, Kruger noted, "Such exercises of language and visual exposition occasionally fall under the rubric of 'political.' But of course all esthetic production carries a politic, an indicator of its position within the life of the culture."[2]

Our most significant collaborative undertaking was the partnership with Independent Curators Incorporated (ICI) to publish the catalog for ICI's 1984-86 national touring show, *Verbally Charged Images*, curated by Nina Felshin. While the magazine did not have input into Felshin's curatorial selection, her roster of participants included Dotty Attie, Vernon Fisher, Kruger, and Alexis Smith, who had previously published writings in *White Walls*.[3] The catalog itself appeared both as a separately bound book that traveled with the exhibition and as a forty-eight-page insert in a double issue (*WW* #10/11) of the magazine. Roberta Allen and Anne Turyn also contributed separate text works to that issue and Tim's essay, "Symbolism and Semiotics: the calling of the caption," marked the debut of artist-authored critical writing that would subsequently become an important aspect of the magazine's evolving editorial policy.

The cost of producing two simultaneous publications played havoc with our modest grant funding from the Illinois Arts Council plus our own editorial pockets. As a result we began accepting private gallery advertising, which enabled us to resume publication with *WW* #12 in Autumn 1985. We also received the first of several publications grants from the National Endowment for the Arts in 1985, and began placing copies of the magazine for sale in such Chicago alternative art spaces as N.A.M.E., Artemisia, ARC, and later on at Randolph Street Gallery. Almost from the beginning we were distributed by Printed Matter Inc. in New York. The bookstore at the Museum of Contemporary Art had carried copies of *White Walls* dating back to 1983, and beginning with *WW* #10/11 the Art Institute of Chicago began shelving us as well.

Following publication of *WW* #17 in Autumn 1987 I resigned from the organization while preparing for my move from Chicago to Los Angeles. Tim continued as editor through *WW* #25, becoming the longest serving editor of the publication that ultimately produced forty-five numbered issues plus many artists' books, thematic anthologies, exhibition catalogs, a CD and a vinyl record. The last issue of *WW* #45 (Terra Form) was published in 2004, but the organization had become primarily a book imprint several years earlier. The transformation happened in 1999, when in addition to the release of *WW* #41 (Crafting History), the organization published two artists' books: Helen Mirra's *Names & Poems* and Stephen Lapthisophon's *Hotel Terminus*, and co-published, with the Museum of Contemporary Art, the exhibit catalog, *Sarah Sze*, accompanying the artist's MCA installation.

Portions of this essay are taken from Spector's remarks in a 2004 lecture at the Hyde Park Art Center, Chicago, in conjunction with the exhibition *Fine Words Butter No Cabbage: 26 years of White Walls.*

1 The installation at the Bergman Gallery included painting, drawing, sculpture, and photography using text by Terry Allen, Arakawa, Dotty Attie, Austé [Peciura], Steven Beyer, Carole Caroompas, Agnes Denes, Vernon Fisher, Rosemary Mayer, Jim Melchert, George Miller, Lucio Pozzi, Ed Ruscha, Alexis Smith, Michelle Stuart, and William T. Wiley.

2 Kruger's selection included a text-bearing work of her own along with contributions from Judith Amman, Biff Products, Victor Burgin, John Fekner, General Idea, Mike Glier, Hans Haacke, Jenny Holzer, Mary Kelly, Joseph Kosuth, Margia Kramer, Michael Oblowitz, Lee Quinones, Tony Rickaby, Klaus Staeck, and May Stevens.

3 The ICI exhibit included work by Roberta Allen, Ida Appelbroog, Dotty Attie, John Baldessari, Luis Camnitzer, Robert Cumming, Vernon Fisher, Douglas Huebler, Jasper Johns, Barbara Kruger, Marcia Resnick, Karen Shaw, Alexis Smith, Anne Turyn, and William Wegman.

Tactical Media in the City of Machine Politics

Ryan Griffis

And I'm not saying the streets are dead, just that there is an important difference between the experience of organizing one's own collective political project versus the experience performing protest. That was a realization that became very important to me.

– Emily Forman[1]

Ask yourself, "What images would I like to see more of in the world?" Make them.

– Gregg Bordowitz[2]

This story concerns some ideas about political culture-making that were called "tactical media" (TM). In particular, it's about how some of these ideas intersected with a body of projects and events in the city of Chicago, such as Pilot TV, Department of Space and Land Reclamation and Version Festival. Tactical media, elaborated by artists like Critical Art Ensemble (CAE) and others, highlights the valorization of the amateur, collaborative, horizontal, and, perhaps most importantly, the oppositional.[3] One of the most-cited definitions comes from Geert Lovink and David Garcia's "The ABC of Tactical Media":

Tactical media are what happens when the cheap "do it yourself" media, made possible by the revolution in consumer electronics

and expanded forms of distribution (from public access cable to the Internet) are exploited by groups and individuals who feel aggrieved by or excluded from the wider culture. Tactical media do not just report events, as they are never impartial; they always participate, and it is this that more than anything separates them from mainstream media.[4]

The "tactical" in tactical media derives its meaning from the cultural theory of Michel de Certeau, who in turn drew on the military theory of Carl von Clausewitz. Tactics are understood in opposition to strategy, where tactics are the language of movements during a battle while strategy is the language of staging battles to win wars. Using von Clausewitz as a point of departure, de Certeau expanded his reading of tactics to the field of everyday life. For de Certeau, the distinction comes down to the possession of power to control space—strategy is the "calculation of power relationships" made possible by the "power to provide oneself with one's own place."[5] Tactics, then, are the "calculated action(s) determined by the absence of a proper locus," where they "must play on and with a terrain imposed on it." In short, "a tactic is determined by the absence of power."

TM practitioners claimed a broad lineage of cultural and political movements: the twentieth century artistic avant garde, the New Left and black liberation struggles in the US, critical theory, the AIDS Coalition To Unleash Power (ACT UP), the women's healthcare movement, media activists like Paper Tiger TV, various European "free" and "open" culture initiatives, and the counter-globalization protests that started the new millennium. Parallel cultural contexts, from culture jamming to citizen journalism, accompanied the political economy of the dot-com boom and the growth of corporate and academic speculation in the future of new media. With the increasing virtuality of late capital, proponents of TM argued for appropriate forms of resistance, recognizing that the digital was as much an ideology as it was a technology of late capital. The technologies that enveloped us as workers and consumers had to become the site of resistance, from radio waves to DNA. The Independent Media Center movement took up the need to have a coordinated effort of self-representation and activist journalism, while the art collective ®™ark coordinated an electronic market for funding acts of corporate sabotage. The Electronic Disturbance Theatre organized a virtual sit of the Mexican government in solidarity with the Zapatistas, launching FloodNet from Ars Electronica in Austria. CAE and subRosa brought biotechnology out of the lab in acts of recombinant theater. The Institute for Applied Autonomy and the Bureau of Inverse Technology developed contestational robots and instruments for citizen science. Electronic mailing lists, such as <nettime>, the Old Boys Network,

711, and others functioned like magazines without borders, where theorists, artists, historians, activists and others debated and promoted tactical media, cyberfeminism, net.art, and analyses of the Internet's infrastructure (among many other things, like poetic interventions into the space of the list itself). International festivals such as the Next 5 Minutes and Ars Electronica, cultural institutions like De Waag (Amsterdam), Sarai (Delhi), and Public Netbase (Vienna) all became hubs of research and development.

TM was not without its internal debates and tensions. Artist and media theorist David Garcia (who went on to found the Next 5 Minutes) recalled being confronted by artist-activist Gregg Bordowitz at the 1990 Seropositive Ball in Amsterdam, an event that brought together various communities working on aspects of the AIDS healthcare crisis:

> The way the conference is organized is based on a utopian notion of a free exchange of information, instituted through technology; a use of technology that is unquestioned, uncriticised, unproblematized; the notion that a universal space can be established through phone links, faxes, and modems. If there is one thing that is established through the kind of work we do is that there have never been such things as universal categories, principles, or experiences.[6]

The contradiction described by Bordowitz—the promise of a post-ideological subject made possible by communication technologies and the material conditions that dash any possibility of such a subject—is something Garcia and his fellow organizers grappled with in the following years, and in conjunction with serial tactical media labs that were staged in New York, São Paulo, Zanzibar, Croatia, and Singapore, among other locales. During the heyday of TM, between the late 1990s and 2005, a range of related activities were also occurring in Chicago that similarly struggled with difference and collectivity, autonomy and commitment.

How does one practice tactical media in a city known for machine politics?

We weren't really interested in making those [tactical media toolkits]. We weren't really interested in taking the Department of Space and Land Reclamation and installing it somewhere else. It was of and from the ground that it was on and it was going to feed back into that ground. There was nowhere else to go.

– Josh MacPhee[7]

Pilot TV's cover to the guide for *Experimental Media for Feminist Trespass,*
October 8-11, 2004. Courtesy of Pilot TV.

One of the central themes of Pilot has always been the exploration of 'feminist trespass.' By this we mean strategies which resist the biopolitical control of our everyday lives, be it in the form of wars, patents, laws, borders, biotechnology, reproductive control, slavery, or control of access to bodily needs such as mobility, shelter, food, water, and healthcare. By 'feminist trespass', we are also describing the desire to move feminism forward, to trespass its irrelevancies and reclaim it as a critical form of political solidarity, analysis, ethical and aesthetic practice. Other questions surround new articulations of 'transfeminism', media democracy, and the role of identity politics within larger anticapitalist movements.

The weekends' planned projects highlight many other themes and questions. For example, Mary Patten and Dara Greenwald will share histories of queer women's organizing around ACT-UP, and the importance of grounding ourselves in the early histories of collective media production. Daniel Tucker will collect a public resource listing on Border Crossing and cross-national organizing projects. Tara Mateik and the Society for Biological Insurgents will investigate the links between bioterrorism, trans bodies, and homophobia. Megan Palima mobilizes visceral interpretations of the integral contact between affect and technology. Other projects highlight everything from feminist uses of depression, to 'economies of precariousness', the medical industries and the No Border network, to radical sexuality and food production.

Not only are we interested in sharing our strategies with each other, editing video and distributing our TV Pilots to each other, but we actually hope to build these connections made over the weekend into new networks, guilds, think-tanks, and underground distribution railroads: forms of organization which can contribute to the radical infrastructure of the future.

Pilot TV's strategies and goals for *Experimental Media for Feminist Trespass,*
October 8-11, 2004. Courtesy of Pilot TV.

One event of importance in considering TM in Chicago is the Department of Space and Land Reclamation (DSLR) that took place over a weekend in late April of 2001, and was headquartered at the Butcher Shop, a multi-use warehouse space in the city's Near West Side. Instigated by Josh MacPhee, Emily Forman, and Nato Thompson, and carried out with the help of more than seventy other artists and organizers, DSLR didn't bill itself as a tactical media convergence, but rather addressed public space, or the lack thereof, in the city. More than fifty projects were staged throughout Chicago that largely exhibited an experimental approach to agit-prop aesthetics. DSLR subscribed to the "by any media necessary" model of the TM campaign—conventional public projects like wheat-pasted posters and altered signage were deployed alongside a kissing-strangers-in-public performance, camouflaged audio works made for the street, and a pirate radio broadcast. In the following months, many of those involved in DSLR would continue to develop campaigns that directly addressed the politics of housing and real estate, organizing to liberate the cast of MTV's *The Real World: Chicago* from their Wicker Park loft apartment, and staging fake real estate ventures in the gentrifying Pilsen neighborhood. DSLR was also responsible for inspiring self-initiated variations in other cities: DSLR West in San Francisco (2003) and the October Surprise in Northeast Los Angeles (2004).[8] As with DSLR Chicago, these campaigns primarily addressed concerns of public space, gentrification, and ideas of the "right to the city" through programming that combined interventionist projects (to use the moniker later championed by Nato Thompson) and community-specific political campaigns.

Approximately one year after DSLR, the first of many annual Version Fests, Version>02, took place, more specifically aligning itself with the discourse on TM and digital culture. As with DSLR, Version>02 was initiated by a small number of organizers (Ed Marszewski, Brien Rullman, Karl Kuhn, and Brian Dressel) with an extensive list of coordinators and participating venues that included educational institutions (like the School of the Art Institute of Chicago and Columbia College) and artist-run spaces (like Deadtech, a no-profit space dedicated to experimental and electronic art run by former Chicago-based artist Rob Ray from 1998–2008).[9] With institutional support from the Museum of Contemporary Art Chicago (MCA) for the first two festivals, Version brought national and international participants together with locally generated projects that included film screenings, public art installations/performances, a web exhibition, and a multimedia publication (*Select*).[10] Notable participants included urban theory scholar Saskia Sassen, *Adbusters* magazine, leftist PR consultants Smartmeme, Negativland's Mark Hosler, and artists Valerie Tevere and Brett Bloom, along with groups active in TM like the Institute for Applied

Autonomy, CAE, subRosa, and Hactivist. Panel discussions that covered topics from Afrofuturism to genetic engineering occurred alongside workshops on reverse engineering electronics and performative protest techniques. Version Fest, like DSLR, exhibited a euphoric eclecticism born from the desire to maintain a position of tacticality, something that would continue through various thematic and geographic reorientations over the following decade. While these shifts—driven by the changing composition of the festival's organizers, and their changing personal and intellectual investments—would take Version further and further away from the discourse of TM, the focus on Chicago's lived spaces as the site of both joy and struggle have remained a core value.

As CAE has argued, the goal of a TM convergence should remain rooted in experimentation and skill sharing, rather than addressing larger, systemic political questions.[11] If both DSLR and the early Version Fests practiced this philosophy, they also revealed something of an underlying strategy that remains central to much of the self-organized cultural work still being done in the city. What can be said to be strategic about these projects is the deliberate focus on methods for mutual self-recognition, support, and, what Nato Thompson once referred to as, "infrastructures of resonance."[12]

What is so significant about what was developed in Chicago during the "era of tactical media" is the practical and intellectual investment in infrastructure as a creative endeavor. While there are certainly many individual projects and organizations that contributed to TM's cultural engagement with public politics in Chicago, it's the attempt to provide space for these projects to meet that is noteworthy.[13] This was happening in affiliated autonomous and artist-run spaces like the already mentioned Deadtech and Mess Hall, as well as the temporary campaigns and convergences of DSLR, Version, and Pilot TV.[14] It was also about the intersection of groups.

This is seen in Garcia's response to Bordowitz's critique of the Seropositive Ball reflecting upon the two cultures of resistance that he believed were brought together in that early predecessor to the Next 5 Minutes.[15] Taking Bordowitz's statements to heart, Garcia nonetheless believed that there was an undeniable benefit to this coincidence of two otherwise unrelated activist communities: those mobilized to solve global access to treatments for HIV/AIDS (such as ACT UP) and technophiles that privileged open access to communications technologies. For Garcia, the meeting of these two cultures *was* tactical media. What the historical (and ongoing) efforts in Chicago make clear is that TM was a meeting between not just gizmo-producing geeks and community-based activists, but between what CAE has labeled "egoists" and "collectivists," those seeking autonomy from conformity and those seeking to mobilize collective action toward a singular cause. What the campaigns in Chicago discussed

here offered was a queered collective that aspired to maintain difference even as they sought to bring people under a single umbrella. As DSLR and Pilot TV organizer, Emily Forman, said of Pilot TV:

> Clearly what needs to happen is a total rethinking of the project of social protest and what we do with the agency of collectives. The premise during Pilot was to make this performative nature transparent in order to open it up for poetic, aesthetic, and practical restaging. We shared a really wide array of possibilities with each other; from direct political interventions like the Women on Waves pirate abortion ship to the intimate performance of John and Yoko's Bed-In against the war in Vietnam... Our basic idea was that we should work out these questions with our peers in a productive, performative, open-ended space.[16]

The tactical may always come from a position of powerlessness, with no means to exert control over space, but what DSLR, Pilot TV, and Version showed, however, is that one can remain tactical while *imagining* what it would mean to control space. Not space in the abstract, but the spaces in the city of Chicago where people live, work, and struggle alongside one another. These projects reflected the need for both representations of a different world and spaces where those images can be safely made and received, even if only temporarily.[17] Without attempting to overcome neoliberalism through policy battles or an oppositional political party, these examples tactically asked their participants to imagine the end of neoliberalism, while confronting its concrete and regulatory reality... in other words, breaking the law.

1 Daniel Tucker, interview with Emily Forman and Josh MacPhee, *Never the Same*, http://never-the-same.org/interviews/emilyforman-joshmacphee/.

2 Gregg Bordowitz, *The AIDS Crisis is Ridiculous and Other Writings, 1986–2003*, ed. James Meyer (Cambridge, MA: MIT Press, 2004), 78.

3 See Critical Art Ensemble, *Digital Resistance: Explorations in Tactical Media*, (Brooklyn: Autonomedia, 2001).

4 David Garcia and Geert Lovink, "The ABC of Tactical Media," *nettime.org*, 16 May 1997 09:38:11 +0200, accessed January 7, 2014. For more on the historical discourse of tactical media, including critiques of its blind spots and omissions, see the Tactical Media Files project, edited by Eric Kluitenberg, David Garcia, and Magdalena Kobzova: http://www.tacticalmediafiles.net/; Brian Holmes, Daniel Tucker, and Luther Blisset, *Tactical Media Generation:*

Signs Taken for Wonders, Autonomous University, http://autonomousuniversity.org/content/
tactical-media-generation; *Virtual Casebooks on Tactical Media*, eds. Barbara Abrash and Faye
Ginsburg, *http://www.nyu.edu/fas/projects/vcb*.

5 Michel de Certeau, *The Practice of Everyday Life*, trans. Steve Rendell (Berkeley, CA:
University of California Press, 1988), 29–42.

6 Andreas Broeckmann, interview with David Garcia and Geert Lovink, "The GHI of Tactical
Media," *Transmediale.01 Festival*, Berlin, July 2001, http://www.uoc.edu/artnodes/espai/eng/
art/broeckmann0902/broeckmann0902.html.

7 Daniel Tucker, interview with Emily Forman and Josh MacPhee, *Never the Same*, http://nev-
er-the-same.org/interviews/emilyforman-joshmacphee/.

8 I was a co-organizer of October Surprise, along with former Chicagoan and DSLR partici-
pant Steve Anderson, Cara Baldwin, Sandra De La Loza, Ken Ehrlich, Jennifer Murphy, Marc
Herbst, Robby Herbst, Valerie Schultz, and dozens of participating artists, activists, and con-
vergence spaces.

9 For more on Deadtech, see Kelly Reaves, "Dormant Art: An Interview with Rob Ray of
Deadtech," *Art & Culture in Chicago*, March 21, 2009, http://artandcultureinchicago.wordpress.
com/2009/03/21/dormant-art-an-interview-with-rob-ray-of-deadtech-3321-w-fullerton/.

10 The overlap, especially from 2002–04, between *Version*, the parallel *Select Media Festival*,
and the publication *Lumpen* reflected the historic efforts of Bridgeport-based designer, orga-
nizer, and cultural entrepreneur Ed Marszewski and the many collaborators he enlisted on
these projects. Such overlapping projects continue in the form of a non-profit organization
called the Public Media Institute, that, along with *Version* and *Lumpen*, is also responsible
for the MDW art fair, the Co-Prosperity Sphere cultural center, and the craft beer festival and
publication *Mash Tun*.

11 Critical Art Ensemble, "Framing Tactical Media," *Tactical Media Files*, http://www.tacti-
calmediafiles.net/article.jsp?objectnumber=38003.

12 Nato Thompson, "Hactivist Interview," *Select Version 3: Digital Detournement* (Chicago:
Edmar Productions, 2003), 119. *Select Version 3* was the reader for Version>02.

13 Collectives like Street Rec, Pink Bloque, and CHAOS immediately come to mind. For
more on these and other related projects, see Daniel Tucker and Emily Forman, *Trashing the
Neoliberal City*, (Copenhagen, Denmark: Learning Site, 2007).

14 Mess Hall was a no-profit, key-holder run cultural space in a storefront in the Rogers Park
neighborhood that operated for ten years until 2013. For more on Mess Hall, see Dan S. Wang,
"Mess Hall Ends Its Hall," *Propositions Press*, February 28, 2013, http://prop-press.typepad.com/
blog/2013/02/mess-hall-is-ending.html. Staged in the Fall of 2004, Pilot TV was organized by
artists Emily Forman, James Tsang, and others. It announced itself this way in its call for par-
ticipation: "Calling all trans-activists, border crossers, and trespassers of all kinds! Together
we will stage a takeover/makeover of (capitalist) TV through skill-sharing and community
action. Let's pilot a new feminist take-off! We invite you to take part in 4 days and nights of par-
ticipatory, creative problem-solving to rethink how we *stage* protest. PILOT will be an open-
ended space for those of us involved in the global anti-capitalist movement to come together in
sweat-space..." Archived at http://www.16beavergroup.org/events/archives/001153print.html.

15 David Garcia, "Two Cultures of Resistance," *Select Magazine,* 6.66 (Chicago: Select Media, 2003): 27. This issue of *Select* was the published reader for *Version>03: Technotopia vs. Technopocalypse*, a contribution to the Next 5 Minutes 4 festival's global series of tactical media labs.

16 Daniel Tucker, interview with Emily Forman, "Building the Temporary Autonomous TV Studio," *The Journal of Aesthetics & Protest*, (2005): 163.

17 Brian Holmes makes a compelling argument for this in his contribution to the NYU-hosted *Virtual Casebooks on Tactical Media* casebook: http://www.nyu.edu/fas/projects/vcb/defin-ingTM/holmes_brian.html.

Department of Space and Land Reclamation exhibition catalog cover, 2001, offset print.
Design and photos: Josh MacPhee.

DEPARTMENT OF SPACE AND LAND RECLAMATION

APRIL 27-29, 2001 • CHICAGO, ILLINOIS

Alternative Arts Funding in Chicago

Bryce Dwyer

Many of the difficulties in philanthropy come from an unconscious division of the world into the philanthropists and those to be helped. It is all assumption of two classes, and against this class assumption our democratic training revolts as soon as we begin to act upon it.
— Jane Addams, "The Subtle Problems of Charity"[1]

Over the past ten years in Chicago, arts funding has accumulated in odd places. It's turned up in a bar's till at the end of the night. It's been passed over a table and into the cash apron at a farmer's market. Money eventually used to support artists has been stowed by the doorman at a dance club and stuffed into a jar passed around an improvised dining hall. All of this money has been routed toward the arts by a profusion of alternative arts funding projects. While many of these initiatives are and have been aware of each other and even collaborated from time to time, they have each been run by independently minded groups of individuals motivated to intervene in a funding ecosystem they might not ordinarily have the clout to take part in. The funds raised by these organizers come from collective meals, dance parties, self-organized giving circles, and the sale of local foodstuffs. Resources are allocated in kitchens, living rooms, bars, and around shared meals.

All of the following independent fundraising projects operated in the city at some point during the Great Recession: Chances Dances, Peace Party, Co-op Sauce, Maria's Community Bar Grant, Fire This Time Fund, and

Sunday Soup. All six were started by people whose view from the ground substituted sophisticated knowledge about their communities' needs for the deep pockets and infrastructure of conventional funding organizations. Their organizers regularly gained an understanding of who and what needed support through direct experience. The "unconscious division" that Jane Addams remarked on in 1899 does not exist here: the philanthropists and "those to be helped" are one in the same.

Of course, most creative projects, from the Chicago Symphony Orchestra to the self-published zinester, need money. The variables are the amount of money and the conditions it comes with. The independent fundraising projects discussed here augment what they lack in sheer quantity of money with thoughtful and generous provisions for its use by the people who receive it. In other words, they distribute funds with little to no strings attached. In the foundation world, strings are attached in the form of expected outcomes so that granting bodies can begin to make some assessment of their activities. Experimental, process-oriented artworks and projects whose radical politics might not mesh harmoniously with the logic of outcomes are at a disadvantage.

The challenge is, with so much culture being produced, how does a community support the culture that enriches and enlivens it without shifting too much of the burden of securing resources to the artist? In this climate, organizers of alternative fundraising projects have themselves

Chances Dances Critical Fierceness Grant, call for proposals, 2009.
Courtesy of Chances Dances, Chicago.

taken on the focus and responsibility of supporting culture that isn't conventionally thought of as "fundable." A few hundred well-spent dollars can do things like secure a venue, rent a last-minute projector, feed participants, and otherwise meet critical project goals. Many of these funding projects support people with little to no formal experience applying for grant money and intentionally modify the application process to level the playing field.

The Chances Dances Critical Fierceness Grant provides a good example of a hybrid grant process, one that adopts methods from traditional grant making and adapts them to suit its specific purposes and values. Chances Dances is three monthly queer dances parties and the name of the group that organizes, deejays, and hosts them. Since 2008, this group has donated a portion of its door take and its cut of bar sales, administering and distributing the Critical Fierceness Grant twice a year to "individuals or groups who wish to utilize the grant for artistic purposes and who identify themselves or their work as queer." Moreover, Chances has formed a well-organized and meaningfully articulated funding structure to support the creative work of queer communities in Chicago. A board of directors, invited by the Chances organizers, makes the final decision on awards to applicants[2] who submit a mission statement, project summary, and budget. In addition, Chances has made a habit of regularly providing extensive and candid feedback to both successful and failed applicants, with the intention that this is a learning process for anyone denied about writing a successful grant, and they are encouraged to apply again. The entire process becomes a way to educate anyone who applies about writing a successful grant. Queer communities are often forced to navigate structural hurdles to funding and queer artists are among the first targeted in conservative attacks on public support for the arts. The Critical Fierceness Grant process might equip an artist to better navigate this gauntlet more effectively.

Fire This Time Fund (FTTF) was an independently organized giving circle that operated from 2006 to 2010.[3] All the members of the group contributed some of their own money to the fund. FTTF asked fund applicants to conceive of their application as a love letter explaining their work. Rarely if ever do artists applying for support receive an invitation to invoke in the application itself some of the same creativity they put into their work. The rhetorical innovation of the application-cum-love letter opened up a space in the process for such an open-ended, generative reality of art making. FTTF also conceived and introduced intentional practices into their giving process to encourage greater understanding of their applicants and fairness in their awards. An outreach committee, consisting of paired fund members, conducted site visits with applicants; people of similar backgrounds were split up so that so that a more diverse perspective could be gained and anyone who had been previously affiliated with an applicant would not be part

of the pair doing its site visit.[4] After getting to know applicants personally, everyone who conducted site visits reported back to the group so as to further aid making decisions about how to award the money.

Yet alternative funding practices in Chicago have experimented with more than application formats. Sunday Soup, which along with Fire This Time Fund and Chances, was the only other project that regularly fielded grant applications. It was organized from 2007 to 2012 by InCUBATE, a group (of which I am a member) dedicated to exploring, questioning, and generating new forms of support for artists.[5] Even though we performed many functions of a typical arts non-profit—running an artists' residency program, hosting and organizing programming, running and administering a grant—the group made a decision not to go through the lengthy process of incorporating as a 501c3. Instead, time and energy was dedicated to the small-scale, self-organized projects that mattered most to the members. Its primary activity became Sunday Soup, which, in its original form in Chicago as a collective meal at InCUBATE's storefront space, raised enough money to give away a grant of a few hundred dollars raised by each month's meal. Everyone who came paid ten dollars. After covering the cost of the food, the remainder became the Sunday Soup grant. Each month we solicited one-page grant proposals. During the meal, diners had the opportunity to review the proposals and discuss them with their tablemates. At the end of the meal, everyone voted. Intended from the outset as a freely adaptable model, not a fixed brand owned and overseen by a single group, Sunday Soup has gradually spread around the world. As I write, ninety-three independently organized "sister projects" have organized meals with Sunday Soup as a basic model and given away a combined $79,000. This achievement would have been impossible had the concept been treated as proprietary.[6]

Other funding projects in Chicago have found ways to make legal structures work for them. Co-op Image Group is a non-profit devoted to providing free art and entrepreneurship programs to young people in the city, especially in the Humboldt Park neighborhood where it is based. In 2003 founder Mike Bancroft and youth in the program started making and selling hot sauce to raise money to support the organization's activities.[7] Ten years later, Co-op hot sauce is ubiquitous in Chicago: it's in restaurants, on the shelves of big grocery stores, and sold regularly at farmers markets. It is doubtful that the project's ambitious expansion could have been supported by a non-profit. Instead Bancroft invested in the development Co-op Sauce independent of Co-op Image, turning it into a B-Corp: a corporate form legalized in Illinois in 2013 for businesses emphasizing social change over profit.[8] These days it employs five youth part time and donates its profits to Co-op Image.

Alternative fundraising projects in Chicago tend to be very social. Hierarchies between funders and fundees often erode because, in most

How To Start Your Own Sunday Soup

Sunday Soup is an international network of initiatives that each use public suppers to communally fund creative projects.

While the size and scope of these grassroots suppers varies, the formula is that for an affordable donation, diners come together and receive a meal as well as a curator's ballot. They each vote on a number of projects and at the end of the night, all the votes are counted and the project or projects with the most votes receives all the money collected. An alternative funding model for the arts, the Sunday Soup Network allows artists to receive money for projects from the community and in turn create projects for that very community.

The Sunday Soup Network

Art Bombe — Duhacun, IA
Artist Bailout — Los Angeles, CA
Brattleboro Essential Arts Network — Brattleboro, VT
Bread KC — Kansas City, MO
Buffalo Sunday Soup — Buffalo, NY
Cole Harrington — Huntington, WV
CarbonSoup — Carbondale, IL
Chatterham's Sunday Soup Sessions — Clintonham, UK
Ciosa trolle in gendoids? — Bologna, Italy
CUBSoup — Roseville, MI
DC Kitchen of Innovation — Washington, DC
Detroit Soup — Detroit, MI
Feast Brooklyn — Brooklyn, NY
Frost Moss — Boston, MA
Feast Mpls — Minneapolis, MN
Feast Tampa Bay — Tampa, FL
Feast Toronto — Ontario, Canada
FortWorth Dish Out — Fort Worth, TX
Bremote — Milano, Italy
Greensboro Picnic — Greensboro, NC
HartFeast — Hartford, CT
Highbridge Artists — Newcastle Upon Tyne, UK
InCUbate — Chicago, IL
Madison Soup — Madison, WI
NIKEsi — Milwaukee, WI
Philly Stake — Philadelphia, PA
Portland Stock — Portland, OR
Providence Provision — Providence, RI
Public Meal — Alfred, NY
Salt City Dishes — Syracuse, NY
Soup — Iowa City, IA
Soup W.hi — Pittsburgh, PA
Soup Semikors — Providence, RI
Soup Stock — Ann Arbor, MI
Sprout — Santa Fe, NM
Sprout Seattle — Seattle, WA
Square Meal — Charleston, WV
Sunday Borscht — Sunday Soup
Sunday Soup OR — Grand Rapids, MI
Sunday Soup — Phoenixville, PA
Supper — Flagstaff, AZ
Vallee Feast — Northampton, MA
Wilmington Stir — Wilmington, DE

"Living As Form" presented by Creative Time

October 1-2, 2011

Int'l Day of Soup

1. Find a space and build a dedicated team.

2. Source supplies, promote event, call for proposals.

3. Charge a modest amount for a meal and a ballot.

4. Serve food, engage guests, present the projects.

5. Guests vote for their favorite project.

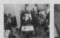

6. Distribute the event's proceeds according to the vote.

7. Document, reflect, share your experiences with others.

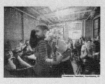

sundaysoup.org

"How to Start Your Own Sunday Soup," 2007-2012. Courtesy of SundaySoup.org.
Design: Golden Arrows.

cases, the folks involved are members of linked or intersecting communities. It should come as no surprise then that lots of meetings and even two projects take place in bars. Peace Party (currently on hiatus) happened on the occasional Monday night at Danny's Tavern in Bucktown. Mondays aren't generally busy nights at bars, so it was always the organization's job to help bring people out. The bar benefits from patrons that might not regularly go there, and the organization and its supporters have the opportunity to spend unstructured time together in a congenial atmosphere. There was no cover charge to get in, but a portion of the sales went to the project honored at a given night's party. The beneficiaries of each Peace Party were usually arts projects and organizations that address social justice like Tamms Year Ten, Kartemquin Films, and the Unlympics.[9]

Community Grant Night at Maria's Bar in Bridgeport operates similarly to Peace Party and has occurred intermittently since 2011. While Peace Party supports projects across the city, Maria's generally benefits creative projects generated by or directly relevant to the neighborhood in which it is located. Ed and Mike Marszewski took over the bar from their mother Maria in 2010. Ed is a catalyst for much of the artistic activity that occurs in Bridgeport, especially through the Co-Prosperity Sphere art space, which he initiated, and the annual Version Festival which he co-founded. On Community Grant Night, the bar gives all the proceeds from specific drink specials to the project chosen for the grant by those who come. So far it has funded art exhibitions; Too Young To Die, a community arts project for youth affected by violence; Pocket Guide to Hell, which produces reenactments of important moments in local history; and the nearby Benton House Food Pantry. The grant is as local as it gets, supporting projects that take shape within the few dozen blocks of the bar.

All of these funding initiatives share in common methods that people without plentiful resources have developed to make do. Rent parties, church basement dinners, and giving circles are nothing new. None of these tactics can take the place of systematic efforts like a well-funded, responsive group of local foundations or a progressive arts fund collected and distributed by local, state, and national governments. However, alternative funding projects in their nimbleness and dedication to specific values, find ways to redirect resources quickly to challenging culture that likely wouldn't be supported any other way. As experiments, whether rooted in old traditions or generating new ones, they serve as glue that holds communities together over time. These webs of support ask us to imagine what the world might look like when ordinary people actively support the production of creative projects by their fellow citizens, and then begin to sketch in the contours to make that world visible.

1 Jane Addams, "The Subtle Problems of Charity," *The Atlantic*, February 1, 1899.

2 "Chances Dances Critical Fierceness Grant," http://www.chancesdances.org/fierceness.

3 "Fire This Time Fund," http://www.firethistimefund.org/.

4 Kristen Cox, "Kristen Cox: Fire This Time Fund," interview in *Resource Generation*, http://www.resourcegeneration.org/resources/resource-library/ giving-giving-plan-resources?id=105:coxthefirethistimefund&catid=4.

5 The members of InCUBATE are: myself, Matthew Joynt, Roman Petruniak, Abigail Satinsky, and Ben Schaafsma, who was central to the original conception of the Sunday Soup Grant and all of our work as a group. Ben passed away in 2008.

6 For more on Sunday Soup, see "Sunday Soup," in *A Guide to Democracy in America*, ed., Nato Thompson (New York: Creative Time, 2008); Abigail Satinsky, "How to Grow," *Proximity* 7 (Spring/Summer 2010), 56–63; Abigail Satinsky, "Sunday Soup," in *Feast: Radical Hospitality in Contemporary Art* (Chicago: Smart Museum of Art, 2013), 204–210. Exhibition catalog.

7 "Co-op Sauce" http://coopsauce.com/about-us/.

8 "B-Corporation" http://www.bcorporation.net/.

9 Tamms Year Ten is an organization that advocated for the closure of Tamms, Illinois' supermax prison. The Unlympics was a series of public events initiated by Anne Elizabeth Moore aimed at bringing attention to questionable City practices in the run-up to Chicago's bid for the 2016 Summer Olympics. Kartemquin Films is a non-profit film organization that has produced award-winning documentaries like *Hoop Dreams* and *The Interrupters*.

South Side Community Art Center, group photo (detail).

SOUTH SIDE
COMMUNITY ART CENTER

ARCHIVE AS
SITE

Archive as Site

Artist collectives, artist-centric non-profits, and experimental institutions are always in the process of actively reimagining their art worlds. Artist organizations happening at the grassroots level (even if they become fully functional non-profits later on) are often operating without a fully developed infrastructure, making do on very limited budgets or surfing on generosity, and risking the burnout of organizers and invested community members. The social life of these spaces and projects is often hard to capture. It is bound up in in the organizers' ideas and passions for new community or pushing the boundaries of the institution of art. And those ideas are made and remade by the practice of building the infrastructure itself—whether that's sweeping the floors after an opening, making publications, juggling communications and leadership roles, figuring out where the money comes from, and just shoving ephemera away in boxes for later or putting it in the basement to be discovered by next generations or, if we're lucky, to be shuttled off to a library.

Because of the informality of these spaces and associations, by necessity or principled resistance to formalizing, it can be hard to parse out the actual kinds of social encounters that happened, the overlapping networks of people, or the spirit of these different comings together that informed their founding values. The narratives formed by makeshift archives, personal accounts, ephemera remnants, missions, and manifestos tell us only a fraction of the story that also depends on varied and, at times, competing perspectives and experiences. It's the problem of "you had to be there," which is considerable, as this section and most of the work throughout the volume addresses art experiences that are constituted socially.

Never the Same, a grassroots archiving project initiated by Daniel Tucker and Rebecca Zorach, on socially and politically engaged art practices in Chicago, takes its name from the transformative potential that such work offers, highlighting the impact on the individuals involved. Such a subjective emphasis forms the basis of their project that encompasses interviews, exhibitions, public presentations, and independent classes of histories that are not often preserved. Their impulse to collect and archive Chicago's social art history as a usable, interpretable, and always incomplete resource echoes the artist-generated histories in this section, which also use ephemera and archives as material for art, either to reanimate them in the spirit in which they were created and lived or to question their relevancy in the present. As Zorach, explains in "Making Usable Archives":

> It needed to be a living archive. The community, independent, grassroots archive that we admire most are living archives with an expansive sense of the ongoing usability of their materials— their artistic and political generativity. But how do you keep that generativity going? How do you make materials available in usable ways while still preserving them—or do you just not preserve them, thereby violating (to the potential dismay of professional archivists) standard archival practices? And if usefulness is a criterion, is there some point at which you might decide they are not useful anymore?[1]

ESCAPE GROUP's *Ya Presente Ayer* activates their research into the tools and sites that hold historical significance for the Chicago Latino/a community, and questions how to move through and interrogate these notions in the form of a performance script. Faheem Majeed discusses with Tempestt Hazel how he has engaged with the legacy of the South Side Community Art Center, through an archival artist project at Hyde Park Art Center, the oldest, still extant, alternative artists' space in the city. *Every house has a door* and Paige K. Johnston interpret the archives of Randolph Street Gallery, a seminal site for the Chicago performance community as well an exhibition venue, video and film screenings, public art, education programs, grants to artists, and the original publisher of *P-form: Performance Art Magazine*, which was in operation from 1979 to 1998. As a laboratory for new art forms, it focused on artists who were unsupported by commercial and institutional funding sources, and brought scores of national and international artists to the city. Cauleen Smith looks at the El Thmei Research Institute, a community of autodidacts on Chicago's South Side—led by experimental musician, poet, and philosopher Sun Ra and his business partner Alton Abraham. She discovered them in a near-lost

archive, their activities scribbled in the margins of books rescued from the trash by writer, gallerist, and champion of free jazz and improvised music, John Corbett.

These selected pasts, enacted and framed through the perspectives of artists and their creative research practices, give us just a glimpse of Chicago's disparate art communities, overflowing with complexity and contention, and resonating in the present as material to be put to use. As Matthew Goulish explains in "9 beginnings at Randolph Street Gallery," "Our cameras cannot select as well as our brains. To enact, to re-enact, frames and focuses. It makes a claim to what is important."

—AS

1 Rebecca Zorach, "Making Usable Archives," *Unfurling: Explorations in Art, Activism, and Archiving,* eds. Daniel Tucker and Rebecca Zorach (Chicago: Gray Center for Arts and Inquiry at University of Chicago, 2014), 11.

Augmenting Our Cultural Garden

Faheem Majeed
Interviewed by Tempestt Hazel

Tempestt Hazel: *Faheem, if you were to dig into the corners of your closets and mine the contents, locating the residual objects of your existence, what story would they tell? It seems that this was your process in creating* Planting and Maintaining a Perennial Garden *for the* Hairy Blob *exhibition at the Hyde Park Art Center in 2012. You also combined this with your experience as the Executive Director of the South Side Community Art Center (SSCAC) while also incorporating artifacts created, used, and set aside throughout the SSCAC's rich history in order to reimagine its past, understand its relevance today, and visualize its future.[1] Can you revisit the trajectory you traveled to arrive at that point?*

Faheem Majeed: I studied sculpture while an undergrad at Howard University in Washington, DC. It was very traditional and the focus was basically making something well...something that was beautiful. When you first encountered my work, I was trying to stretch within the confines of what I knew. I wanted to do more...say more. Around the same time, I was trying to find a place to squat and work on my art while I looked around for a studio and I landed at SSCAC. It was fascinating to me because this was a place I studied while at Howard. Over time, I moved on to a studio space but remained involved at the Center. That relationship morphed and changed over time as I developed this infatuation with the space, the history, and the people. I transitioned from volunteer to curator to Executive Director over

the course of eight years. At about five years into that relationship, I was taking on more and more responsibility, trying to push the Center in a different direction than it had been previously, and to be honest, that was exhausting.

At the same time, I was still trying to maintain my own art practice but that was falling to the side. It was my passion and what drives me, and yet I wasn't doing it. I was also at a crossroads with my work where I knew I wanted to try something new, but I didn't feel like I had the exposure or skills set to do that yet. So what do you do when you don't know what to do? You get another degree, and that was the right next step for me. I needed a safe place to explore, I needed exposure to other artists, and I needed some candid critique of my work. Pursuing my masters at University of Illinois at Chicago (UIC) opened the doors for me to try and sometimes fail. But I still had this challenge that I was spending so much time and investing so much energy at the Center. That's when I decided to do an experiment and try to merge my role as an administrator and my role as an artist, adding, too, the perspective of a curator. I started to explore other mediums—performances, video, audio, and photography—and the attempt to merge these gave me a great outlet for the frustration I was feeling, while also giving me the space to explore and redefine myself as an artist.

As I was preparing to graduate from UIC and still Acting Director at SSCAC, I initiated a number of conversations about the Center's survival. That led to a shift in focus from merging administration with my art practice to institutional critique and appropriation. I was trying to make a statement about this organization, to both wake new people up to its existence and shake up all of us who had been close, perhaps too close, to the Center for so many years. In that journey I talked to other institution leaders and realized that the challenges faced by the SSCAC were not unique. This piqued my interest to this whole idea of culturally specific institutions: their purpose, survival, and redefinition of what they are in context of an evolving society. The *Hairy Blob* exhibition and some other shows I have planned are my way of transitioning into a new conversation that moves my previous work into a different direction.

TH: *Your title* Planting and Maintaining a Perennial Garden *is taken from an article written by Anna Tyler for the* International Review of African American Art *in which she recounts the history of the Center and its programs, the people and energy that went into getting it off the ground, as well as the ups and downs that are the threads of its historical fabric. What resonated with you, prompting you to title the installation after this essay?*

FM: I found it to be one of the best summaries of the SSCAC's history and significance, and I utilize it in my teaching. I have also always found the tittle to be intriguing and peculiar. She never addresses the metaphor in the actual text. Over my tenure at the SSCAC, I have always been very vocal, and

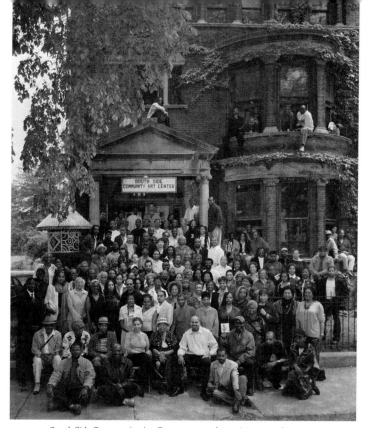

South Side Community Art Center, group photo. Courtesy of Jonathon Romain.
Photo: John Moye.

admittedly, sometimes overly transparent about the complex issues that faced the organization both externally and internally. Similarly, Anna Tyler was an artist and writer who was also passionate about the spaces and people she cared about; she never held her tongue or edited her opinion. In many ways titling this piece after her writing is in homage to her voice.

I looked up perennial gardening on the Colorado State University website and found the description to be a great metaphor for the organization's history: "A well-designed perennial garden can provide many years of beauty and enjoyment. Careful selection of plant materials and thoughtful planning can result in a full season of color." As my role in the institution became more complex, I realized that in a lot ways I, my predecessors, and the many other stakeholders were the gardeners of the cultural landscape of the SSCAC.

TH: *Through this installation you are breathing new life and adding value to objects that have been lost, forgotten, and nearly discarded, yet when revisited and accumulated become priceless pieces to the story of the South Side Community Art Center.*

FM: Over my time at the Center I was intrigued by what was deemed valuable and interesting. The Center has an amazing collection of painting, prints, sculptures, and historical archives dating back to the 1930s. But I was always intrigued by what didn't make it into "the vault," the things that aren't necessarily deemed worthy of keeping versus the things that are semi-valuable and end up on a shelf in one of the classrooms. There are also accumulations of things forgotten and abandoned by artists and community members. The Center in many ways has been entrusted with these objects' safety pending the slight chance their owners return. Regardless of how it came to rest or where it was stored at the Center, these objects are markers of events and the passing of time within the space. Together, these items tell a story about the Center and share a history.

TH: *You state that they are "almost collectible." What makes something being collectible and others ephemera?*

FM: Value is subjective and differs from person to person. At the Center there are spatial limitations to what can be collected, so tough decisions have to be made. This is also a question of positioning and exposure. Some may be valuable to certain audiences, but lose their appeal if unbundled from the larger story, thus limiting their value as a collection.

In this installation, I intuitively knew that I wanted to include ephemera. In trying to better understand the meaning of this word, I realized that the word "ephemeral" was a better descriptor of the collection of objects I was

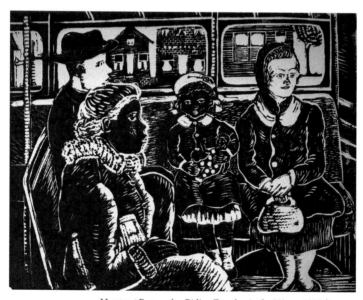

Margaret Burroughs, *Riding Together in the 60's*, ca. 1990, linocut.
Collection of the Koehnline Museum of Art, Gift of Dr. Margaret Burroughs, 2008.19.

using within the piece because they were transitory in nature. They had moved past their original purpose and been discarded because there was no perceived value or at least no value had been placed on them yet. What made these objects fascinating to me was that singly they did not speak to a history or story and they might be passed over—but together, in their accumulation, they spoke volumes when positioned within the piece.

In digging deeper into the more technical origins of the word "ephemera," I came across the term "ephemeron" which refers to an object of a transitory or impermanent nature; it is used on the context of computer science and refers to a process known as finalization that occurs when a garbage collector informs an application that an object is "almost collectable." The almost collectable becomes a new class of objects: ephemerons. The part of this that fascinated me was the idea of "almost collectible." That phrase really resonated with what I was doing and how these objects ended up where they were.

TH: *Your installation does not attempt to tell a comprehensive story of the Center, but it is definitely telling a story different than what we are accustomed to. The placement of objects is highly intentional and while you aren't forcing connections, you are helping the viewer along to occasionally land on a particular narrative. How does this reshape your own understanding of the institution?*

FM: After spending so many years gaining intimate knowledge about all of the people, events, and objects that had passed through the building, I knew there was a statement to be made about that history in a non-traditional way. The objects in this piece can be overwhelming. The word hoarder springs to mind for some people when they first see the installation protruding into their line of sight, but through this piece, I feel that these objects gain a voice and a tangible feel. I selected objects that might point to smaller un-highlighted moments in the Center's seventy-year history: a flyer from a show in the sixties, a fundraiser hosted by Bill Cosby, oil cans, and car parts, printing inks, and leftover painting supplies from art classes. I feel that there is an abundance of information about the Center available and if this installation piques the interest of a viewer, there are places to find that information. These objects represent seemingly irrelevant moments in the history of the organization, but my argument is that each moment, no matter how insignificant, adds to the canvas of this space's existence. My goal was to show the magnitude of the smaller happenings.

But even when I first stepped back from the piece, I was overwhelmed, frustrated. It was such a departure from my normal aesthetic that I didn't know what to make of it at first. Your eye starts to jump around, but as you settle in for the journey, I hope you land on my intentional curating and the story starts to emerge.

Of course, that story depends on your history or lack of connection with the SSCAC. Older stakeholders from the Center can navigate the piece and intimately recount the origins of objects or explain the content surrounding these things. For someone who has never known of the Center, a familiarity of the types of things collected suggests value. At one point someone told me the piece reminded them of the former Maxwell Street Market. Something familiar is important to the success of the work because it offers a place of entry. Similar to many experiences around the Center, you may not know everything about the space or history but you do get a sense of value, warmth, and history.

TH: *You mention that this is part of an ongoing series of work that utilizes cedar wood panels to host a variety of interventions. My mind automatically goes to an intervention as a something that situates itself within a known understood path toward a predicted destination. How does the installation, performances, and the other ways you utilize materials act as interventions?*

FM: The interventions I'm speaking of are intended to make people pause and take notice of the Center or change the way people have viewed the Center, even change the way the stakeholders view and interact with the Center. I find myself drawn to work that can drive dialogue and sometimes make actual change. As I transitioned out of the Center to refocus my work in other areas, this approach and passion are things I took with me and I want to continue to create situations and curate in ways that bring people together and can act as a catalyst for change.

This text was adapted from the interview originally published as part of the Sixty Inches From Center's Chicago Arts Archive, May 14, 2012.

1 Founded in 1941 during the Work Projects Administration in Chicago's Bronzeville community, the SSCAC served as a platform for black artists when their creative opportunities to gather, exhibit, and engage around their work were limited. The SSCAC provided a supportive home, and throughout its long history has been a nurturing space for numerous artists, including such distinguished figures as Gwendolyn Brooks, Elizabeth Catlett, Gordon Parks, and Charles White; for artists groups, notably AFRICOBRA, the Association for the Advancement of Creative Music (AACM), Black Artist Guild, and the Organization of Black American Culture; and more recently, contemporary artists from the South Side and across the city dealing with social issues and the black experience in Chicago.

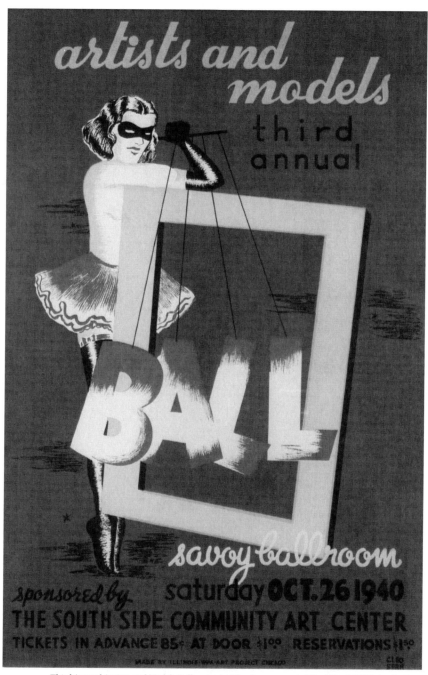

Third Annual Artists and Models Ball poster by Cleo Sara, as part of the Illinois WPA Art Project, Chicago, 1940. Courtesy of the South Side Community Art Center.

Ya Presente Ayer

ESCAPE GROUP

Ya Presente Ayer, loosely translated as "Already Present Yesterday," is meant to express an often-neglected and invisible Latino/a cultural past. This absence led us on a search for history and a greater understanding. Throughout this journey we gathered bits of our history, beginning with our personal roots in the American Southwest and continuing through to our present home in Chicago, where we looked in particular to the various histories of Latino/a cultural production present within the city. Our research into the many centros, muralists, alternative newspapers, and print studios of the Pilsen and Little Village neighborhoods, helped us locate the personal relationships, ideologies, interlocking goals, and narratives that we felt had been missing.

Feeling that a single text could not contain the breadth of what we had uncovered, we chose to follow our artistic practice and create a performance script to organize the list of tools, historical sites, and actions of those that came before. Actions related to the work of Latino/a cultural producers in Chicago appear at the top and bottom; sites of historical significance appear on the right side. The list of tools on the left varies from the easily attainable to the more challenging, opening up the possibility for collaboration by reaching backwards to a historical printing press or reaching sideways to a friend with a pickup truck. The center portion of the script is a timetable in a chevron pattern designed to suggest movement. A performance can be made by selecting an element from each part of the script and then selecting a duration for the performance from the center. Once all elements are selected and a duration determined, the performer can decide how those elements will be used and how to order the performance.

OBSERVE BORROW COLLECT BECOME

INTRODUCTION TO THE ENVIRONMENT

CHOOSE A SITE, CHOOSE A TOOL(S), ORDER THE PERFORMANCE, LOCATE A START TIME AND END TIME

AM

12:00 - 1:00

1:00 - 2:00

2:00 - 3:00

3:00 - 4:00

4:00 - 5:00

PM

12:00 - 1:00

1:00 - 2:00

2:00 - 3:00

3:00 - 4:00

4:00 - 5:00

PRINTING PRESS BOOK OF DICHOS PAINT

5:00 - 6:00
6:00 - 7:00
7:00 - 8:00
8:00 - 9:00
9:00 - 10:00
10:00 - 11:00
11:00 - 12:00

5:00 - 6:00
6:00 - 7:00
7:00 - 8:00
8:00 - 9:00
9:00 - 10:00
10:00 - 11:00
11:00 - 12:00

REMAIN DISPERSE RETURN GLOW

CAMERA PICK-UP TRUCK NEWSLETTER

ESCAPE GROUP, performance script.

9 beginnings at Randolph Street Gallery

Every house has a door

Part One
Matthew Goulish

Randolph Street Gallery, an artist-run space, existed in Chicago from 1979 to 1998. One entered into a large gallery space, with offices at the end, and beyond the offices a smaller gallery space in the back. Another room, long and narrow, accessed through doors on either end of the long main gallery wall, hosted performances. The archive describes it as "a laboratory for new forms, new thought, and new ways to distribute art in the world." I remember that as true.

Nexus

Every house has a door composed in 2013-2014 *9 beginnings: Chicago*, a performance in an ongoing series of works derived from archival collections. It responds to the Randolph Street Gallery Archives (RSGA) held at the School of the Art Institute of Chicago. The performance weaves together the beginnings of nine performances, by nine different artists or groups. These performances, documented on video, all happened in that same narrow room at 756 North Milwaukee Avenue. The room had an uneven wood floor, below which trains ran audibly from time to time, trains today called

Blue Line, but in those days called the O'Hare-Congress. Randolph Street Gallery offered a meeting place where people gathered regularly to experience the results of diligent and intelligent curatorial practice, along with a certain uncontainable edge of roughness.

Noise

Why not just play the tapes in public? A journalist asked me this. Why enact the performances? I told him there is too much noise in the system of those videos, too much extraneous information. In the live event we have learned how to filter, through attention and the empathy of physical proximity. The body shrinks in the visual field, but in the room it swells and attracts. Our cameras cannot select as well as our brains. To enact, to re-enact, frames and focuses. It makes a claim to what is important.

Representation

I mean *representation* the way a photograph represents its model, but also the way a representative speaks for a community. Whose voice is whose? Here is a long quote from *The Claim of Reason* by American philosopher Stanley Cavell.

> To speak for oneself politically is to speak for others with whom you consent to association, and it is to consent to be spoken for by them—not as a parent speaks for you, i.e., instead of you, but as someone in mutuality speaks for you, i.e., speaks your mind. Who these others are, for whom you speak and by whom you are spoken for, is not known a priori, though it is in practice generally treated as a given. To speak for yourself then means risking the rebuff—on some occasion, perhaps once for all—of those for whom you claimed to be speaking; and it means risking having to rebuff—on some occasion, perhaps once for all—those who claimed to be speaking for you. There are directions other than the political in which you will have to find your own voice—in religion, in friendship, in parenthood, in love, in art—and to find your own work; and the political is likely to be heartbreaking or dangerous. So are the others. But in the political, the impotence of your voice shows up the quickest; it is of importance to others to stifle it; and it is easiest to hope there, since others are in any case included in it, that it will not be missed if it is stifled, i.e., that you will not miss it. But

once you recognize a community as yours, then it does speak for you until you say it doesn't, i.e. until you show that you do. A fortunate community is one in which the issue is least costly to raise; and only necessary to raise on brief, widely spaced, and agreed upon occasions; and, when raised, offers a state of affairs you can speak for ...[1]

First person plural

Simone Forti, Robert Metrick, Jennifer Monson and Yvonne Meier, Andy Soma and Alan Tollefson, Example: None, Shrimps, Mary Brogger and Brendan DeVallance, Chris Sullivan, Nancy Andrews, and a bonus track of a pre-show announcement by Mary Jo Schnell. We labor in the recognition of the extent to which these individuals, in particular through these beginning moments of their compositions, known but forgotten, or unknown but recognized, speak our minds now. We speak as them as they speak for us. What has stifled these voices? Time passing has muted them, as has our lack of diligence in keeping them present in memory. We will keep them before us now. We will assemble their beginnings into a new composition that flows in its own way like a meandering river of echoes and associations. When I say *we*, I mean the team: Lin Hixson, director; Selma Banich and Sebastián Calderón Bentin, performers; Nicki Polykarpou, assistant director; Daviel Shy, project administrator; and myself, dramaturge.

Circles grow wider

Why have we taken on this project? We have responded to an invitation, and we responded in this way because we have always needed a source to reimagine. These acts of staging have become acts of restaging some interface between the personal and the communal, with the accompanying anxiety of representing both. We have, without really trying, broken down and reconstructed the systems (economic, social) that endowed these moments with their forum. The source tape here is closer and maybe riskier, since Lin and I know the people recorded, or if we do not we were subject to only two degrees of separation at most. Or does that make it less risky? Or does it redefine risk altogether? Who do we think we are? This project is for us a kind of homecoming, a return, and an invitation for others to that particular orbit and address. Our team does not know these artists, unless we introduce them. Selma, Sebastián, Daviel, Nicki: this is Chris Sullivan; this is Robert Metrick.

Reach and touch

What is an enduring context? What is an abstract enduring project? Where do we find abstract representation and solidarity with people whom none of us has ever met? These moments reach across years, across decades. They share an enduring scarcity of resources and an abundant economy of creativity, humor, and tireless attention. When Mary Brogger made her entrance in 1989, wearing white spats on her shoes, did she offer her de facto consent for us, or for anybody, to re-create the entrance twenty years later? For Selma Banich to enter in spats and recite her speech, not to speak for her, but to allow and endorse how she spoke, and still speaks, for us? The voices carry across the nearer distances, the passages of time that we can reach across and try our best to touch.

What have we lost?

Any analysis of the reasons for the end of RSG lies beyond the scope of this essay or this project. It folded at a time we can with hindsight recognize as a turning point, from aspirations of collectivity and collective responsibility with all the accompanying fraught conflicts, to a time of forced atomization, of celebrating the adventures of individualism and the loose friendships of arrangements over groups, wandering in a strange wilderness in which no one is ever really alone, or left alone, for long. Much has been gained, and much has been lost, and of the things lost, that room, as a physical presence, and as a condition. It allowed certain types of movement to emerge. Those are the movements we have tried to study.

Part Two

She walks into the room
Lin Hixson

She walks into the room carrying a pile of newspapers and lays them on the floor.

On her knees, she shapes the newspapers into a map.

She reads, speaks, and moves her body in response to the news.

One interesting thing about ... uh ... the whole area of the Persian Gulf and the ... and the ... moving in to Afghanistan is ... uh ... that the Arab continent is a ... separate continental plate ... and its drifting ... Iran ... the long

A projected slide, on the back wall, interrupts her words.

She moves to the side of the room.

Motionless, she faces the audience.

"February 11, 1989—Simone Forti"

says the slide and then disappears.

She returns to the floor and continues where she left off.

coastline on the gulf...but up here on Afghanistan...and the pressure builds up on these mountains...And these are the mountains that the Russians moved across...

She stops abruptly, and when she continues it will not be to continue this, but to enact another beginning. Selma Banich has completed the beginning that begins our performance *9 beginnings: Chicago*. It is taken from choreographer Simone Forti's *News Animation Improvisations* presented at Randolph Street Gallery on February 11, 1989. Forti describes the process of performing these improvisations in the book *Taken by Surprise: A Dance Improvisation Reader* edited by Ann Cooper Albright and David Gere.

Somewhere along the way I would get the idea for what topic I was going to start with. ... as the lights came on I would be shaping the papers around on the floor, making them into maps. I would start talking and animating the human dramas above ground, interwoven with the seismic/tectonic dramas below.

In our performance, Selma does not walk into a dark room and find a topic to address on the way. I think Selma needs to perform the exact words Forti spoke on February 11. For these words, said in 1989 and spoken now in 2014, disturb me. They are too familiar, too commonplace, too day-to-day. When the performance is interrupted by the announcement of the date and artist's name, Selma stands motionless in order to construct a gap. It is in this pause and separation that Forti's performance can begin to haunt ours. After this moment, Forti's words are distanced and become prophetic. They are slightly ahead and slightly behind the now. This fracture opens up a system of presence that operates like connective tissue. Forti's remoteness comes into view but so does the length of her reach. It crosses time and disrupts the proper order of the now.

On Re-enacting
Sebastián Calderón Bentin

In order for a part of the past to be touched by the present instant there must be no continuity between them.

— Walter Benjamin, *The Arcades Project*

I am looking intently at a video recording on the TV screen. It is from the 1980s. April 8, 1988 to be exact. I am looking at the people on the screen. Four men. They are dancing—well, shaking—it's a shaking dance. It's a small space with white walls. I cannot see the audience. I can only see the performers. The performance is titled *Shrimps*. I watch the men move, I look at one man in particular, he is the one that interests me the most, I count his steps, I notice the way he stares at the audience, how he stands, his timing, his costume. I pause the tape, I rewind, I watch again. This is my script.

In *9 beginnings: Chicago* we re-enact, remake, redo the beginning of nine different performance pieces that took place at Randolph Street Gallery between 1988 and 1992. As part of the rehearsal process we worked off videos in order to reconstruct every beginning, each video a microscript to the overall performance score. As I watched intently trying to imitate each performer's choreography, memorize the words they spoke or sang, and adopt their stage presence, I quickly realized that unlike working off a written text, improvisation, or directives, the videos were more than scripts. The more I gazed into them the more I realized it was not only me who was looking. The artists were turning their gaze at me. I was the one being watched.

I am a copy of an original.

Suddenly the technicity of the exercise (Was I doing it right? How close am I getting? How close do I *want* to get?) gave way to an ethics of the gaze. After all, here was a person, a fellow performer, who had done this thing, written by him, imagined by him, and here I was, years later, copying him. Watching him during rehearsal, jotting down notes, watching him at home on my laptop, redoing this stranger's movements in my bedroom. It all suddenly started feeling a bit personal. Like stalking. Like some self-induced act of possession. I started to think about the artists, what they were doing now, if they still performed, if they had enjoyed performing that day, if they were happy with the work. I started thinking about the responsibility of remaking someone's work, seeing their faces on the screen every day, copying minute gestures, slight shifts of weight, realizing that they probably never imagined someone would be staring at them decades later trying to figure out if they had taken five steps forward or four, if they had said "huh" or "hmm," if they were looking straight at the audience or past them.

I am the origin of a copy.

I suddenly felt responsible not only to the audience but to the performers whose work I was redoing. Technical questions became ethical questions. If I copy his voice, does it sound like I am making fun of him? If I am too precious with the work, does it become an elegy? How do I make it mine? Is there even room for me between the constellation of live audience and source performance? Am I just a vessel? There are no neutral vessels. "There is no neutral," Lin correctly pointed out once. And it was glaringly clear now. There is nothing neutral about redoing someone's work.

I am an original copy.

The work asked for a rigorous generosity that acknowledged the discontinuity between then and now, them and us, live and recorded. We entered the discontinuity as a group, this was where the work would live and thrive. I imagined the artist and then I imagined what they were doing, the mask they were wearing, what they were putting on. I stopped focusing so much on the *appearance* of the mask, but rather I tried to identify the relationship between the performer and the mask. This distance became my compass, technical and ethical. It is what I tried to re-create for myself, not the same mask, but the relationship to the mask, even if that meant things would look different.

This is the difference between remembering and actualizing.

Discrimination of the archive

Nicki Polykarpou

On what basis are materials selected to be part of an archive? In the case of the Randolph Street Gallery Archives held at the School of the Art Institute Chicago, my understanding is that in addition to the video recordings of live performances, flyers, posters, and program notes are also included. Whether by accident or not, it was fortuitous that when someone pressed "record" at the start of the performances, some videos captured the welcoming speeches before the shows commenced. These speeches—because they announce upcoming performances and festivals taking place—give another dimension to the archival material and comment on the political, social, and economic time in which the recordings took place. In 9 beginnings: Chicago one of these speeches by Mary Jo Schnell is made use of in its entirety and, in my opinion, marks a pivotal point in the 2014 performance piece. I wonder what could have been used in its place if this speech was not, as I suspect, accidentally captured on the video recording. Leading on from this thought is the idea that what is considered important to be captured as archival material might need to be expanded.

During the Chicago residency, Lin and Matthew said they would like to see Thomas Demand's *Model Studies* exhibition at the Graham Foundation, and I went along with them to see it. For part of this exhibition, Demand made use of the architectural models from the archives of the architect John Lautner. His approach to this archival material is particular—he creates large-scale photographs from Lautner's "weathered over time" models for the exhibition. Demand wrote that he was attracted to the models because "[i]t's the sculptural presence and the traces of someone's practice, of understanding and remodeling, which raised my attention."[2] I can't help wondering that it is unfortunate that this type of source material is absent from what is normally included in a performance archive: that the traces of performance artists' practice isn't usually captured. Instead, performance archives focus on documenting the final production, which although worthy of archiving, shouldn't be the only part of artistic endeavor that is represented.

As a spectator of Demand's photographs, I take a glimpse into Lautner's creative process: his use of inexpensive, everyday cardboard material, his feverish pencil marks, the blobs of glue holding the models together—a myriad of infinite details that I would otherwise not have access to and which allow for a very different perspective—all the while noting that I am seeing this work through Demand's artistic selection of what to include and highlight. My point is that perhaps it would be worth considering how performance artists make work and the "working tools" (to borrow Demand's

term) should be included as part of the archive instead of a wide-reaching and well-established effacement of the artist's creative process in performance archives.

I am the first to be jealous of that moment
Daviel Shy

> People Mary Jo mentions, and the artists in *9 beginnings: Chicago* are still around. They are making videos and uploading them to Vimeo. We watch these shaky tapes, can't fix the tracking, guess through bifurcated bits repetition and study.
>
> Cecilia Dougherty.
>
> Trying to give the same to her current work, to use the eyes as if
>
> this too were rescued from a basement
>
> Will this then become important to someone yes. *Then* means a contingency, also the thing coming next and the time that has passed.
>
> I am the first to be jealous of that moment
>
> when the word lesbian was spoken maybe 9 times in one pre-show announcement, rambling *on and on in a wonderful way*
>
> But I should take note, it is this moment when we will be seen seeing them then
>
> we will be seeing them again.

Epilogue

Pre-show announcement, May 23, 1992
Mary Jo Schnell, Performance Committee, Randolph Street Gallery

– one: in your program notes, we note to please, if you're interested in being informed of upcoming events, sign up for our mailing list and you'll be kept apprised of upcoming events and programing here at Randolph

Street Gallery. There is a mailing list at the front desk where you purchased your ticket. There is also a little, ah [gesture] red sheet of paper. It's about Randolph Street Gallery membership. In order for us to continue to present programs such as the one you're going to see tonight, and hopefully more, we are in need of your support. More and more, as I'm sure you all know, the governmental funding for the arts is still going through some terrible reconfigurations. That's putting it mildly, huh? So in any way if you wish to support Randolph Street Gallery, please do take into consideration becoming a member of Randolph Street. There is a number of different levels at which you can join. All that information is on that little red piece of paper. Also there is a monthly, or bi-monthly calendar at the front desk which will give you information about the rest of the events that we'll be finishing out our season with, which is through June. Then we'll start up again in September. [strokes hair] There are some events taking place this summer, so if you are on the mailing list now, you'll be notified about those.

This weekend is the first weekend of four, for the third annual *In Through the Out Door* series, which I'm very happy has lasted this long and continues to develop. There are, after this weekend, next weekend is video work being done by lesbians, queers, homosexies, however you want to ... *claim* ... those labels. The first night, Friday night, is a piece by Cecelia Dougherty. She's a video artist from San Francisco who has recently completed a piece called *The Coal Miner's Granddaughter.* It's done with a Fisher-Price camera. It's pixel vision, which Sadie Benning, if you've been here the last couple of years, has been presenting her work here as well, and she works very much in that format. It is the first, and I believe the only feature-length video by a lesbian, queer, homosexy, I'm not sure what she chooses, I myself like queer, and we're bringing her out for that. So she'll be here Friday night for the video screening, as well as for discussion afterward. Saturday night there is another program called *Who's Zooming Who— Lesbians on Tape.* There's a number of artists who we've curated. This coming weekend is co-sponsored by Women in the Director's Chair, which is a wonderful establishment here in Chicago, and I hope you give them your support as well. Chicago artists Rose Troche will be screening some of her newer work as well as work in progress, and also there will be Pamela Jennings, a Brooklyn-based artist actually, who will be screening her work ...*the silence that allows....* There will also be an excerpt of a work-in-progress by Mary F. Morten and Natalie Hutchinson of *The Nea Project: Images of African-American Lesbians* screened that night, and that will be also followed by discussion. It will be a very wonderfully informative couple of evenings about what is being done by a variety of women in the United States, and specific also, also in Chicago.

The third weekend of the series is Lisa Kron from New York, who is a solo performance artist. She's one of the Five Lesbian Brothers at Wow Café

in New York. She'll be doing a solo work called *All My Hopes and Dreams*, guaranteed to be a really good program, a really good evening, very happy she could participate in the series. And closing out the series: four performances by Pomo Afro Homos, postmodern African American homosexuals. They'll be doing their piece *Fierce Love*, and, they've been all over the country and are actually at this point in Europe now with this piece, and it's received much critical acclaim, and we're also very happy they could be participating in the series as well. More information on each of those weekends in the calendar. Please help yourself.

Ah, this, getting back to this weekend, and tonight... There's so much work being done in performance art in Chicago. And specifically for this series, gay and lesbian queer bi, and on and on, in a wonderful way, there's much work being done. We did a call for submissions for this weekend, and we had two guest jurors, who looked at the work and programed this weekend's performance artists. Steve Lefreniere, who was one of the main persons behind *Spew—The Homographic Convergence*, which was a part of last year's series. If you were here, you know what I'm talkin' about. If not you really missed something. And Iris Moore, who is, who has performed here in the past, and actually, [looks at flier] she will be performing at Club Lower Link's, splitting the bill with Lawrence Steger, in June, Fridays and Saturdays in June. Please look it up. Her work is really strong, really interesting work. She's with us tonight. Here [To Iris] You probably don't want to hear about it, but... [To audience again] In any case, there's fliers out in the hallway here, please help yourself.

Anita Loomis could not make it tonight. She was originally programed to be here, but because of a last-minute scheduling conflict, really had to be in another place right now. So the artists that will be here tonight for the first half of this evening, will be a work presented, done, a piece by Ken Thompson, *Three Women*; he will be joined by Gino DeGrazia and Ames Hall. The second, Marcia Wilkie in *Dana Dear*, and the third of the first part of this evening, *The Final Product*, which is an excerpt, and this piece is done by Travers Scott, D. Travers Scott. After those three we will take a ten-minute intermission, the bar will be open, and the doors will be open, we'll get some air going through here. So you can get up and stretch your legs, but I'll let you know when that is. So without further ado, welcome, thank you very much for coming tonight, and we'll start the evening, please.

1 Stanley Cavell, *The Claim of Reason* (Oxford and NY: Oxford University Press, 1979), 27.

2 Thomas Demand, *Model Studies* (London and Madrid: Ivory Press, 2011).

ARCHIVE AS SITE

146

Selections from the Randolph Street Gallery Archives

Paige K. Johnston

The Randolph Street Gallery was an influential artist-run space in Chicago from 1979 to 1998. Governed by a participatory, non-hierarchical ethos, the gallery championed challenging performance and installation art that was too young, too new, or too raw for established Chicago institutions at the time. Their exhibitions, performances, and activities demonstrated a deep commitment to artists, widening still over time to incorporate community involvement as it engaged diverse populations of Chicago residents and tackled topics such as homelessness, discrimination, and the AIDS crisis. The Randolph Street Gallery Archives (RSGA) is held by the John M. Flaxman Library Special Collections at the School of the Art Institute of Chicago.

Urban Processes: Circuits and Sediment, 1987

Among the materials artist Dan Peterman submitted to Randolph Street Gallery in preparation for the 1987 exhibition *Urban Processes: Circuits and Sediment* is a diaristic account of how minor environmental disasters shaped his youth. By turns wry, mordant, and darkly funny, these vignettes comprise a personal history of power, ethics, and consequence. He writes:

My family owns some woodland in northern Wisconsin. A small stream runs through it. When I was very young, I was told that it

Photograph from Dan Peterman's *Eau Claire*, 1987, in archival sleeve. Courtesy of the Randolph
Street Gallery Archives, John M. Flaxman Library, School of the Art Institute of Chicago.

was o.k. to piss in the river but not o.k. to drink from it, the reason
being that "you never know what is around the bend upstream."

Peterman's proverbs of ecological irony perfectly capture the tone of his
installation for the exhibition: *Eau Claire* is a functioning machine for dis-
tilling clean water from Diet Dr. Pepper soda. The corruption of good inten-
tions in commodity culture is a sustained theme in *Urban Processes*, curated
by Maureen P. Sherlock, which featured Peterman's work alongside that of
Paul Martin and Amy Yoes. The exhibition explores the shifting semiotic
and capitalist structures that confer value on objects and individuals. In
excerpts from notes Sherlock penned while choosing the exhibition's title,
one can read her influences and patterns of thought. Charting connections
between the spaces, individuals, and refuse that populate our landscape, she
works her way from "catastrophe + garbage theory" to "Civil Residues" to
"Value Village" before arriving at "Urban Processes."

In her curatorial essay for the exhibition, Sherlock highlights the role
that *collecting* plays in the circuits of valuation, calling attention to the
power of the art world to grant (or deny) status to what previously had been
deemed trash or junk. Sherlock sees artists as having the ability to "reveal

that urban processes of decay and transformation belong to the dynamics of wealth and power."[1] In shining a light on this relationship, "they begin to speak with the marginal and dispossessed people in whose neighborhoods they live and work."[2] In this context, Peterman's *Eau Claire* reminds us of the deprivations of the Reagan-era while equally resonating with the post-apocalyptic semantics of the contemporary "food desert."

Your Message Here, 1990

In each frame of this strip of negatives, two billboards are hung, one above the other. "Talk about it," the top one urges, surrounded by photographs of local Chicago teenagers afloat in a cloud of taboo topics ("Condoms," "Crack," "Sexism"). The billboard's sentiment captures the dialogical concern of the 1990 public service project *Your Message Here*, for which ACT UP/Chicago Women's Caucus originally proposed this design. Organized by Randolph Street Gallery in collaboration with the New York artist collective Group Material, *Your Message Here* invited anyone (the general public, artists, advocacy groups, community organizations) to submit a proposal for a non-commercial billboard that would be installed in neighborhoods around Chicago. The exhibition reframed the space of the billboard from one of enterprise and projected desire to one that reflected the concerns and identities of the communities in which they were posted. Randolph Street and Group Material received 200 proposals and selected forty, addressing such topics as drug abuse, AIDS awareness, and homelessness.

The impulse to get people *talking about it* predated this particular submission and was evident in a series of workshops that Randolph Street Gallery and Group Material held at cultural organizations throughout the city in the nine months leading up to the rollout of *Your Message Here*. During these workshops, artists came together with the public to discuss what role billboards played in their communities, how advertising

Negatives from "talk about it," ACT UP/Chicago Women's Caucus (Mary Patten, design and Shelley Schneider-Bello, photography). Part of *Your Message Here*, organized by Group Material and Randolph Street Gallery, Chicago, 1990. Courtesy of the Randolph Street Gallery Archives, John M. Flaxman Library, School of the Art Institute of Chicago.

methods might be used to convey community concerns, and what the guidelines would be used to select the forty final designs. After the initial installation of the billboards, which would each be shown in three different city locations as well as inside Randolph Street Gallery, the artists and the public reconvened for a final workshop on the theme of collaboration and public art.

Encouraging and facilitating community discussions is a worthwhile undertaking insofar as it created a forum for those to speak who may not otherwise feel they can or have a setting in which to do so. Yet it also raises the question: is talking enough? Does public art make room for action? The "talk about it" billboard is a *call* to action, as was *Your Message Here* as a whole, but one which left it to members of the community to take their new-found knowledge out into the streets.

The Whole World is STILL Watching, 1988

What kind of context is a bumper? A space that is perpetually bracing for impact? What is its purpose, its potential? As his contribution to the 1988 Randolph Street Gallery exhibition *The Whole World is STILL Watching*, Tom Kalin produced a bumper sticker titled *1968/1988*. The work summons the tumultuous events of 1968 in order to suggest that 1988 was charged with its own climactic potential surrounding the AIDS crisis.

Originally named *Days of Rage*, *The Whole World is STILL Watching* marked the twentieth anniversary of the violent police crackdown on protesters during the 1968 Democratic National Convention in Chicago. Instead of a straightforward remembrance of the protest, the organizers aimed for a reassessment of the events of August 28, 1968 and the wider climate of that year, seeking to bring them into dialogue with the political and social urgencies of the current day. The work in the exhibition was organized into three categories: "maquettes or proposals for a public memorial or monument to the '68 Convention; new work by artists which makes reference to political or social conditions surrounding the Convention (such as Viet Nam [sic]); and work by artists motivated [by] current political or social concerns."[3] *The Whole World is STILL Watching* was not a solitary endeavor—cultural institutions across the city, from the Chicago Historical Society to the Museum of Broadcast Communications to the Prairie Avenue Gallery were moved to observe this twenty-year marker.

In both the form and content of *1968/1988*, Kalin recognizes the power of distributed presence. The bumper stickers were printed in an edition of two thousand and made available for free at the Gallery and other locations around Chicago, a strategy that gave his work legs (or wheels) to bring its

The Tet Offensive in Vietnam
May '68 riots in France
Andy Warhol's Flesh
The whole world watches the Democratic Convention in Chicago
Martin Luther King is assassinated
Robert F. Kennedy is assassinated
Tommie Smith & John Carlos make a Black Power salute while receiving their medals at the Mexico City Olympics
Queers still invisible; in 1969 drag queens attack police in Stonewall riot— "gay lib" is born

Rubber glove manufacturers increase production by 400%
Helms Ammendment approved, prohibiting educational materials which promote or condone IV drug use and gay
Andy Warhol's estate yields millions in Sotheby's auction
100, 410 with AIDS worldwide
38,000 dead from AIDS in America
Media compares AIDS with Vietnam, stating that more are dead from AIDS than killed in Vietnam. Comparison exclu Vietnamese killed in war.
NYC Health Commissioner Stephen Joseph slashes estimat AIDS cases by 400%—weeks before the creation of a 198
Painting of Harold Washington in bra and panties is arrested—makes international news

Tom Kalin, *1968/1988*, 1988. Courtesy of the Randolph Street Gallery Archives, John M. Flaxman Library, School of the Art Institute of Chicago.

message to unsuspecting audiences. By using the iconic image of athletes Tommie Smith and John Carlos's raised, black gloved-fists, from the 1968 Mexico City Olympics, Kalin highlights the role that media can play in framing and sharing political and social messages, while also reminding us that 1968 was characterized by its own non-violent yet no-less-searing demonstrations of protest and unity (over which violence erupted on the part of the Chicago Police). As for the stickers left over at the close of *The Whole World is STILL Watching*, buried amidst the administrative files of the RSGA for the past quarter century, neither the forward march of history nor the possibility of adhesive disintegration has rendered them impotent—the Strip-Tac plus crack-and-peel backing remains intact waiting for its moment.

1 Maureen P. Sherlock, "Circuits and Sediments." Curatorial statement for the exhibition *Urban Processes: Circuits and Sediment*. Randolph Street Gallery. Chicago, IL. n.d., 5.

2 Ibid.

3 *"The Whole World is STILL Watching* Exhibition Opens at Randolph Street Gallery," Randolph Street Gallery, press release, August 1, 1988.

The Thmei Institute and the Potential of the Autodidact

Cauleen Smith

History is not everything, but it is a starting point. History is a clock that people use to tell their political and cultural time of day. It is a compass they use to find themselves on the map of human geography. It tells them where they are but, more importantly, what they must be.

– John Henrik Clarke[1]

The Thmei Institute was a cadre of some sixty-one Chicago autodidacts, academics, and eccentrics, eleven of whom were women, who gathered to investigate, excavate, and re-appropriate the findings of their research into world histories, cultures, sciences, and occult practices. Their goal was to author an encyclopedic dictionary that redefined the known universe from an Afrocentric perspective.[2] Sun Ra and his business partner, Alton Abraham, were at the center of the operation. In addition to the astounding cache of broadsheets that we can now access thanks to the three *White Walls* publications,[3] hundreds of books recovered by John Corbett and Terri Kapsalis (most of which were so moldy that they could not be absorbed into the archive of Alton Abraham—Sun Ra ephemera housed at the University of Chicago Special Collections). I learned that the Thmei Institute Library existed during one of many Sun Ra geek-out sessions with Corbett. While the Internet community devoted to Sun Ra has long devoured versions of his 1971 University of California Berkeley course reading list,[4] It was too much to hope that some

of the actual volumes from the Thmei Institute, or the El Saturn Research group, as it was also called,[5] would surface some thirty years after Sun Ra left the galaxy of South Side Chicago—but many of them did.[6] Long after Thmei Institute researchers initiated their enterprise, the evidence of their efforts lives on in the title pages and margins of these books, some of which are shared here. For an avid Sun Ra fan and compulsive researcher like myself, this bundle of books might as well be the great papyrus libraries of Timbuktu. In this case though it is not the content of the books that is so revelatory, but rather the way in which it is possible to trace the membership's procedures, interests, and fundamental research questions. The language decoding, the revisionist historical interpretations, and the tracking of primary sources as practiced by Thmei Institute's stalwart members offers much potential in the shaping and archiving of culture.

Endleaves with Sun Ra writings and markings from book in the collection of
John Corbett and Terri Kapsalis. Photo: Cauleen Smith.

On page 299 of the ledger, there is a list of names that appear to record the Thmei Institute member roll. The list is not shown out of respect for their enterprise and their privacy so I describe it to you: on the 299th page of the conspicuously untitled notebook-lined ledger are written in blue and pink (perhaps once black and red) ballpoint pen two columns of names. The first name in the first column written in blue ink is Herman Blount.[7] The second name also in blue ink is A. Abraham. After migrating to the South Side of Chicago, Herman "Sonny" Blount settled into the association of rigorous autodidacts. Eventually the knowledge culled from this project and the community that it provided infused and supported every aspect of Sun Ra's creative practice. The great horn player, Art Hoyle, shared some mem-

ories of his time playing with the Arkestra in Chicago that I feel describe the exponential dividends of the Thmei Institute's social and historical project. He fondly recalls a standing Arkestra gig sponsored by a social club called The Rounders (motto: no squares allowed) on Sunday afternoons at Roberts Show Club on 66th and what is now Martin Luther King Boulevard on Chicago's South Side.

Hoyle describes The Rounders as "a bunch of postmen and factory workers who just liked jazz." The Arkestra played for three or four hours, while The Rounders and their guests danced, drank, ate, and enjoyed the music and each other's company.[8] I indulge in imagining that there was significant overlap between The Rounders and the Thmei Institute membership, thereby facilitating this steady patronage of Sun Ra compositions.

And here we must take a Sun Ra-inspired detour into the parallel history of another majestic autodidact, John Henrik Clarke who pioneered the academy's institutionalization of African Studies as a legitimate department.[9] The son of Georgia sharecroppers, Clarke never graduated from high school or attended college.[10] Yet after settling in Harlem at the age of eighteen, he embarked on a life-long pursuit of excavating the histories of the African continent. He, too, was a member of an autodidact research group, the Harlem History Club.[11] Later in life he went on to publish several books and contribute chapters to many of academic publications. One of Clarke's many accomplishments was the founding of the Department of Black and Puerto Rican Studies at Hunter College of the City University of New York, all of this birthed through the tutelage and support of elder scholars and autodidacts in the African American community and without academic licenses. In this way the venerable Clarke charts an historical orbit around which we can track the Thmei Institute and the social conditions that demanded such clubs.[12]

America in the fifties. When one considers that Brown v. Board of Education rendered Jim Crow unconstitutional in 1954 and that the Voting Rights Act was passed in 1965, one may ascertain the acute inequities present in America's primary institutions during Sun Ra's sojourn in Chicago: a black Chicago worlds apart and economies apart from the rest of the city commonwealth. Academia was (is) in the business of expanding and buttressing the influence and hegemony of Western culture. Many black scholars entered the academy and earned their letters, but few found places to stay. Indeed mid-century America produced the icon of the black mail carrier with advanced degrees as a not uncommon fixture at the neighborhood post office.[13] It is not surprising then, that at the same time that a young and hungry John Henrik Clarke found his way to the Harlem History Club, grassroots scholars, dedicated race-men and race-women, had already built their own institutions and associations.

Regarding the validity and qualifications of autodidactic and collective inquiry, Clarke aptly observed that, "What I have learned is that a whole lot of people with degrees don't know a damn thing, and a lot of people with no degrees are brilliant."[14]

Please consider this astral alignment: John Henrik Clarke was born on June 1, 1915 and returned to the ancestors on July 16, 1998 at the age of eighty-three. Sun Ra (a Gemini) initiated his first of seventy-nine laps around the sun on May 22, 1914 before transitioning back to the cosmos on May 30, 1993. These men escaped from one of the most violently unjust epochs in American history,[15] migrated North to invent themselves, and in so doing reckoned with the urgency of materializing and de-scribing history for a people who had been denied language, origins, human rights, economic autonomy, and one of the fundamentals of citizenship—voting—until the late-middle of their own long lives Clarke began his quest to rewrite the histories of Africa with the Harlem History Club. Sun Ra and Alton Abraham built their cosmology on the spines and notations of primary sources, decoded language, and documents collected by the Thmei Institute whose mission it was to expand material and spiritual understanding of the world and the activity of black thought and culture within it.

When I asked to display these volumes amassed by Corbett and Kapsalis, they asked only that in exchange I document the contents of the crates on loan.[16] The peripatetic inquiries of the Thmei Institute's research were esoteric but focused. It was easy to order the volumes into a handful of categories: Occult and Magic, History, Non-Fiction, Science, Poetry and Fiction, Languages and Reference. Sun Ra's notes can be found in dozens of these books: notes-to-self, logophilic equations, Biblical de-codings, etymological appropriations indicate a rigorous and disciplined inquiry. They point toward the sources that enabled him to develop his cosmological identity, to write *The Innumerable Equations* poems, and to generate some of the most influential music of the late twentieth century. I should not have been surprised to find in those crates a gorgeous volume of the *Masonic Encyclopedia*. After all, this alphabetized laundry list of all things Masonic could well have served as the structural model for the Thmei Institute's own ambition to author an Afrocentric encyclopedic dictionary.[17] And I was stricken, though not at all surprised, by the absence of John Henrik Clark's volumes whose empirical historical texts have forever shifted the foundations of world and American history, but were not published or distributed until the late 1980s, long after the Thmei Institute's membership dissipated. (This is another way in which the careers of Clark and Ra parallel one another.)

These books illuminate the ambitions of the Thmei Institute and represent more than a singular discrete collection. The library exemplifies the

vast tradition of grassroots autodidactic practice in black thought and cultural production; it presents a potent model for extra-institutional critical resistance through historical engagement without which America willfully limps into the future blind in one eye, deaf in one ear, and palsied in all joints. The autodidact fills the void of erasure imposed by the collegial halls of Western thought to make us whole. The urgency and potential of the Thmei Institute's mission is as essential today as it was in 1954. And so it goes:

> Beyond other thoughts and other worlds
> are the things that seem not to be
> And yet are.
> How impossible is the impossible,
> yet the impossible is a thought
> And every thought is real
> An idea, a flash of intuition's fire
> A seed of fire that can bring to be
> The reality of itself.
> Beyond other thoughts and other worlds
> are the potentials...
> That hidden circumstance
> And pretentious chance
> cannot control.

—Sun Ra, *The Potential*, 1972[18]

1 Lumumba Umunna Ubani, *Afrikan Mind Reconnection and Spiritual Re-Awakening*, volume 1. Google Books for Xlibris Corporation.

2 John Corbett, Anthony Elms, and Terri Kapsalis, eds., *Pathways to Unknown Worlds: Sun Ra, El Saturn, and Chicago's Afro-Futurist Underground 1954–1968*, (Chicago: White Walls, 2007), 7.

3 Sun Ra, *The Wisdom of Sun Ra: Sun Ra's Polemical Broadsheets and Streetcorner Leaflets*, eds. John Corbett and Anthony Elms (Chicago: White Walls, 2006). Corbett, Elms, and Kapsalis, eds., *Pathways to Unknown Worlds*. John Corbett, Anthony Elms, and Terri Kapsalis, eds., *Traveling the Spaceways: Sun Ra, The Astro Black and Other Solar Myths* (Chicago: White Walls, 2010).

4 "Sun Ra's Reading List for African-American Studies 198: The Black Man in the Universe," *New Day*, January 30, 2010, http://sisterezili.blogspot.com/2010/01/sun-ras-reading-list-for-african.html.

5 In the University of Chicago Library Special Collections Alton Abraham–Sun Ra Archive one can find stationery letterhead, rubber stamps, and business cards tracking the shifting name of this group of researchers. Sun Ra notoriously changed the name of his Arkestra to suit pressing conceptual and sonic concerns. I propose that he handled the administration of the research group and his record label with similar creative license. Saturn, Saturn Research, El Saturn Research, and Ihnfinity Inc. are all names that I found linked to the historical research project as well as other enterprises.

6 It is rumored that at the Thmei Institute's peak they had amassed more than 15,000 volumes. The cache recovered from Abraham's basement consisted of about 250.

7 Herman Blount was the name Sun Ra brought with him to Chicago from Birmingham, Alabama (The Magic City). It is telling that this is the name on this list as it supports the supposition that the members of the Thmei Institute played an active part in enabling Sun Ra to access the information he needed to describe, define, and name his cosmic identity.

8 The Rounders social club is cited on page 149 of *Space Is The Place: The Lives and Time of Sun Ra* by John Szwed. While it is difficult to cite the source of this information Szwed interviewed Art Hoyle extensively. I believe that Szwed is citing the same anecdote that Hoyle shared with me via telephone on December 9, 2013.

9 Barbara Eleanor Adams, *John Henrik Clarke: Master Teacher* (Brooklyn: A & B Book Distributors Inc., 2000).

10 Phillip F. Rubio, *There's Always Work at the Post Office: African American Postal Workers and the Fight for Jobs, Justice, and Equality* (Chapel Hill, NC: The University of North Carolina Press, 2010).

11 William Leo Hansberry was a member of the Harlem History Club with ties to Chicago. He was the uncle of playwright Lorraine Hansberry, who penned *A Raisin In The Sun*. This play depicted the struggles her family endured in their fight to own a home in the Washington Park neighborhood on Chicago's South Side.

12 It is worth noting that many of these ad hoc historical research and culture clubs aspired to and succeeded in building permanent institutions and collections. The Schomberg Library in Harlem New York, and the DuSable Museum of African American History in Washington Park Chicago jump immediately to mind.

13 Rubio, *There's Always Work at the Post Office*. My father, Clarence Smith, worked as a postal worker for two years after earning his Masters of Social Work from the University of Tennessee in Knoxville. He began using his MSW degree after migrating to California in 1960.

14 Eric Kofi Acree, *John Henrik Clarke: Historian, Scholar, and Teacher*, http://africana.library.cornell.edu/africana/clarke/index.html.

15 For an introduction to the violent histories of early- to mid-twentieth-century America, begin with: Amy Louise Wood, *Lynching and Spectacle: Witnessing Racial Violence in America, 1890–1940* (Chapel Hill, NC: The University of North Carolina Press, 2011).

16 Cauleen Smith, *The Library Book*, a photographic documentation of the contents of the El Saturn Research book collection exhibited at Threewalls, Chicago September 2012. Self-published, available online at Blurb Books.

17 A more likely influence may have been the 1912 edition of Daniel Alexander Payne Murray's

Encyclopedia of the Colored Race, which was co-authored by Arturo Alfonso Schomburg (for whom the 135th Street Harlem Library Branch The Schomburg Center for Research in Black Culture was named.)

18 Adam Abraham, ed., *Sun Ra Collected Works Vol. 1: Immeasurable Equation* (Chandler, AZ: Phaelos Books and Mediawerks, 2005).

Honey Pot Performance, *Price Point* (detail).

APPLIED
KNOWLEDGE

Applied Knowledge

In 1889 Jane Addams opened Hull-House, one of the first social settlement houses in the United States, which served as an educational and community center for immigrant, minority, and poor communities in Chicago. While working to address the city's immigration explosion, she astutely realized that the lack of social services was not the only problem facing her neighbors: people need cultural spaces that are responsive to their lives in order to thrive. The settlement workers started a range of programs, including the Butler Art Gallery, which featured artworks by the settlement residents, a circulating loan collection of art, and the Labor Museum, which highlighted the native crafts and traditions of the immigrant laborers. Addams and the other settlement workers collaborated with the community to produce conditions for solidarity and cross-cultural understanding, which was as much a learning process for the more privileged settlement workers as for the members of the neighborhood. In "A Function of the Social Settlement," Addams describes a school for non-professional and non-commercial ends, where philosophy can be applied to everyday conditions and all people, no matter their social position, to realize the beautiful experience of living their lives in a meaningful way. She writes:

> It is frequently stated that the most pressing problem of modern
> life is that of a reconstruction and a reorganization of the knowl-
> edge we possess; that we are at last struggling to realize in terms
> of life all that has been discovered and absorbed, to make it over
> into health and direct expressions of free living. Dr. John Dewey,
> of the University of Chicago, has written: "Knowledge is no longer

its own justification, the interest in it has at last transferred itself from accumulation and verification to its application to life."[1]

Seventy-eight years later, in 1967, Gwendolyn Brooks, the first female African American poet to win the Nobel Prize in Literature and Poet Laureate of Illinois, offered weekly workshops in her home for the Blackstone Rangers, a neighborhood youth group in the Woodlawn neighborhood, which formed in the 1950s and later became a street gang known as the Almighty Black P Stone Nation.[2] It was around this time that she became radicalized herself after meeting other black writers like Haki Madhubuti, one of her students who, along with Johari Amini and Carolyn Rodgers, went on to found Third World Press, which remains the largest independent black-owned press in the country. After her 1968 volume with Harper and Row, *In the Mecca*, Brooks stopped publishing with mainstream presses and worked only with black houses such as Third World Press. Her poem in this volume, *The Blackstone Rangers*, speaks to her own transition as a writer, utilizing vernacular expression and a free-verse format that echoes the social and political lives of her subjects and evokes a learning process that was mutually educational.

This section focuses on methodology by addressing the many different processes of collaborators learning together—whether through collective skill sharing, alternative pedagogical platforms, intergenerational collaboration, or applied practice—to produce new social forms of knowledge based on people's lived experience. Rather than institutionalized, formal education, the artists and projects here deal with the many different forms in which people learn together and utilize artist spaces, institutions and infrastructures in order to ask public questions about where education occurs. The "How We Learn" lecture series, organized by AREA Chicago in conjunction with *Pedagogical Factory: Exploring Strategies for an Educated City*, an exhibition by the Stockyard Institute staged in a temporary public laboratory at the Hyde Park Art Center in 2007 brought a community of artists, adult learners, and community activists, both local and non-local, into conversations around the intersection of art and education. John Ploof worked with an artist community with developmental challenges at Little City, addressing notions of power, authorship, and collaboration, and frankly discusses these challenges of "speaking for and speaking with" in the pages of the artist journal *White Walls*, edited at the time by artist and activist Mary Patten.

The community-based and collaborative performance projects of Honey Pot Performance draw upon spiritual and ancestral histories, popular forms of art, and academic scholarship to consider the value of creativity and creative labor in the present moment. The informal network of peo-

ple at Mess Hall, described by Mike Wolf, had a practice of critically think-
ing and making together as a form of alternative education in and of itself.
This also shares similarities to the strategies devised by 3rd Language to cre-
ate contexts for emerging queer artists of color. Finally in his essay, Lane
Relyea challenges such hopeful thoughts, reminding us that art schools and
the proliferation of the MFA have become de facto legitimizing institutions
for today's contemporary artists, displacing museums and galleries, and cre-
ating the professional networks that students use throughout their careers.
Thus, school becomes the staging ground for the formation of social groups,
alliances, and dialogues that shape their ongoing practice. He calls for sol-
idarity among such artists to realize within these networks a potential for
a politics that addresses the profession's larger social relevancy, asking "Is
it possible that the category of art can itself be made to resonate politically,
even conjure its own utopian social vision?"

—AS

1 Jane Addams, "On the Function of the Social Settlement," *Pragmatism: A Reader*, ed. Louis
Menand (New York: Vintage Press, 1997), 276.

2 For more on this series of workshops, see Haki Madhubuti, "The Roads Taken,"
http://www.poetryfoundation.org/poetrymagazine/article/181739. For more on the Blackstone
Rangers, see Natalie Moore and Lance Williams, *The Almighty Black P Stone Nation: The Rise,
Fall and Resurgence of an American Gang* (Chicago: Chicago Review Press, 2011).

The Blackstone Rangers

Gwendolyn Brooks

I
AS SEEN BY DISCIPLINES

There they are.
Thirty at the corner.
Black, raw, ready.
Sores in the city
that do not want to heal.

II
THE LEADERS

Jeff. Gene. Geronimo. And Bop.
They cancel, cure and curry.
Hardly the dupes of the downtown thing
the cold bonbon,
the rhinestone thing. And hardly
in a hurry.
Hardly Belafonte, King,
Black Jesus, Stokely, Malcolm X or Rap.
Bungled trophies.
Their country is a Nation on no map.

Jeff, Gene, Geronimo and Bop
in the passionate noon,
in bewitching night
are the detailed men, the copious men.
They curry, cure,
they cancel, cancelled images whose Concerts
are not divine, vivacious; the different tins
are intense last entries; pagan argument;
translations of the night.

The Blackstone bitter bureaus
(bureaucracy is footloose) edit, fuse
unfashionable damnations and descent;
and exulting, monstrous hand on monstrous hand,
construct, strangely, a monstrous pearl or grace.

III
GANG GIRLS

A Rangerette

Gang Girls are sweet exotics.
Mary Ann
uses the nutrients of her orient,
but sometimes sighs for Cities of blue and jewel
beyond her Ranger rim of Cottage Grove.
(Bowery Boys, Disciples, Whip-Birds will
dissolve no margins, stop no savory sanctities.)

Mary is
a rose in a whiskey glass.

Mary's
Februaries shudder and are gone. Aprils
fret frankly, lilac hurries on.
Summer is a hard irregular ridge.
October looks away.
And that's the Year!
 Save for her bugle-love.
Save for the bleat of not-obese devotion.
Save for Somebody Terribly Dying, under

the philanthropy of robins. Save for her Ranger
bringing
an amount of rainbow in a string-drawn bag.
"Where did you get the diamond?" Do not ask:
but swallow, straight, the spirals of his flask
and assist him at your zipper; pet his lips
and help him clutch you.

Love's another departure.
Will there be any arrivals, confirmations?
Will there be gleaning?

Mary, the Shakedancer's child
from the rooming-flat, pants carefully, peers at
her laboring lover
 Mary! Mary Ann!
Settle for sandwiches! settle for stocking caps!
for sudden blood, aborted carnival,
the props and niceties of non-loneliness—
the rhymes of Leaning.

This poem was originally published in *Blacks* (Chicago: Third World Press, 1987). Reprinted by consent of Brooks Permissions.

JULY

Sunday 7.22—Opening Event!
How We Make a Pedagogical Factory
Come check out the Pedagogical Factory exhibit featuring works and proposals by Josh MacPhee, Dave Pabellon and Daniel Tucker / AREA Chicago, Center for Urban Pedagogy (Brooklyn), Counter Cartography Collective (Chapel Hill), temporary Services, Neighborhood Writing Alliance, Renee Drug (NYC), Angela Tillges / Redmoon Theater, Anne Elizabeth Moore, Stockyard Institute, Jess Seay / Experimental Sound Studio, Think Tank (Philadelphia), Shaping San Francisco, Watie White and more.

Wednesday 7.25 How We Remember
w/ Chicago Underground Library (CUL) and other local archivists

CUL is a location-specific library of independent works from the area. Including anything and everything, regardless of perceived quality or importance, the collection uses the local context to bridge gaps between content, format, and commercial viability while encouraging cross-pollination in collaboration and research. CUL coordinator Neil Taylor presents items from the collection to illustrate the reasoning behind the CUL's atypical, highly detailed (and unscientifically approved) approach to indexing a community's creativity and the impact that access to unfiltered data can have on how we remember.
http://www.underground-library.org | info@underground-library.org

Come Discuss Libraries!
You Know Who You Are, You—The Organised Person!

Saturday 7.28
How We Learn: Buildin
w/ Mess Hall, Platypus, Fe
Railroad Efforts, Bronzevi
Center, African Diaspora,

You are invited to join a discussi
tional initiatives committed to te
tions and projects operate outs
fessional skill development. We
the city and encourage new par
Additionally, by showcasing inn
sense what possibilities are curr
traditional educational settings
efforts and our city. This public
Humanities Council

Adults Need Quali
Critical Education

AUGUST

Wednesday 8.1 How We Remember: Oral Historians
w/ Stephen Haymes and other oral historians

Stephen Haymes is the author of the book Race, Culture and the City: Pedagogy for Black Urban Struggle, published by State University of New York Press. Imaged: his book Outstanding Book on the Subject of Human Rights in North America. He is currently working on a new book that will be published by Romeo and Littlefield Publishers, titled Pedagogy of Our Ancestors: The Existential Wisdom of African-American Slave Culture.

Saturday 8.4 How We Move Workshop
w/ Meredith Haggerty and Lovie Raven

How We Move will be a workshop in movement and how it relates to social movements. The workshop leaders have been brought together by the University of Hip Hop, which has been doing movement education in the city for over 15 years. Contact haggerty@uichicago.edu for more information.

Saturday 8.4 How We Make a Pedagogical Sketchbook
w/ Stockyard Institute

The Pedagogical Sketchbook began as an obsessive compilation of ideas and lessons, that stood in stark contrast to the typical offerings most adolescents were exposed to in their school art space. The project which now includes an audio curriculum is growing as artists, thinkers, map makers, socialites, ex students, construction workers, priests, addicts and ideologues (to name only few) have joined in making contributions to what will be presented as a new high school art textbook. The project will be published on demand and developed as an online resource. One copy of the project will be sent to every high school art department in Illinois. factoryo7@gmail.com

Jim Duignan is an artist, educator and activist and drives the collaborative artist project Stockyard Institute (http://www.stockyardinstitute.org). Duignan directs Visual Arts Education at DePaul University in Chicago and works as an advisor to AREA Chicago: Art, Research, Education & Activism

Wednesday 8.8
How We {and also I} Make and Tell Stories About What We Do
w/ Andrew Gryf Patterson (Artist in Residence)

From Andrew Paterson: "My artist-organiser practice involves working in variable roles of initiator, participant, author and curator, according to different collaborative and cross-disciplinary processes. Recently, these roles have operated inbetween the fields of media or environmental activism, participatory and socially-engaged arts; where I like to engage with a devised workshop, situation, or performative event.

"This residency period will be dedicated to exploring, refining and abstracting how other people—individuals and collectives—in the Pedagogical Factory process, make and tell stories about their projects and processes. I will explore how the 'special embassy' and 'bare-bones' storymaking/telling can help." http://agryfp.info

Calling All Storytellers!
Find out what Andrew has been doing and where he is going

Saturday 8.11
How We Peoples Make a People's Atlas of Chicago
w/ Daniel Tucker & Dave Pabellon aka The Speculators

How can we use maps to remember? What do we want to remember? Notes for a People's Atlas presents maps of the blank outline of the political border of the city. For this event we will get together and look at a map archive that was created on a recent trip to Zagreb, Croatia by AREA Chicago editors Daniel Tucker and Dave Pabellon. The other map archive is AREA's ongoing collection of Chicago maps by local artists, educators, students and activists. Please come and add your map to the archive! Because maps are never finished and only tell part of a story. Because they are visual tools for sharing with others. Because they can be produced by many people and combined together to tell stories about complex relationships. Because power exists in space, struggle exists in space, and we exist in space. Because we cannot see know where we are going if we don't know where we are from.

Calling all mapmakers & radical historians
informal researchers and citizens with good memory

Saturday 8.11 How We Make a Pedagogical Sketchbook
w/ Stockyard Institute (see August 4 description)

Wednesday 8.15 How
Self-Education and U
w/ Baltimore visiting or a
Done Nester and Nichol

From the artists: "We will pre
are working on in Baltimore
many issues: from self-educ
based urban planning,

Saturday 8.w
w/ Lou Malloz

How We Listen w
Christina Kubisch
the world—and pe
audio networks

Experimenta
the production ar
ESS is to make an
creative process.
Trained as a comp
tion to realize her
her work with sou
as the "synthesis
the visual arts an
form on the often
general administr
several artists an
time, he establish
responsible for co
co-produced perf
visiting artist pro
Soundscape Proj

Saturday 9.8 How We Build
Come discuss the state of architecture/design education. Where has it been it going? We often discuss the ways in which the built physical environment but how does it get built in the first place? What is the relationship between education and the built environment? How does what gets taught to children professionals impact the designed world? And how can we rethink it? To get the discussion contact Charles Vinz charles.vinz@gmail.com or just show up

SEPTEMBER

Saturday 9.1 @ Experimental Station
How We Brew/Bake/Mead Etc Cottage Expo

Today we will explore the world of do-it-yourself food production with Material Exchange and Monk Parakeet Group at Experimental Station. There will be a several hour-long workshops on making your own beer and on baking bread. Space is limited (24 spaces total. 8 in each workshop) so PLEASE (you must) reserve a place by contacting info@material-exchange.org

Saturday 9.1 How We Think
A Walking Tour in Honor of John Dewey

The philosopher John Dewey (1859–1952) fought for "civil and academic freedom, founded the Progressive School movement." A resident of Chicago's Hyde Park neighborhood, Dewey published one of his most important works of educational theory, How We Think, in 1910. The study deals primarily with the concept of thought training, and its place in school environments. Today we will have a walking presentation and discussion about Dewey's impact on the field of education and visit some important sites in the neighborhood where he lived and worked. Contact factoryo7@gmail.com if you know a lot about Dewey and would like to help lead the tour.

Wednesday 9.5 How We Celebrate People's History
w/ Josh MacPhee of JustSeeds

The Celebrate People's History poster series is an on-going project producing posters that focus around important moments in "people's history". These are events, groups, and individuals that we should celebrate because of their importance in the struggle for social justice and freedom, but are instead buried or erased by dominant history. Posters celebrate important acts of resistance, those who fought tirelessly for justice and truth, and the days on which we can claim victories for the forces of freedom. These posters are posted publicly (i.e. wheatpasted on the street, put up in peoples' homes and store-front windows, and used in classrooms) in an attempt to help generate a discussion about our radical past, a discussion that is vital in preparing us to create a radical future. The project has also built a loose network of artists interested in creating radical public art as well as showcased the work of lesser known artists that want to create culture that is functional, carries a social message, and doesn't get buried at the bottom of the heap of the mainstream art world.

Josh MacPhee is an artist, curator and activist currently living in Troy, NY. His work often revolves around themes of radical politics, privatization and public space. His second book Realizing the Impossible, (AK Press, co-edited with Erik Reuland) was just published. He also organizes the Celebrate People's History poster series and is part of the political art collective Justseeds.org. (http://www.justseeds.org/artists/celebrate_peoples_history/)

Come Hear About One Amazing Effort To Make
Hidden and Radical History Public! It Is A Street Curriculum!

Wednesday 9.5 How We Make a Pedagogical Sketchbook
w/ Stockyard Institute (see August 4 description)

Wednesday 9.12 How We Listen
w/ Vocalo Producers

How We Listen will be a discussion with produ
which aims make "community-created media"
go.com-watt broadcast. The project, by Chica
ing this summer online as www.vocalo.org and
Vocalo will be on the air in Chicago and and w
hear what their plans are and get local media
discuss ideas and proposals for content on ra
world of radio because it offers greater potent
that will be aired on the radio. The station will
experimental radio, listeners will have potentially g
We are excited to welcome Vocalo onto the loca
presence is a promising addition. Come check it

Saturday 9.15
How We Make a "Disorien"
w/ Local University Activists

In recent years many students and p
towards the university itself. They ha
tique that is generally encouraged ar
into a more inward practice that take
university system. What role and res
they inhabit in the knowledge econo
they produce research, and the conte
with students from several local univ
of Chicago, to talk about one of the ta
displays such self-critical research a
"Disorientation Guide" to UNC-Chap
discuss the possibilities of creating
Get in touch with factoryo7@gmail

STOCKYARD INSTITUTE Hyde Park ARTCENTER AREA Chicago

The Stockyard Institute is a Chicago-based artist project led by Jim Duignan. Focusing on the intersection between education, art, activism, and the media, the Stockyard Institute collaborates with artists, writers, and various cultural workers to develop projects with youth and community residents, such as Designing a Gang-Proof Suit (2006), a design and sculpture project with youth of the Back of the Yards community of Southside Chicago, LOCO COOL Radio Project (2007) an experimental audio project developed and broadcast with youth, and the Austin Community History Book (2004). Projects have been exhibited and published in the US and internationally. Jim Duignan received an MFA from the University of Illinois at Chicago. He is currently a professor of Visual Arts Education at DePaul University.

www.stockyardinstitute.org

The Hyde Park Art Center is a not-for-profit organization that presents innovative exhibitions, primarily work by Chicago-area artists, and educational programs in the visual arts for children and adults of diverse backgrounds. The Center is funded in part by the Alphawood Foundation; The Chicago Community Trust, a City Arts III grant from the City of Chicago's Department of Cultural Affairs and the Illinois Arts Council; The Gaylord and Dorothy Donnelley Foundation; The Field Foundation of Illinois; Lloyd A. Fry Foundation; The Leo S. Guthman Fund; The Illinois Arts Council, a state agency; The Joyce Foundation; The Mayer & Morris Kaplan Family Foundation; The MacArthur Foundation; The MacArthur Fund for Arts and Culture at Prince; The Orbit Fund; The Polk Bros. Foundation; Polk Bros. Foundation; The Clinton Family Fund; South East Chicago Commission; The Wallace Foundation; and The Andy Warhol Foundation for the Visual Arts; and the generosity of its members and friends.

5020 S. Cornell Avenue, Chicago IL 60615
(773) 324-5520 | www.hydeparkart.org

AREA Chicago Art/Research/Education/Activism is a publication dedicated to researching, supporting and networking local social, political and cultural movements. AREA's magazine issues are organized around themes and focused on dynamic fields of practice that are making Chicago (and the world) a more livable place. Addressing complex topics through the lens of local grassroots work, AREA Chicago has explored privatization and welfare cuts, local food systems, the history of social movements and the concept of solidarity, and the impact of the criminal justice system on Chicago communities. AREA is developing an issue of around informal/formal education as a companion to the Pedagogical Factory, issue #5—"How We Learn"—is due out in Summer/Fall 2007. We also make maps ("The People's Atlas of Chicago") hold events ("The Infrastructure Lecture Series") and send email newsletters ("Another Chicago Newsletter"). See our website for past issues and opportunities to get involved

PO Box 476971 Chicago IL
areachicago@gmail.com | www.areachicago.org

Saturday 8.18 **How We Sound** Audio Workshop
w/ Jesse Seay

Favorite Chicago Sounds (2006–2007) is a collaborative web-based project designed to showcase unique audio portraits of Chicago and mirror what Chicagoans think about their city's soundscape. Favorite Chicago Sounds (FCS) will explore the Hyde Park community as a site for audio research and will identify sites for recording and expanding the scope of this ongoing project. The FCS web site invites visitors to answer a short questionnaire about their favorite sounds of the city. Once they've submitted a response, visitors gain access to the general catalog of submissions. Recordists then record selected sounds from the catalog, which are posted online in MP3 format and downloadable for free.
FCS is a project of Experimental Sound Studio and operates in partnership with Chicago Public Radio (WBEZ), who auditions FCS-collected sounds for broadcast as part of their ongoing Sonic Soundscapes project.

Wednesday 8.22 **How We Use Abandoned Urban Space**
Screening of Not Anymore | Not Yet,
a film by Daniel Kunle and Holger Lauinger (Berlin)

Not Anymore | Not Yet reflects on the possibilities of abandoned city spaces. The film presents a new generation of cultural interventions in abandoned spaces: unconventional players, projects, and visions dealing with the reactivation of "urbanness" in very different sites. What could abandoned spaces communicate to the city dweller?
Daniel Kunle studied experimental film at the Academy of Fine Arts in Berlin, where he lives and works as a film director, cinematographer, and editor. Holger Lauinger works as an independent journalist in the field of urban and regional planning.

How Do We Listen To The City?

Saturday 8.25 **How We Teach**
w/ Various Artists, Activists and Educators

An experimental forum about the act of teaching. Get in touch with factoryo9@gmail.com to get involved. (More details TBA.)

Saturday 8.25 **How We Make Educational Posters**
w/ Watie White

Through the eyes of portraiture (which finds part of its educational background in the work of northwestern psychologist Dan McAdams) work that graphs personal life narratives), Watie White represents a more reasonable plan for exploring narratives as strategies for confronting realities. White's work exhibits a larger vision than indexing learned spaces and has enabled a pedagogical pursuit through his work that attracts some needed attention to the city. Attention that should be drawn by teachers, youth and artists to see how work can direct activity for change and illuminate better questions of where we are going, what determines a city and what kind of space do we occupy.

Wednesday 8.29 **How We Felt**
w/ Feel Tank Chicago

Come Discuss This Summer's Most Interesting and Ambitious Project About Political Depression

In the Fifth Annual International Parade of the Politically Depressed, Feel Tank Chicago and collaborators felt the feel and walked the walk—and seethed the seethe, and balked the balk. Now we sigh the sigh. Members of Feel Tank (and vice versa) in a report back from this summer's Pathogeographics exhibition. We'll raise issues of collaboration, funding, intensity, opacity, and publics. What does it mean to take and make the temperature of the Body Politic? What do we know and feel that we didn't before we started? Join in and share your feelings, experiences, critiques, and new directions. http://www.feeltankchicago.net/

Saturday 9.15 **How We Engage**
w/ Anne Elizabeth Moore

How do we voice dissent in an age when we know few listen? On what topics do we feel comfortable or expert enough to raise our voices? Are there ways to work collectively without sacrificing autonomy? In what media do we speak, and to what audience do we reach out? For 22 years, Anne Elizabeth Moore has been exploring these questions through the combination of printing, writing, and radical modes of distribution. These have included zine-making, flyering, newspaper appropriation, questionnaires, and participatory street comics, to name just a few. Come explore the different ways you might actively engage in dissent, even if you are kind of shy, don't think you know how to spell, or don't have anything to say right now: it's always good to practice for later!
Anne Elizabeth Moore lives in Chicago, where her work has been collected by art museums, gotten her permanently banned from a retail shopping establishment, and been called "Fun" by the business magazine FASTCOMPANY. She is unsure how she feels about any of this.

Saturday 9.22 **How we use AREA Chicago** as a pedagogical experiment and also move towards an independent political and cultural education network in Chicago

In this final event of the series we will reflect on the work and conversations of the Pedagogical Factory Exhibit and the programs of the How We Learn Series. We will look towards the upcoming "How We Learn" Issue [#5] of AREA Chicago and make plans for using the project in new and different ways as a freely distributed curriculum about critical culture in Chicago. Come and participate in the discussion and perhaps we will all build a school together. Topics to be discussed might include: Militant research, public curricula, the limits of popular education, the drawbacks of critical pedagogy; and the school versus the street, the street versus the art gallery, the page versus the screen, and why binary relationships have gotten us down. A short presentation about the past/present/future of AREA Chicago will be followed by group discussion and brainstorming. Please come with the best old ideas or the new fresh ideas.

Wednesday 9.19 **How We Fund**
w/ Kristen Cox of Fire This Time Fund

In recent years there has been increased scrutiny and critique of the funding structures within which cultural and political work in this country are produced. This gathering will look at some alternatives to foundation funding and the conventional non-profit organization model and highlight some of the work that is going on locally to get money and resources into the hands of groups and initiatives that are doing vital and important work in the city. The event will be organized by Kristen Cox of the Fire This Time Fund (a two-year-old giving circle that gives money to radical cultural initiatives in Chicago). Other invited presenters will share their own experiences with experimental funding efforts with the hope that the conversation will help identify new directions, strategy and possible alliances to make our work more meaningful, grounded and sustainable. Email kristengcox@gmail.com to get involved.

Other Events: Time/Place TBA
Contact areachicago@gmail.com for more information

How We Coordinate, pt.2 with local publications who will coordinate to produce a "Right to the City" issue of each of their publications

How We More Effectively Network Local Critical Culture

How We Make Sense of Ren2010 and the Privatization of Chicago Schools

Previous "How We..." Events leading up to this series included:

How We Schedule @ A+D Gallery / Columbia College Chicago,
part of the Pass It On: DIY art show.
w/ Gapersblock.com, New World Resource Center, Optionalevents, and InCubate Chicago.

How We Coordinate, pt.1 @ Version Fest
w/ Contra Tiempo, Journal of Ordinary Thought, Lumpen, Skeleton News, and others.

"How We Learn" lecture series poster. Program organized by AREA Chicago in conjunction with Stockyard Institute for the exhibition *Pedagogical Factory: Exploring Strategies for an Educated City* at the Hyde Park Art Center, 2007. Courtesy of AREA Chicago and Stockyard Institute.

Artist-in-Residence at Little City

John Ploof and Mary Patten

Introduction

John Ploof's contribution below originally appeared in "Local Options," Number 36 of *White Walls: a Journal of Language and Art.* It was part of "We're Nice Guys But We Mean Business,"[1] a cluster of images, texts, and documents from a collaboration between adult artists at Little City Foundation in Palatine, Illinois, and a group of artist-teachers including Ploof, Terry Amidei, Laurie Palmer, Michael Piazza, and James Keegan-Sommers.

One of a handful of art journals published in Chicago, *White Walls* was an experimental venue in book form. Projects were a collaborative effort between artist/contributors, the editors, and designers. Artists' pages, conceptual works, photo-text pieces, drawings, anagrams, digital experiments, adaptations of performances and of moving-image works, documentation of site-specific projects, and original essays and criticism were all possible formats. *White Walls* sought to provide opportunities for local artists to present their work side-by-side with an interesting mix of artists from across the country and internationally.

In late 1994, Joyce Fernandes and Joyce Bollinger approached *White Walls,* while I was an editor of the publication, with a proposal to document *Chicago Portraits,* a mobile collaboration and traveling exhibition organized by residents and activists from several of the city's African American, Polish, Chinese, Mexican, and Native American communities. This prompted us to consider devoting an issue to collaborative projects between artists and

communities not adequately documented or recognized by a wider audience. For "Local Options," *White Walls* was particularly attentive to projects that offered new models of interaction, frankly addressing troubling issues around authorship and authority, power relationships, reciprocity and voice. The Little City Projects, and works facilitated by Michael Piazza with young people from the Cook County Juvenile Detention Center, constituted the heart of the issue. Images and texts, multiple voices, and diary fragments emphasizing process were interspersed with thoughtful and self-critical commentary.

In the 1990s, Little City operated the only media arts center for people with developmental challenges in the US, producing a fantastic cable-access show called *Kiss My TV*. By 1994, programming expanded to include a fine arts residency, matching twenty-four artist-participants with visiting artist-teachers who worked together, one-on-one, for four months. People with developmental challenges constitute what Terry Amidei called an "invisible culture."[2] In "Local Options," Amidei outlined the broad range of life conditions experienced by people at Little City: some had physical challenges, others emotional precariousness; some were verbal, some not. Individuals manifested myriad kinds of awareness, perception, and ways of communicating. Some disabilities were created or intensified by institutionalization itself. Amidei argued the necessity of recognizing people with disabilities as part of all of us, while constituting "a culture unto themselves." This balance between autonomy and participation characterized the collaborative art projects. Diverse in form, content, and method, all embodied a messy, self-reflexive, idiosyncratic process.

For Ploof, relationships began by sharing stories, slides, and videos, all the while paying attention to a pattern, proclivity, habit, tendency, or desire. Ploof noticed the pleasure Mike Hill derived from pulling rope and string, prompting their work together on a performance video installation. Ploof's collaborations with Little City resident Chick Loehr led to turning phrases and proclamations into public signs. He worked with Barbara Gruskovac to create video monologues and with Charles Beinhoff to make a series of self-portrait/map drawings. None of these projects were impairment-fixated. The focus was on flourishing.

The residency program generated drawings, videos, installations, objects, and events, culminating with an exhibition, *Great Doings!* at the Renaissance Society in August 1994. *Great Doings!* created visibility for the artists and awareness for the broader community. More profoundly, the entire process spawned unprecedented connectivity among artists hailing from distinct worlds, but not without engaging the hard questions. Amidei cautioned that "with people who have exercised fewer choices in their lives,

the role of artist/teacher/facilitator becomes problematic." Thus, exchanges navigated the gray margins between facilitation and control, speaking *for* and speaking *with*. The willingness of participating artists to articulate dilemmas inherent to any artist /community collaboration is what distinguishes this extraordinary work.

—Mary Patten

I work downtown at the School of the Art Institute of Chicago (SAIC), and in the suburbs at the Little City Foundation. Over the past year I have been a conduit for the exchange of information, by way of stories, slides, and videotapes between artists at these institutions. Information from each location has been greeted by the other with varying degrees of intrigue, veneration, suspicion, and sometimes dismissal—but usually with the underlying realization that there is value in sharing something with each other.

How can one offer choice? In both contexts, power relationships are inherently unequal. However, through finding ways to communicate opinions and ideas, coupled with enlightened listening, a discourse may develop that is social, equal, and satisfying. Working relationships in both places require a mutual understanding of what we hope to accomplish by working together. At Little City, roles are less easily defined than at SAIC. Language is not a given and basic communication requires alignment from person to person. How does a lifetime of limited choice affect one's ability to choose? How do issues of collaboration differ from those of facilitation? How is process and the relationship between artists visible in the work?

How can people with challenges enter, control, and direct a sociopolitical discourse of representational production? People with challenges are most frequently represented, in high-visibility venues, through advertising produced by disability charities, and by humanist-genre photographers. Most representation has been impairment-fixated—focusing on a disability rather than on an entire person. Impairment-fixated imagery operates, sometimes paradoxically, in creating a site for the construction and reinforcement of oppression/control/victim status. What makes our culture and our society uncomfortable acknowledging and accepting people with challenges, particularly when their voices are replete with sexuality, humor, anger, and demands for an active place in society? During this project, we have attempted to open up a discourse, expanding possibilities for self-image-making and broadening representation. People with developmental challenges are refusing victim status. Their voices present subversive, political threats at every point where representation has resulted in control and subjugation. How can these

threats be converted into power and analysis, into further intervention in image discourse, into a more democratic development of a social body?

How can these questions be developed, with fluency and critical analysis, into strategies for change? This process has been filled with questions, deep-seated in issues that do not begin or end here. Artists have the ability to imagine and project the future, not only through images, but also through actions and relationships. In this ability there is promise for developing more equal, lateral relationships within our society. Someday I hope a larger portion of the studio program at Little City will be run by people with challenges. I hope there is still room for many different kinds of artists to draw on their backgrounds, their skills, and on their capacities for collaboration and interaction in making art with other human beings.

Chick Loehr, portable signboard, 1994.
Courtesy of John Ploof. Signs: Teamer's Signs.

4/15 Chick was clearly not interested in traditional art practices. He was somewhat interested in painting. Not "art painting," but painting the walls (maybe we can do this). Today he painted four pieces of paper, completely covering each page with a solid color. Combined, they begin to cover the wall.

5/13 Chick kept saying, "I run this whole place." I asked if he had a story to tell and he came out with a flood of phrases, "We want people to know who we are and what we are. We are the bosses. We are the heads of everything." We talked about ways to send public and private messages—letters, posters, flyers, billboards etc. Chick wants to make some posters that say Mr. Loehr, President of Little City; Chairman of the Board; and Jack and Chick, bosses." How big should the posters be? "Pretty big, but not too big." He wants the posters to have photographs and official-looking type. I'll bring in several samples of type so we can start to lay out the messages.

7/29 Chick was irate. He had angry messages about his home, institutions, and possibilities for change. Some are poignant, articulate pleas, demanding a place for people with challenges in mainstream community jobs, some are mad at the world. "Change before it's too late. I will go to the senators and the senators will go to the governor of the state, James G. Edgar, and things will be changed right away. Better freedom. More actions. Better friends to be with—not like Little City shit-house."

8/7 I spent a long session with Chick today at his house. He says that the more inflammatory messages are better shared between us. We discussed scale and methods of putting the posters out in the world. Today Chick said the letters could be bolder. I can't make them any bolder on my computer. How about a sign painter? Yes. He is completely invested in making the posters (but just as he doesn't like to get involved painting pictures, he doesn't want to mess around making the signs). We decided to look for a professional sign painter pronto.

This is an excerpt from the text originally published in *White Walls*, 36 (1995), with a new introduction by Mary Patten. Reprinted courtesy of John Ploof, Frank Tumino, and Anthony Elms.

1 The title of the collective image-text piece was a quote by Little City artist Chick Loehr.

2 Amidei (1951–1996) was video artist-in-residence at Little City's Media Arts Center, and director of the Art Residency Program.

To Art and Profit

Honey Pot Performance
Interviewed by Danny Orendorff

Danny Orendorff: *Honey Pot Performance has foregrounded the lessons and theories of Afro-diasporic feminism through multi-arts performance works. As a performance, activist, and research collective in Chicago you began under the identity ThickRoutes Performance Collage in 2001 and then evolved by 2011 into a collaborative in which each member contributes academic and street-level expertise from different fields: Felicia Holman in health and wellness, Aisha Jean-Baptiste from social work/services, Abra M. Johnson from sociology, and Meida Teresa McNeal from performance studies.[1] You seem to find hope and inspiration within informal networks of reciprocity and exchange, as well as through dedicated, sometimes spiritual relationships to art, music, and the survivalist strategies of ancestors. I also find it striking how you use personal or cultural phenomena in your work to highlight widespread feelings of exhaustion, escalating cases of panic disorders, demographic disparities in terms of unemployment and incarceration rates, all of which are byproducts of a failing economic system. Could you speak to how your personal and professional backgrounds come into play in your collaborative work?*

Meida Teresa McNeal: Performance studies as a framework and training in ethnography have allowed me to sort of dance between the micro and the macro. The question that circulates throughout all the work is: what is the macro-frame that any micro-story sits within, and how can performance be this really incredible vehicle for knowledge? There's a meta thing that's about honoring that "this shit is valuable" and saying so in that way

in order to connect with people or tap into something that isn't exclusively academic. It can be intellectual, but it is also very emotional.

Abra M. Johnson: I teach sociology, so I take on the really fun task of reading about structural issues every single day, and then I have to present that research to students that get thoroughly depressed. But the part I like is when we get to my last module, which is always about social movements. We start with the social construction of identity as a byproduct of these larger economic forces, and then we discuss individuals who are always talking back and resisting. I teach how throughout the seven periods of violence within US history, there has not been one single policy alteration without violence, without protest, without mass protest.[2] So I teach how we have to cyclically keep rejecting, so that research part of what I contribute to Honey Pot Performance is something I'm doing every day.

I believe in sociology as a ministry, similar to how Meida feels about performance studies. It speaks to my deepest sentiments about what's happening and, to me, it's the most beautiful language for explaining that everything that's happening in your world is not just yours. Instead there's a part of you that belongs to society, there's a part of you that you never had a voice in designing but that at some point you do get a voice. So to be mindful of the way that voices can actually alter structures, but only in their collectivity, is important to convey. Sociology helps mitigate that individual fear—"Am I crazy?"—because it offers so many actual examples of "No, you are not crazy; in fact this is what is happening, and we can prove it."

Aisha Jean-Baptiste: For me, before I was a therapist and a health educator, I had a background in community organizing and activism. Using that within performance is really critical in order for me to feel like I am still contributing to what is ultimately the fight for liberation. Being on stage and talking about these crucial issues allows me to educate others. Even in my practice now as a clinician, serving people who find catharsis in sitting with me and sharing their narratives, I realize how similar it is to being on stage. I am doing the same thing.

Felicia Holman: I pretty much came to the realization after years of doing the corporate, nine-to-five, get-a-salary, get-benefits kind of thing that I had always actually been passionate about some other creative endeavor, and that in being a part of the corporate world my soul was dying. That was when, while in cubicle land, I caught the lifeline of fitness and made the transition into that industry as a personal trainer and group exercise instructor. So when I got with these ladies, first as ThickRoutes and then as Honey Pot Performance, I realized how the writing, public speaking, and movement exercises we were engaged in really fed into the work I was doing in health and wellness to guide people beyond just physical instruction.

I mean, all of us being African American women and having had expe-

APPLIED KNOWLEDGE

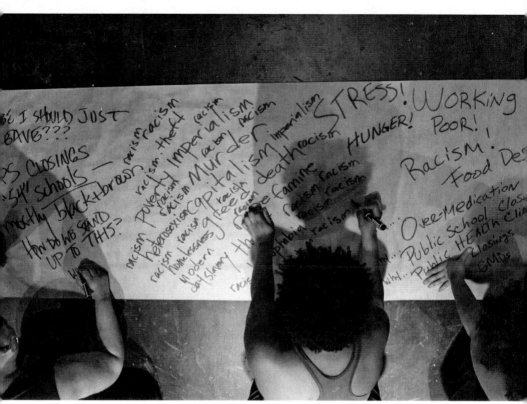

Honey Pot Performance, *Price Point*, 2013, still from performance. Courtesy of the artists.
Photo: Ania Sodziak.

riences with institutionalized systems of assistance but not really being helped in any way, we have a real perspective on how systemic disadvantage truly affects your quality of life and your access to safe spaces. Considering how we are all instructors and advocates, the impulse to make artwork together came from a mutual feeling that these experiences we all share are disturbing, and that we've got to do work about it.

MTM: The rhythm is typically like this: we settle on an idea and then it's a long gestation period, at least a year for most of our evening-length works. It's a combination of collecting critical essays, research articles, and other resources to take apart our topic on a conceptual or theoretical level. Then this is mixed with reflection in our own individual journals or through stories gathered from other people, and then pulling out what is shared in order to create a collage of stories informed by a patchwork aesthetic. So, really, the works are built in episodic non-linear ways throughout which we define connective tissue.

AMJ: For me, from a social sciences understanding of capitalism, the connective tissue is this notion of the body as product and really taking issue with the way that we are reduced to being a product through inequitable valuations of our labor-capacities, and as related to global histories of

181

exploitation, enslavement, incarceration, and systemic disadvantaging.[3] It's a way that I've understood the body from being within my particular identity, so I feel very clear about the ways in which we are considered products. But at the same time I reject the notion of simply being a product. Being a particular body and having a particular identity, the struggle is actually trying to interject humanity within that and communicate the notion that— throughout it all—we can be vulnerable and not just strong. Interrogating what strong means is part of it, especially under these backbreaking economic conditions in which even the so-called strongest of the strong of us have to admit that we are weak within a culture that stigmatizes the admission of weakness.

FH: Or of needing help.

AMJ: At the same time, being in this body and having these identities has made me very familiar with the history of living under harsh, unforgiving kinds of conditions for centuries, being perfectly comfortable with sharing resources, and comfortable with being a part of a community that helps one another. If this is what we are familiar with, if this is the historic part of being a part of this subculture, why not share the ways in which we share? Why not share the ways in which we've been able to survive, reject, or at least challenge and resist notions of our bodies as products? I think that's part of what we're offering.

MTM: I agree. This notion of rejecting the idea of the body as product is at the crux of our method. Instead, our work is all about the complexity and nuance of the human experience. That we are more than just this container. That we are more than just a story that's been created about who I am based on a reading of my phenotype. Both our performances and workshops are very much geared toward exposing these kinds of methods of self-understanding.

DO: *I'm really interested in the connections between ethnography and choreography that you refer to in your artists' statement. When you talk about how our identities are done to us, or how we are constantly determined/ affected by cultural and economic forces beyond ourselves, it feels almost like a kind of structural social choreography. I'm wondering if you could speak more to these connections, and perhaps how they relate to your research into how folk and everyday sources of knowledge counteract our more institutionally received notions of one another.*

FH: Part of our generative process will include content from other people. We may ask audiences to share their economic frustrations and experiences at the end of performances. We've conducted audio and video interviews with people sharing their experiences, and it's very possible that this content will be incorporated. This is part of what we strive for in our work: bringing marginalized voices to the fore, which is, of course, related to

this ongoing notion of value and whose stories, whose labor is valued.

AMJ: And not just marginalized voices, but silence. I think that there are voices that are not marginal, but who feel pressure to be silent. And I think we, as Honey Pot Performance, attempt to facilitate a release of that kind of silence.

MTM: In terms of the connection between ethnography and choreography, it's this idea that everybody and every body matters. Every body has a vocabulary, a lexicon, a language, a logic, an order for its own existence. In choreography and theater you are often creating new languages or lexicons for the world of the work being made. With Honey Pot Performance, we consider the world we are making—its issues, its players, its cultural material, its architecture—and we build the world of the performance creatively using its own tools.

For our work *Price Point* that's a world of screwed-up economies, of human beings affected by those economies in spirit and psyche, and in the physical world. To tie this often-schizophrenic range of issues and experiences together, we created a series of chants, song fragments, a song cycle if you will, that captured the anxieties, the desperation, and the challenge in the face of the pressures of this particular economic frame and its dysfunctions. We also used popular media and music in a new kind of way for us; it became a kind of thread that helped move the world along, taking the audience from vignette-to-vignette. And those elements became part of the lexicon in the world of this piece. So the connection is about digging through the creative process for the appropriate socio-cultural lexicon and using that lexicon to figure out the work's existence.

On the other hand, there is this very central idea of play and laughter in our process that finds its way into each work. Like, we present a lot of hard, interrogative shit, but we attempt to make you laugh—and ourselves.

FH: Because that is part of our lexicon, too: laughing to keep from crying, a lot.

MTM: And to affirm the fact that this shit is absurd, which gives an audience so many different entry points or portals into the work.

FH: In *Price Point*, I think the moment that initially really gives an entry is the segment on the *Negro Motorist Green Book*, published first in 1936 by Victor H. Green and described as "a listing guide to help traveling African Americans find accommodating businesses during the first Jim Crow era."[4] It was based on Green's own personal needs as a postal worker, and he created this as a response to the overwhelming need for shared resources that the whole community of African Americans had throughout this country. So we wanted to model and share that impulse for strategizing alternatives, not just for other African Americans but for working poor and unemployed individuals all over.

DO: *Throughout our conversation what I've noticed is how you present models of self-care and self-exploration that may actually offer a way of seeing how the personal becomes translated into the political and into art. It also speaks to your interests in alternative economies or cooperative networks of exchange and reciprocity. It seems these alternatives come about because of widespread feelings that resourceful and inventive survivalist strategies have become increasingly necessary.*

FH: For me, personally, thinking about concepts of alternative economies is really just a return to foundational economies of barter and trade or just simply helping each other out without currency. These impluses are based on good will and a desire to keep each other and the community healthy.

MTM: And of valuing people.

AMJ: The whole concept of self-care is premised on the notion that you are worthy of being cared for. But when you live in a society that in general reduces everybody to a state of production, and then layer onto that actually having pieces of your time chopped up and put into a hierarchy of value, it seems you as an individual are always at the bottom. So the notion that you are even worthy of being cared for, that you are worthy of a safe space, is really the first part of creating a culture in which everyone feels valuable.

MTM: Alternative economies is what all of the works we've done in the past several years have tried to address. The festival *To Art and Profit* was very much about interrogating this idea of creative labor and trying to make a space for artists to come together from different mediums and address feelings of not being valuable or of living in a state of shame due to their economic circumstances. To get together in a container of collectivity and talk to people who are going through the same things as you is catharsis, but it's also the beginning of a conversation about what can be created to get us all out of these circumstances.

This sense of a collective conversation is also apparent in our developing project *Juke Cry Hand Clap* where we are asking the public—an intergenerational and diverse public—to share their stories about house music, pleasure, and social practices in Chicago. We will use these stories, in addition to our own, to write and perform a new narrative about house music's importance as a critical and unsung piece of contemporary Americana. Coming back to the idea of alternative economies, this is about reclaiming a story and reinserting people of color back into the center of the narrative of this story. In many ways dance music has become whitened to the point that a lot of folks don't even know that house music emerged out of communities of color. We want to help make that intervention through performance and the archiving of that history by everyday bodies.

So here again we are seeing our work as an engine to stir up a social and cultural conversation, to open a space for dialogue about what bodies mat-

ter and which voices get heard, even in spaces that might seem innocuous, like the club or set. We want folks to understand and feel the way that folks of color have taken on that marginalization and found ways to resist and transform attempts to make them invisible. We open the space to the public to help us dig for the lexicon, the language, the important cultural symbols—and especially in this new work—the dance and musical sounds that will create this next performance and paint its world. Again it is this collective conversation and knowledge-making about how we construct a relevant story together that is the most important ingredient.

AMJ: In sociology theory, it would be called emergence.

This interview was conducted on December 15, 2013 in Kansas City, Missouri.

1 For instance, with the group's *Price Point* in 2013 they interrogated the existence of a social contract in an era of late global capitalism and fiscal collapse through personal stories of structurally engineered poverty that affect one's mental, spiritual, and physical health; while also bringing in historical and contemporary alternatives for unionizing, resisting, and forming collectivity under violent economic circumstances.

2 The phrase "seven periods of violence within US history" is gleaned from Thomas Dye and Brigid Harrison's assessments of revolutionary violence occurring throughout American history within their co-authored 2010 textbook *Power and Society: An Introduction to the Social Sciences*. Dye and Harrison define these seven periods as "the birth of the nation (revolutionary violence), the freeing of the slaves and the preservation of the Union (Civil War violence), the westward expansion of the nation (Indian Wars), the establishment of law and order in frontier society (vigilante violence), the organization of the labor movement (labor-management violence), the Civil Rights movement (racial violence), and attempts to deal with the problems of cities (urban problems)." Thomas Dye and Brigid Harrison, *Power and Society: An Introduction to the Social Sciences* (Stamford, CT: Cengage Learning, 2010), 351–352.

3 The phrase "body as product" is used by Johnson as a summation of her research and comprehension of the literature on labor, enslavement, race, gender, class, and capitalism, particularly considering the objectification of black bodies and female bodies during enslavement and after, within the entertainment industry, mass media, and labor force.

4 Victor H. Green, ed., *The Negro Motorist Green Book*, (New York: Victor H. Green and Company, 1936–64).

Can Experimental Cultural Centers Replace MFA Programs?

Mike Wolf

While it starts in a place relatively remote from Chicago, this text focuses on Mess Hall, an experimental cultural center in the city's Rogers Park neighborhood.

In June 2006, I was on a long walk in southern Minnesota. While spending the night at a Best Western in Cannon Falls, I caught a brief report on the TV—something about Stephen Hawking (a British physicist known for his work on black holes), saying that he felt there ought to be a global effort to colonize outer space, as a response to impending global disasters like nuclear war and radical climate degradation. It certainly wasn't a new idea, but this time the notion lodged itself in my head. Days later, I arrived on the outskirts of a town called Mankato, where my grandmother lives. I had been walking for three or four days on a former railway converted to a bike path. In addition to the new buildings and strip malls, I saw a few gas stations, some fast food drive-throughs, and of course, parking lots. It was at that moment that Hawking's idea about colonizing space became dislodged.

How appropriate, I thought. This is all very good practice for space travel. If we are going to colonize space, we are going to have to learn how to live without touching the ground. We are going to have to be able to conduct most of our communications electronically. We are going to have to learn how to live in small, sealed containers.

However, my inclination at the moment is to involve myself in things that are on the other end of the spectrum of mediated experience: to learn

things that bring me closer to the ground, to learn the pleasures and dangers of communicating face to face. While I think I will never forget the pleasure of movies, screens, and remote media, I want to know what it is like to spend extended periods of time being entertained by the people who are near to me. The question I was asking myself, after walking more or less alone through a rarified corridor for several days, being confronted by strip-mall culture is, "Is this how we want to be living?" Of course, everyone can answer for himself.

First off, let's remember why it is important to ask this kind of question. Depending on the circumstances of the person asking, questions like this may be about things that we feel are beyond our control, or matters where we have no choice. So why bother asking? Questioning is powerful because it is inherently open-ended and unfinished. It is an act that produces liquidity, requires improvisation. It invites participation and solution making. It is an act that, rather than closing things off, produces openings. Another great thing about it is that we are all capable of it. Our minds are constantly spewing forth questions. Only a few of the questions are allowed to surface; that is our training. For me, the exciting implication in the question "Is this how we want to be living?" is that we learned how to live this way: strip mall culture. We taught each other to live this way, so it stands to reason that we could eventually teach each other something else, maybe numerous other ways of living.

The more I participated in cultural work, the more it seemed obvious to me that an artist ought to be able to organize social events and gatherings to involve different kinds of people as a means of self-education. Before, so many of the gatherings of people I had been a part of were arranged by the schools I had attended: classes, field trips, or large commercial ventures like sporting events or fairs. I had somehow falsely learned that people cannot gather themselves without an institution involved. But growing up, I also experienced other kinds of everyday experiences of coming together. There was my family who gathered almost daily for dinner, and seasonally in larger groups for holidays and celebrations. Also there was skateboarding, truly a way of gathering with people and making decisions, as a loose, changing group, about where to go and what to do. Gathering on street corners and finding alternative and provisional uses for public space may be one of the more valuable self-directed educations I was fortunate enough to have.

Later in Chicago, as a recent Bachelor of Fine Arts recipient, I began to go to some art galleries in the city. I learned about galleries in apartments, a space in a garage, or in an old warehouse. And when I was brave, I could talk one-on-one with the people who initiated these spaces, and to the artists who contributed to the exhibitions. I saw how they worked, and that while there are some risks involved, they are actually quite minimal and

that it is quite easy to put something in a space like this. It takes little more than the help of a few trusted cohorts. That is, I saw how the artists helped each other, how they spent time working on things that were not their own. Some artists had technical knowledge and time that they would share with other artists, and some had equipment that they would share. I came to see that so many projects would not have happened without this kind of sharing and mutual support. And I realized that if this was really important to me, I'd better start helping too. It was all very similar to some of the things that we were doing as skaters, building ramps, lending each other tools or parts to keep rolling, but also I can see parallels to the family activity; there is passion and love of the deepest kind involved here.

So far I've been talking about my education leading up to my involvement in Mess Hall. Now I want to talk about my education since my involvement with Mess Hall. But first, here's a joke:

How many autodidacts does it take to change a light bulb?
Answer: I don't know; figure it out yourself.
No, seriously: How many people does it take to make an experimental cultural space?
Answer: There is a core group of eleven "key holders" that coordinate and organize all of the events the take place at Mess Hall—or under the Mess Hall name, since sometimes Mess Hall projects happen at other places, too. I am one of the people in that group. But beyond that group there are so many people who have contributed huge amounts of energy, thought, time, material, and emotional support to this experiment: neighbors, scholars, speakers, activists, introverts, artists, technicians, organizers, locals, tinkerers, eccentrics, landlords, hoarders, travelers, archivists, cranks, writers, cooks, talkers, audience members. All of them are cultural contributors: the foundation of Mess Hall.

Egregiously, I left educators off that list. Certainly many professional educators have contributed to Mess Hall and wonderful things have come out of that, but Mess Hall has also been a place for co-education, a place where non-professionals can educate and where there is some possibility for anyone to become a teacher. Sometimes teaching happens by overt, formal lesson; sometimes in spontaneous situations where lessons can't help but bloom, and other times there are difficult situations that can only be navigated by on-the-spot learning.

An MFA can be a very important part of an artist's or cultural worker's education. Many dear friends of mine have this degree, but I can't help ask the question: what kind of education does an MFA provide and can it answer all of my needs as a cultural worker? Can it teach me the lessons I need to

learn? Surely people have learned to do vital, interesting cultural work without going to art school. What makes that possible? Mess Hall, for the past three years, has been central to my education as a cultural worker. I have been in the privileged position of being a key holder. Becoming a key holder was nothing like applying and getting accepted to an MFA program. It was what I would call an organic process. When Mess Hall started I was a friend and great admirer of the work of the people who first initiated the space, so I spent as much time as I could there, soon became involved in some events, and then was invited to be a key holder. To be sure, there are certain things that a place like Mess Hall can provide and certain things that it can't. But I have come to think of my work at Mess Hall as being a replacement or an alternative to attending an MFA program. This might not work for everyone—hell, it might not even be working for me—but I think some comparison is worthwhile: between my Mess Hall experience and what a graduate school experience might have been.

MFA programs provide a lot of different things for different people, obviously. Let us assume that all these things are important parts of a contemporary education in art. There are four main categories that I can think of when it comes to what an MFA program provides a student: (one) space and time to work, (two) critical thinking skills, (three) networking, and (four) qualification for possible employment. I am going to flesh out each of these four main categories and draw some comparisons with experiences at Mess Hall.

Space and Time

Most MFA programs will provide studios or some kind of working spaces for students, along with some equipment and technical resources. This is a defined, protected, and even rarified place for concentrated work, and I assume time spent in the studio is one of the central features of most MFA programs.

My own cultural practice has been about working in the cracks, finding materials and tools that are cheap and free, making space in my own domestic space to do work. There is a long tradition in the modern avant-garde of turning one's own domestic space over to one's artistic practice. For better or worse, I have embraced that tradition. For a short time, I rented a small studio a couple of miles from my apartment but found that I didn't like trying to split my time between there and my domestic space, so I decided the expense wasn't worth it. On more than one occasion, Mess Hall itself has served as a studio or working space for various projects, both for individuals and groups. But there is not enough room there to let one person use it on a permanent basis. All of this is a contrast to working in a

studio space provided by an art school or a university. It is all more tenuous, and often less convenient, and that affects the outcome, but it also forces me to be more creative in problem solving and depend on other people a bit more to finish my work (which I see as advantageous). As far as time is concerned, I have had a full-time job for much of the time that I have been a key holder at Mess Hall. That in itself, though, may not be different from people who have to hold down a job, or even two, while they attend graduate school to keep up with tuition, bills, and other living expenses. It's not ideal, but it is real.

Critical Thinking

Another central aspect of a graduate education in art is to engender strong skills in critical thinking. This includes learning where and how to find knowledge and knowledge resources, deepening reading skills, and becoming more articulate when writing and speaking.

One of the central values of Mess Hall is an ethic of self-interrogation. That is, we are constantly asking ourselves and each other about the effects and meanings of the work we are doing: whom it is serving, and what interests it represents. Each key holder looks at every event and project proposal that comes our way, and has to evaluate whether it fits in. There is no consensus process at Mess Hall. Events can happen even if some of the key holders don't like them, but there is always an exchange and space made for people to voice their concerns. There is a unique atmosphere of mutual respect and trust that has somehow emerged among the key holders, so we are always interested in each other's points of view. Sometimes the exchanges can become quite intense. It is a pragmatic criticality that is at work, always asking, "What would the effects of this event or project be? Why is it a good idea?" Or "Why does it not fit in at Mess Hall?" Sometimes we will share an article or a piece of text with the group, something to help inform what Mess Hall is, or will help us clarify a position on a given project. Since a great deal of these exchanges also take place over email, the whole process has helped me to become a better, more articulate writer, both in terms of making my arguments and reading other people's.

Networking

On a very basic level, a graduate program brings people into contact with like-minded people in an intensified, somewhat closed or rarified atmosphere. It is a place to bond with people in the field, to learn how pro-

fessionals in the field speak. It is a place to meet and learn from people who have experience interacting with and working with people who have power in the art world. Teachers and staff at an art school have often dealt with curators, funding organizations, benefactors, administrators, gallerists, collectors, non-profit organizations, and other art institutions. It is their job to show you how to do the same.

Sometimes it seems like that's all Mess Hall is: a network. It is a network with eleven key holders somewhere at the middle, all drawing on every connection they can think of to accomplish all of the events and projects Mess Hall does. Temporary Services, who have been doing cultural work together for about ten years, initiated Mess Hall when Al Goldberg, the landlord, gave them use of the space for free in 2003. Because the space is given for free, no money exchanges hands within Mess Hall; it runs entirely on an economy of generosity. They have reputation for doing engaging, challenging, radical cultural work among many different people all over the country and in different parts of the world. In short, they have a great deal of cultural capital; that is, many people pay attention to what they are doing and find it meaningful. The cultural capital of Temporary Services has undoubtedly been an important part of the robust social network from which Mess Hall has been able to draw. But at the same time, each key holder is part of another set of social circles that nobody else in the group may have known about or had access to, if not for Mess Hall. The networks we are a part of at Mess Hall connect up with some of those people in power in the art world—curators, non-profits, galleries, and so on—but part of the reason that Mess Hall exists is a frustration with the limitations and assumptions held by these kinds of institutions. (And often even by those people who work at them—indeed, many key holders do) Mess Hall makes overt efforts to connect and network with people who would normally have no interest in, or feel alienated by, art galleries or museums. And in some cases it actually works. Mess Hall is more or less funded out of pocket, and tries to do as much as possible with surpluses and for free. Unlike many non-profit institutions, it is not beholden to funding organizations, benefactors, and the wealthy.[1] We are free to expend our social energies with people, regardless of their economic status or background. It has been a place for me to interact and learn to communicate with people of widely varying cultural and economic backgrounds. While I don't always succeed, I have begun to learn ways of communicating the sometimes very complex and nuanced ideas and projects we deal with at Mess Hall to a broad cross section of people. And while I hope not to condemn the value of art school critiques, that's a stark contrast to defending your work in a critique with other graduate students.

Mess HALL

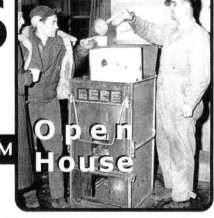

Open House

Friday, August 8, 7-11 PM

WE ARE OFFERING:

❂Music & Food

❂A large selection of publications from N55, YNKB, White Walls, Autonomous Cultural Center, Red76, CNEAI, Temporary Services, and other initiatives.

❂A vast wall of posters by artists and groups - Mess Hall organizers and similar intiatives from around the world.

❂Project by: Nance Klehm - **Field Trip** I On July 20th, a shopping cart planted with pre-Depression era corn began to travel from 25th & Kedzie (Little Village) to 6932 North Glenwood (Rogers Park). The circuitous route was determined by the individuals who live between these two areas who were willing to participate in this produce delivery.

❂Project by: Dan Peterman - **Vertical Storage** I The bins are made from post-consumer plastic in extruded board form. They will anchor a long term, creative neighborhood recycling and reuse initiative by Mess Hall. We will accumulate and redistribute unused material from local individuals and businesses

> **Mess Hall is a new non-commercial resource in the Rogers Park neighborhood. Housed in a store front, Mess Hall will feature a reading resource area, exhibitions, workshops, lectures, public projects, actions, events, meals, and more. It is provided by Ava Bromberg, Sam Gould, Jane Palmer and Marianne Fairbanks, Temporary Services (Brett Bloom, Salem Collo-Julin, Marc Fischer), and Dan S. Wang.**

6932 N. Glenwood Avenue (Morse stop on the Redline – west side of the el' tracks)
Hours: Tuesday 12 – 7 PM, Thursday 12 – 7 PM, Saturday 11 AM – 5 PM
For information: 773–465–4033 or my.calendars.net/messhall

Mess Hall poster, 2003.

Employment and the Possibility of Employment

Often a graduate program provides a first opportunity for the student to become a teacher. MFA students often teach introductory undergraduate courses for pay or even as part of their curriculum. For many, it is their first experience working with students. It also seems that an MFA is a minimum qualification for teaching at most art schools or university art departments, which is very important since—unless one is lucky enough and skilled enough to become successful in the commercial art world—teaching often seems like the only option for paying the bills when working in a cultural field in the US.

This is where things get a little touchy, feelings perhaps get a bit more raw. First of all, I don't think being a Mess Hall key holder will muster qualification enough for most hiring committees, but who knows? Doesn't it depend on who you know? But my raw feelings give me a very strong urge to question the very economic structure of art education at the college level, and at the same time I cannot propose solutions to the problems I see. I have seen so many friends with MFAs live by the skin of their teeth, trying to pay bills and student loans on the salary of a part-time teacher with various art programs in Chicago. I have seen friends competing for the same teaching jobs with meager pay and no health benefits. They have become frustrated and depressed, and it is hard to watch. It sometimes seems like teaching in the cultural field is becoming more and more like the blue-chip art market, an economy that sets people against each other and can only support a fraction of the people who aspire to be a part of it. I think as far as answering our economic needs and the need for health security, collective creativity is needed. I also think that everybody who has a desire to teach should have the chance to do so. The need to teach is as plain as any human need. If you think about it, it is no less essential than the need to learn. It is a basic right to which everyone should have access, and maybe not always expect to be paid for it. I don't claim that Mess Hall has the solution to these problems, but I do claim that Mess Hall is one among millions of open spaces that are needed to begin to make visible our capacity to begin the long process of transformation. Mess Hall is in fact a place where I, despite not being in an MFA program, have begun to teach people and even to work with college students. It has taught me, experientially, that I can teach.

It is okay not to answer questions right away. It may be better to let them stew, to let the question change and develop, both inwardly and outwardly. Undoubtedly the questions will affect our actions.

Many people I know are disturbed, depressed, and hurt by some of the ways our culture operates and by the way our economies affect us and

other people around the world. We are upset that there are very few places to gather with others and learn from each other, and that the places where people can do so seem somehow very limited in scope or are prohibitive on some level. Most places, like movie theaters, museums, bars, cafes, or restaurants, cost money. And others, like churches, have a religious agenda that is far from inclusive.

We want conditions to improve.

Maybe, not unlike an MFA program provides a kind of safe space for a young artist to explore and work on things that seem outlandish to most people, one thing that an experimental cultural center can do is provide a safe space for a variety of people to come and ask questions and see how those questions affect our actions, both in the space and beyond it. This seems like it could be a valuable part of the slow process of improving conditions. And the times when we are able to work to improve conditions locally are wonderful times.

This text was originally published in *AREA Chicago,* 5, (October 2007). After a ten year run, Mess Hall closed in March 2013 after the landlord decided to not renew the lease.

1 It should be noted that the storefront space we use is given to us for free by our landlord, Al Goldberg, with whom we have a good relationship. He has never imposed any unreasonable conditions on us for using the space, and we have never felt any need to "butter him up." As things stand, we have a trusting respectful relationship with him. At the same time we feel that Mess Hall—though it would certainly become something else, as it always is anyway—would not collapse entirely, if for some reason Al turned crazy and stopped sharing the space with us.

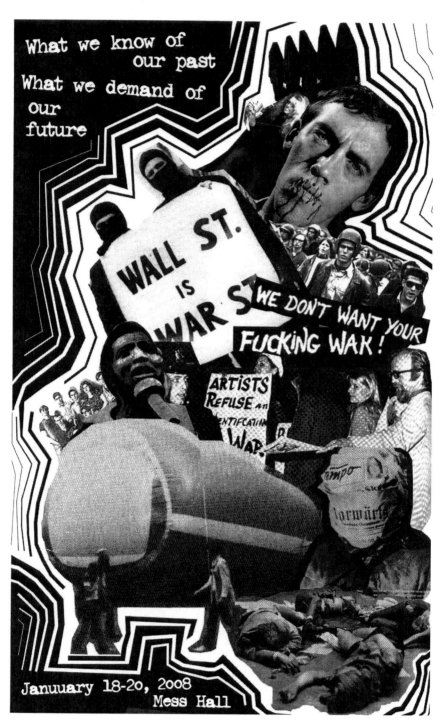

Mess Hall poster, 2008.

A RADICAL HEALTH VIDEO SERIES
TWO EVENINGS OF FEMINIST
FILM & VIDEO W/ DISCUSSIONS

SATURDAY, AUGUST 26-7PM
Faith Wilding (*subRosa*) &
Terri Kapsalis (*Chicago Women's Health Center*)
present:
Near the Big Chakra
(Anne Severson
16mm, 17min, 1972)
Period:
The End of Menstruation
(Giovanna Chesler
DVD,53 min, 2006)
Vulva de/re Constructa
(subRosa, DVD. 10 min,
2000)

SUNDAY, AUGUST 27-7PM
Pomegranate Radical
Health Collective
present:
Speak Out!:
I Had an Abortion
(Gillian Aldrich,
DVD, 2005)

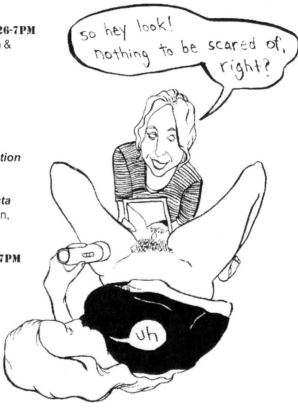

*illustration by
Becca Taylor*

TAKE CONTROL OF YOUR SEXUALITY!

*for more information on the presenters
or the media:*
www.periodthemovie.com
www.cyberfeminism.net
www.canyoncinema.org
www.pomegranatecollective.org
www.speakoutfilms.com
www.chicagowomenshealthcenter.org

MESS HALL
6932 North Glenwood Ave
'Morse' stop on the Redline
messhall8@yahoo.com
Tel: 773-465-4033
www.messhall.org

Mess Hall poster, 2006. Design: Bonnie Fortune. Illustration: Becca Taylor.

Queer Lineage

3rd Language
Interviewed by Abigail Satinsky

Abigail Satinsky: *As a Chicago-based collective of young people of color, you produce a quarterly publication on the work of queer-identified artists exploring themes of queerness, queer thought, and queer work; curate exhibitions and performances; and host workshops. I'm interested to talk about your annual summer program for young queer artists of color and young adults. What was your group's impetus to create these summer workshops, specifically Our Voices, Our Community, Our History, in 2013 for a core group of eleven self-identified LGBTQIA participants?[1] This program seemed to build not only participants' technical skills (printmaking, photography, bookmaking, and creative writing), but also expose the group to queer cultural histories, and, importantly, privilege the lived experience of the participants.*

3rd Language: 3rd Language was founded in 2012 as we grew tired of the lack of queer individuals, people of color, and others marginalized by economic and social circumstances in art galleries and arts-related spaces. As we began to think of ways to provide a platform for these individuals, including ourselves, we decided to form a collective of artists and thinkers in Chicago who were exploring and embracing difference, otherness, and transgression, adopting the label queer for this distinctness. We are interested in a queerness that emphasizes ambivalences and the shifting and questioning of boundaries. Our queerness is rooted in, but not solely defined by, our identification within the lesbian, gay, bisexual, and trans* spectrum, including the many trans* identities that exist—transgender, transsexual, gender non-conforming, and so on. Then what began as an

idea for an exhibition became the groundwork for our quarterly publication.

In our first two publications, *The Shape of Uncertainty* and *Queer Utopias and Nihilism*, we were introduced to a talented group of emerging artists in Chicago and throughout the country. It was during this process of building our artistic network and curating the publications that we began to question how we could expand our net beyond art schools, Facebook, Tumblr, and queer parties, which can be exclusive and isolating. In 2013 the summer workshop, Queer Lineage and Archives, was born out of this desire to engage various communities within Chicago in an accessible dialogue about the reclamation of one's own image, voice, and personal history as a marginalized person. Often as queer people, and specifically those of color, our stories are told from an outsider's perspective. The summer workshops functioned as a vehicle to use the power of personal narrative and primary-source accounts, while building and expanding upon a collective queer archive. They were funded by the Davis Foundation's Projects for Peace grant and individual donations.

AS: *How did you undertake the logistics of locating participants for the workshop?*

3L: We initially contacted several Chicago Public Schools and local art centers; however, we found that interest primarily came from folks who were nineteen and older via the Internet, and so that age range made up the majority of our students. We received messages from people out-of-state, but we wanted to work with local participants with the hope for continued communication past the workshop. NIC had worked with three of the summer workshop participants at About Face Theatre. Other participants found out about the workshop through social media, fliers, and word-of-mouth.

AS: *Can you talk about how you conceived of the learning environment, that is, how did you conceptualize the teacher-student dynamic and which communities were you connecting with?*

3L: It was imperative to create an environment where knowledge is co-created, rather than merely transmitted from instructor to learner—a pedagogical strategy aligned with the hierarchal distributions of power we are challenging. In contrast, we privilege the knowledge and lived experience that learners bring into the learning space. We meet learners where they are, both as artists and as human beings. We also acknowledge ourselves as constant learners. More specifically, we are engaged in a process of queering pedagogy: a relearning of how authentic learning and instruction might operate.

We belong to hybrid networks, meaning many of our community ties overlap. For example, Tumblr connects us to a digital community of persons we may not know personally, yet we share commonalities along intersections of queerness, art making, pedagogy, critical theory, and social impact. By hosting our workshops in a location where neither participants

nor collective members reside, or even visit for that matter, we communally crossed unfamiliar geographic borders, inspiring another network.

We believe that it is a radical act to make artwork about our communities as queer people and queer people of color. During the course of our workshops, which were housed at Spudnik Press, this was made quite clear with the exhibition of *Lost Tribes of Renni*: a body of work consisting of "tribal paintings" by Charles Megna, a white male artist, who is described in the description of his exhibition as "[h]eavily influenced by Eastern philosophy, Native American rituals, and American skate culture."[2] This show, which was on view during our six workshops, served as impetus for group dialogue about appropriation, representation, and privilege in the art world. As we were developing a safe space to create artwork that privileged our voices as marginalized people, this exhibition that surrounded us served as a reminder of what has and will happen if the documentation and representation of our cultures is left solely to what we feel is mainstream voices.

AS: *Did the participants see themselves as artists initially or did that evolve over the course of the session?*

3L: In the beginning many participants felt reluctant to claim the title artist. But as they interacted with their peers and the visiting artists, they gradually grew to view themselves as artists and their work as art. Several participants new to art making are now developing bodies of work.

AS: *I'm interested in this categorical distinction of calling oneself an artist. For you, is this necessarily a good thing? In other words, is the goal to convince participants to continue on as artists or is this about transformation and empowerment with art making a means to an end? I'm also posing that question to you, 3rd Language, as to what kind of art worlds you see yourselves participating in, working as a collective and as individual artists?*

3L: We think that what it means to be able to consider oneself as someone capable of making, an "artist," cannot be underestimated. We think that art has a place in everyone's life whether that is more abstractly through creative problem-solving or more concretely through producing works and pursuing what may resemble a more traditional artistic, studio-based practice. We feel that making creative works allows participants to work through tangible and intangible thoughts, concepts, and ideas. We do not hope to somehow convince participants to pursue a specific or predetermined art practice or career. However, we would like participants to take making, and a confidence in their making, with them into whatever they may pursue—to pursue what they do creatively. We don't necessarily see art making as a means to an end or a tool, but perhaps as a method and a constantly evolving process that is specific to the maker, the person. Art and making functions as a way of thinking, a way of approaching concepts, and a way of understanding oneself and one's environment.

It also reminds us of a sort of binary that is set up between community-based art making and fine arts practice. Many of us at 3rd Language have very rigorous studio-based practices that are definitely informed by arts training, theory, and what is going on in the contemporary art world (galleries, museums, and so forth). Simultaneously many of us are deeply involved in the rest of the world around us: we hold retail jobs, teach theater, run after-school programs, work at restaurants. In short, we are not sure there is much of a distinction or a clear line between the many worlds we are involved in. We do believe most of these boundaries are artificial and are constructed as part of our queerness. So it is an aim of ours to continue to blur these lines. We're constantly questioning this trying to figure it out.

This interview was conducted between December 2013 and January 2014 as an email exchange.

1 The program was developed by 3rd Language members NIC Kay and Amina Ross with the help of Joel Mercedes and Allie Shyer, with support from Molly Berkson and Emily Schulert; curriculum was developed by Veronica Stein and H. Melt, who served as the main teaching artist. NIC Kay, Amina Ross, and Veronica Stein were present for this interview.

2 Spudnik Press Cooperative is a Chicago non-profit housing a community print shop, gallery and classroom, independent studios, and shared workspace for writers, bookmakers, artists, students, and others. The exhibition, *Charlie Megna: Lost Tribes of Renni*, took place from June 15 to August 2, 2013 at The Annex @ Spudnik Press. Full text for reference: Heavily influenced by Eastern philosophy, Native American rituals, and American skate culture, Charlie Megna's colorful gouache and gold-leaf paintings combine loaded, symbolic motifs with the banal, the humorous, and the commonplace. In these tribe paintings, we recognize glimpses of sacred ceremonies that feel familiar, but that expand with closer inspection into mystery and secrecy. In addition to the paintings, Megna creates costumes and physical relics to further realize the world of his tribes, and is preparing a small-run artist's book of myths and alphabets to accompany this show. When exhibited along with the paintings, these surrounding materials combine to take the shape of an anthropological exhibition comprised of the real artifacts of an imaginary society. See http://www.spudnikpress.org/2013/06/charlie-megna-lost-tribes-of-renni/.

Society of Artists

Lane Relyea

Living in New York in 1989 and newly radicalized by the AIDS crisis, Gregg Bordowitz came to a realization. "I have no more questions about gallery walls," he declared. "What's useful now is to go out and do directly engaged work that's productive."[1] A year later, in the pages of *Flash Art*, the critic Isabelle Graw noticed that, while "the investigations of Haacke or Buren were designed to increase awareness of the nature of the art institution and its public...younger artists are concerned with aspects that have no exclusive relationship to the visual arts system or its distribution channels."[2] A year after that, Dan Peterman included Jorge Pardo and Joe Scanlan among others into his show *Improvements? on the Ordinary* at Chicago's Randolph Street Gallery. These are a few of the many possible starting points one could use in building a history of what would soon come to be labeled *kontext kunst* (which, according to Peter Weibel, who coined the phrase, "is no longer purely about critiquing the art system but about critiquing reality and analyzing and creating social processes") and later relational aesthetics and nowadays social practice.[3]

It would be nice if this now fifteen-year-old social turn in art could be credited entirely to artists—to their idealism, their creativity, their deep compassion and visionary grasp of a brighter tomorrow, etc. But there are of course other, larger forces that deserve thanks as well. As with other professions, art and artists have been lured into social life as the social itself has become increasingly ensnared within the logic of labor valuation and economic exchange—that is, as information-oriented services and short-term contracts have superseded factory jobs and commodity production

and shifted emphasis onto individual "human capital" and its improvised, on-demand performances. Not only does face-to-face socializing serve as the ground for much artistic practice today, it also has become the very object that larger institutions commission and display. Increasingly museum directors and curators embrace the DIY methods of artists and try to assimilate into their institutions the characteristics of apartment galleries and other artist-run initiatives.[4] As a result, the formerly dominant system of galleries and museums feels less confining as it loosens and becomes more permeable and open-ended—as it gets reconceived as a "convergence zone" or "interhuman space of relationality."[5] Indeed, art appears less aloof as aloofness itself loses glamor. According to a recent sociological study, it's no longer assumed that "people are creative when they are separated from others." Rather, today "creativity is a function of the number and quality of links."[6]

The rise of this more networked, communicational, information-based paradigm places too much emphasis on relations, interaction, and dialogue to allow for either individual artists or artworks to be overly isolated from each other or overly circumscribed within predetermined roles. As a result, the art world today develops beyond a formerly dominant system composed of the studio, the gallery, and the museum—a system based on discrete objects and the discrete transfer of ownership of those objects. The figure of the lone studio artist sheds its luster, but so too does the critique of the institutionally empowered museum that indiscriminately and thoroughly imposes its brainwashing ideology on all who step through its doors. Less a disembedded, autonomous commodity on the market or a disembedded, autonomous representative of transcendent aesthetic achievement in the museum's canon, the work of art instead grows more situated, anchored in relationships and relatively loose and temporally drawn-out collaborations between artists and others.

Many have applauded all of this as exemplary of artists breaking free of the marketplace and the museum in favor of a more loose and intimate framing for their endeavors—one characterized in the social terms of engagement, participation, generosity, mutual support, contribution, trust, reliability, and responsiveness. Indeed, social practice art in particular is often greeted with a utopian rhetoric about spontaneous friendships, egalitarian sharing, and organically formed communities. And it could well be all that. But to a large degree such activity still exists inside, not outside, the art world. Social practice artists are no less professionalized than painters or sculptors—indeed, perhaps more diversely and intensely so, since they have to fold a far wider range of occupational tasks into their overall practice. So what explains this fact, this nagging awareness that all this socializing still very much exists as a separate sphere of activity, addressed to groups

of insiders, namely fellow artists and art-world denizens?

One answer is that the art world today has only replaced one institutional apparatus with another. A new system of standardization has arisen to compensate for the growing limitations of the former studio-gallery-museum system. Instead of a series of white cubes dictating conformity in the production, distribution, and reception of material art objects, today it's art *subjects* who are produced in mutual conformity and interchangeability. And the institution that oversees this reproduction of "human capital" is the art school. As Howard Singerman argued in his 1999 book *Art Subjects*, MFA programs produce not art but artists. That is, unlike on the undergraduate level, where priority is given to instruction in the material techniques for making art objects, it's "artists [who] are the subject of graduate school."[7] But MFA programs don't just query artists about their subjective interiority; given the emphasis on critiques, studio visits, and visiting-artist talks, grad school is also exemplary at getting artists to open up and say what's on their minds. That is, they exteriorize artists, make them social.

This is not exactly new. Part of the point of Singerman's book is to stress how important the teaching of art has remained even after the demise of nineteenth-century academies—and furthermore, how their importance, as with the academies of yore, lies largely in their regulating and organizing the production of artists and integrating that production into the larger social order. What is new is the absolute priority the art world now gives to schools. Indeed, art schools are looked to by today's most innovative curators and directors as models for exactly how to replace monological object display with proliferating information platforms. Several recent large-scale exhibitions and published anthologies have declared an "educational turn" in contemporary art, and there have been international exhibitions like *Manifesta 6* and *unitednationsplaza*, both in 2006, which advertised themselves as short-lived schools. Chicago's art scene is typical in how heavily it relies on its area schools to provide not just art students but many of the contexts—from classrooms and visiting-artist talks to symposia and shows at campus galleries—in which the role of artist can be performed and validated. "The art academy seems to me to be an extraordinary institution with potentially the greatest relevance to current art practice of any in the art world—whether museum, *kunsthalle*, commercial gallery, or studio workshop," proclaims Charles Esche, a co-organizer of a number of recent international biennials and currently director of the Van Abbemuseum in Eindhoven, Netherlands.[8] Today's institutional model for contemporary art, according to Irit Rogoff of Goldsmiths in London, is "part university and part museum."[9]

The more central schools become, the less they represent a short interim or distinct segment in one's path into the art world and instead

stretch out to involve more and more types of activities over the entire course of one's career. Schools are a crucial source of not just jobs and other forms of material support, but they also bring together audiences and facilitate general access, dissemination, and exchange of content; they graduate fellow practitioners and organize most of the occasions when those colleagues can get together and stay informed. The rise in importance of art schools will mean a more informational, discursive, indeed socially gregarious art world. And yet schools are no less institutional than the museums they've eclipsed in importance. And the activity they oversee will still be identified as separate—that is, as belonging to a particular profession, a specialized, proprietary field of knowledge and labor. After all, it's this separateness that the MFA program teaches and reproduces—how to get students to create what's recognizable, what counts as art; how to get them to situate their work as arising from and expanding upon a discourse, accumulating around it a set of related historical and contemporary practices, all backed up with a list of reference points, a bibliography. Regardless of how students might intend their work to affect some wider audience, it's this specialized discipline that they're called upon to rehearse. Whether the discourse is about sensibility, ethnography, or identity politics, whether the bibliography is weighted with French theory or Fantagraphics comic books, matters little. What does matter is that artists will show that they can make unique contributions to their field, and that their work will be recognized and valued first and foremost as the production of fresh research, something new for fellow colleagues to talk about.

And the curriculum at art school now features social practice. "Currently, there are about half a dozen college-level programs promoting its study," writes Gregory Sholette. "However, if you include the many instructors who regularly engage their students in political, interventionist, or participatory art projects, the tilt toward socially engaged art begins to look more like a full-blown pedagogical shift, at least in the United States."[10]

All this will sound a bit downbeat when pitted against the more typically heart-warming explanations for the rise of social practice art. And I haven't even mentioned rising tuitions and suffocating student-loan debt. But there is an upside to this story. For one thing, art schools certainly can't be blamed for separating art from life—indeed, it's precisely by organizing art as a separate profession that schools play a role in the grounding of art in present-day material conditions. "The university and its practices," Singerman points out, "are woven into the economic, social, and signifying structures of the 'real' world ... in New York and California and Kansas and Nebraska."[11] This is a fact we too often ignore. But what's just as important about Singerman's assertion is that he includes Kansas and Nebraska as part of the "real world." Those places don't belong to an art world identi-

fied solely with the studio-gallery-museum complex. That is, there's no way to adequately address the art made in, say, Kansas City, or in Chicago for that matter, or almost anywhere—Memphis, New Orleans, San Francisco, San Antonio, even Brooklyn—by just considering commercial sales and resale values and auction prices and the like. If art now overflows the older model, and if this forces us to have to reconceive the institution of art and who's included in it, to consider it as an apparatus now centered more on MFA programs, then we're dealing with a much larger map and a far greater variety of situations. If not dramatically more inclusive, the art world is definitely becoming bigger and more evenly spread throughout the country—and that's because the number of MFAs awarded each year, in every state and in cities both large and small, has been growing steadily since the 1960s. It never slows despite all the recessions, the defunding of the NEA, art market collapses, etc. The result is a lot of artists whose survival depends on finding alternatives to commercial galleries, who don't even have government support to turn to anymore. Some may be lucky enough to garner support from Medici-like mega-patrons like the Warhol Foundation, but more likely they'll turn to each other through crowd-sourced funding and community-supported-art schemes. In all these fly-over art scenes, artists will have to work together to achieve the level of coherence necessary for internally reproducing things like status, recognition, visibility, and CVs. They will have to devote attention to organizing as well as to object making, they themselves will need to seek out and improvise ever-new situations and contexts for the staging of what can be recognized by their peers as art. All of which is to say that the rise of social practice art is very much a symptom of the MFA's role in the overproduction of artists far beyond what the former studio-gallery-museum apparatus was set up to handle.

At the same time, possessing a common professional education also plays a crucial role in solidifying these groups. Of course, professional solidarity will no doubt seem a far cry from other types of social or political solidarity. After all, isn't the very definition of a radical art based on its ability to transcend its own professional and institutional limitations? And indeed, many of the artists featured in this book and its accompanying volumes do just that: they connect and collaborate with all sorts of non-art world constituencies; they work with prisoners and war veterans, as well as random pedestrians; they engage and impact public policy debates on education, climate change, health care, gentrification, censorship, and so on.

But they still operate as artists. Moreover, they have been slowly but surely putting together a new and different art world, or a federation of art worlds; in ways that resemble (but also significantly depart from) the alternative space movement of the 1970s and 1980s, social practitioners have been at the forefront of recent efforts to assemble the organizational build-

ing blocks necessary for a new institutional apparatus. From all over the country, artists and independent arts organizers now convene at annual or semi-annual conferences, like the Creative Time Summit and Hand in Glove; they publish national directories (*Phonebook* by Chicago's Threewalls, a biennial listing of artist spaces and projects); and out of necessity in today's arts funding climate they've developed new crowd-sourced funding mechanisms like community-supported art and art subscription services. In the last couple of years, with support from the Warhol Foundation among other private patrons, a group of small to mid-sized artist organizations and arts organizers have acted on their sense of interconnectedness, mutual identification, and common cause by forming a new national organization, Common Field, for the purpose of helping to sustain and advocate for any and all such grassroots, alternative artists' initiatives and projects throughout the US.

What should we make of this type of solidarity, this act at once empowering and institutionalizing? In what ways does it represent an expansion and redefinition of the category of art, and in what ways does it reproduce art's separateness? Perhaps another, less divisive way to approach the question is this: is it possible that the category of art can itself be made to resonate politically, even conjure its own utopian social vision? "In assuming the name of the artist as a professional name," writes Singerman, "one assumes a responsibility, an obligation to that name's past as well as its future."[12] The question comes down to whether the very name "artist" can be seen today to entail its own political obligations from those who embrace it. In the not-too-distant past, art of the early modern era was thought by some to represent what labor might become when it reached a surplus, when it became socialized and automated and made efficient enough so as not to be just something necessary for survival—what one does for food, warmth, and shelter—but instead as manifesting free creative activity undertaken for its own sake. Not a means to an end but an end in itself.

Our society produces a good deal of surplus today, only it's misrecognized as individually rather than socially produced and in turn appropriated by an infinitesimally small fraction of the population. On the other hand, throughout the country artists struggle under the weight of huge student loan debt, are barely able to survive, their creativity narrowed by necessity, their art as surplus folded back into scarcity. This historical promise of not just expanding but more equally distributing art as a freedom from toil, as the conversion of labor time into creativity for its own sake, can thus articulate one of the many relationships between the professional existence of artists and that profession's larger social relevance. Struggles to better fulfill such a promise in turn suggest a politics—one that all art, no matter how professionalized, could possibly stand for.

1 Gregg Bordowitz quoted in James Meyer, *What Happened to the Institutional Critique?* (New York: American Fine Arts, 1993), 12.

2 Isabelle Graw, "Field Work," *Flash Art* (November–December 1990), 137.

3 Peter Weibel, *Kontext Kunst: Kunst der 90er Jahre* (Cologne, Germany: DuMont, 1994), 57.

4 See for example Hans Ulrich Obrist and Laurence Bossé, "ARS (Artist-Run Spaces)," in *Life/Live*, 2 (Paris: Musée d'Art moderne de la Ville de Paris, 1996), 12–13; and Claire Doherty, "The Institution Is Dead! Long Live the Institution! Contemporary Art and New Institutionalism," *Art of Encounter/Engage Review* 15 (Summer 2004), 6.

5 Anthony Davies and Simon Ford, "Culture Clubs," *Mute* (September 2000), 23–24; Carl Freeman, "Traffic," *Frieze* (May 1996), 75.

6 Luc Boltanski and Eve Chiapello, *The New Spirit of Capitalism*, trans. Gregory Elliott (London: Verso, 2007), 129.

7 Howard Singerman, *Art Subjects: Making Artists in the American University* (Berkeley, CA: University of California Press, 1999), 3.

8 Quoted from www.protoacademy.org [now-defunct]. See also the essay by and interview with Charles Esche in Paul O'Neill and Mick Wilson, eds., *Curating and the Educational Turn* (London: Open Editions, 2010), 297–319.

9 Irit Rogoff, "Academy as Potentiality," *Academy* (Frankfurt, Germany: Revolver, 2006), 20.

10 Gregory Sholette, "After OWS: Social Practice Art, Abstraction, and the Limits of the Social," *e-flux* 31 (2012). http://www.e-flux.

11 Singerman, *Art Subjects*, 211–212.

12 Ibid., 213.

Contributors

3rd Language is a Chicago-based collective of artists and thinkers exploring and embracing difference, otherness, and transgression. Using Queer to name this distinctness, the group is interested in Queerness that emphasizes ambivalences and the shifting and questioning of boundaries. Their Queerness is rooted in the identification within the Lesbian, Gay, Bisexual, and Trans spectrum. Founded in 2012 as a response to the lack of representation for queer individuals, people of color, and others marginalized by economic and social circumstances at art galleries and arts related spaces, the group shares contemporary work by contemporary artists through a quarterly publication. The group's members include Amina Ross, NIC Kay, Hiba Ali, Molly Berkson, Jory Drew, Jerome Kendrick, Camille Laut, Ashley McClenon, Joel Mercedes, Emily Schulert, and Allie Shyer.

Gwendolyn Brooks (1917 - 2000) was born in Kansas and lived in Chicago for all but the first few weeks of her life. She published her first book of poetry, *A Street in Bronzeville*, in 1945 and in 1950 was the first black person to win the Pulitzer Prize. Brooks went on to publish many books and received over seventy honorary degrees, as well as numerous honors and awards, including the National Medal of Arts and Consultant in Poetry to the Library of Congress. She was appointed the Illinois Poet Laureate in 1968 and remained in that position until her passing in 2000. Her name is engraved on the Illinois State Library, which was renamed the Gwendolyn Brooks Illinois State Library in 2003.

Margaret Burroughs (1917 - 2010) was an artist, poet, educator, and organizer born in Louisiana. In Chicago her first political involvement was

when she and her fellow classmate, Gwendolyn Brooks, joined the National Association for the Advancement of Colored People Youth Council. In 1940, she founded the South Side Community Arts Center, a community organization that serves as a gallery and workshop studio for artists and students. Burroughs earned her Teacher's Certificate at Chicago Teachers College in 1937, her BA in Art Education in 1946, and her MA in 1948 from the School of the Art Institute of Chicago. She co-founded the DuSable Museum of African American History with husband Charles Burroughs in 1961 in the ground floor of their Chicago home. She later served as the president emeritus of the DuSable Museum until her passing in 2010.

Romi Crawford is associate professor in Visual and Critical Studies and Liberal Arts at the School of the Art Institute of Chicago. Her research revolves primarily around formations of racial, ethnic, and gendered identity and the relation to American literature, film, and visual arts. She was previously the curator and director of Education and Public Programs at the Studio Museum in Harlem and founder of the Crawford and Sloan Gallery (New York, 1994-1998). Her publications include writings in *Nka*; *Art Journal*; *Cinema Remixed and Reloaded: Black Women Film and Video Artists* (University of Washington, 2008); *Black Light/White Noise: Sound and Light in Contemporary Art* (Contemporary Art Museum Houston, 2007); *Art and Social Justice Education: Culture as Commons* (Routledge, 2011) and *Service Media* (Green Lantern, 2013), among others. She holds a PhD and MA from the Department of English Language and Literature at the University of Chicago.

Paul Durica is the founder of Pocket Guide to Hell, free and interactive walks, talks, and reenactments on Chicago's past, some in collaboration with such organizations as the Jane Addams Hull-House Museum, Chicago History Museum, Gallery 400 at the University of Illinois Chicago, and Museum of Contemporary Art. In 2014 Durica helped organize *Let's Get Working: Chicago Celebrates Studs Terkel,* a three-day festival of readings, film screenings, music, and performance involving over thirty programming partners. His writings have appeared in *Poetry, The Chicagoan, Tin House,* and *Indiana Review,* and he is co-editor with Bill Savage of *Chicago By Day and Night: The Pleasure Seeker's Guide to the Paris of America.*

Bryce Dwyer is a writer, editor, and organizer from Chicago. He is a member of the group InCUBATE and the Managing Editor of Contemporary Art Daily.

ESCAPE GROUP, an artist collaborative based in Chicago and New York, was formed in response to a lack of individual resources globally and locally. Anchored by Anthony Romero and J. Soto, ESCAPE GROUP includes a

rotating cast of project-specific collaborators who collectively execute public and print-based projects. The group's name responds to the pressures of simultaneously holding their working class Latino/a heritage with the social hierarchies of knowledge and sensibilities that often pervade academia and art making. They believe the contemporary moment is one in which individuals must come together to form relationships founded on both commonality and difference.

Every house has a door was formed in 2008 by Lin Hixson, director, and Matthew Goulish, dramaturge, to convene project-specific teams of specialists that included emerging as well as internationally recognized artists. Drawn to historically or critically neglected subjects, *Every house* creates performances in which the subject remains largely absented from the finished work. Recent works include *Let us think of these things always. Let us speak of them never.* (2009) in response to the work of Yugoslavian filmmaker Dušan Makavejev, *Testimonium* (2013) a collaboration with the band Joan of Arc in response to Charles Reznikoff's *Testimony* poems, and the on-going project *9 beginnings* based on local performance archives.

Joanna Gardner-Huggett is an associate professor of Art History and an affiliated faculty member in the Women's and Gender studies program at DePaul University where she teaches courses on twentieth-century art and feminist theory. Gardner-Huggett's research focuses on the intersection between feminism and arts activism and has published articles and reviews in the journals *Afterimage, British Art Journal, caa.reviews, Frontiers: A Journal of Women's Studies, Social Justice* and *Woman's Art Journal*. Most recently she has written essays exploring the history of the Guerrilla Girls, the Feminist Art Workers, and the women artists' cooperative Artemisia Gallery in Chicago (1973-2003).

Ryan Griffis is an artist living in Chicago and Urbana, Illinois. His writing on art and culture has appeared in publications such as *New Art Examiner, RePublic, ArtUS, Artlink, Rhizome* and *Furtherfield*. He has curated exhibitions for the School of the Art Institute of Chicago, Turbulence.org, Greenmuseum.org, and George Mason University on themes that include the politics of genetic technologies, the growing energy crisis, and artistic forays into agriculture. Under the name Temporary Travel Office, Griffis has created works and publications that use tourism as an opportunity for critical public encounters. Now, he mostly works in the Midwest Radical Cultural Corridor with two group efforts, Compass Collaborators and Regional Relationships, to document and challenge the conditions of neoliberalism in unexpected places.

Tempestt Hazel is an independent curator, writer, artist advocate, and executive director of Sixty Inches From Center, a Chicago-based online magazine and archiving organization. Additionally, she is the arts program manager at the Arts Incubator in Washington Park with the University of Chicago. Her curatorial practice often uses archives and collections as a starting point to draw connections between a variety of histories and the work of contemporary, emerging artists. With Sixty Inches From Center, she advocates for artist legacy-building through arts journalism and ephemera while working to increase visibility of the Chicago Artists' Archive, a collection of over 10,000 records documenting artists in Chicago since the 1940s housed in the Harold Washington Library.

Honey Pot Performance is a woman-focused creative collaborative comprised of: Meida McNeal, Felicia Holman, Abra Johnson, and Aisha Jean Baptiste. Honey Pot forefronts African diasporic performance traditions drawing upon central notions found in performance studies, black feminist discourse, and sociology. Emphasizing everyday ways of valuing the human, the group engages performance methods that cultivate intimacy, unleash vulnerability, and invest in collaborative modes of making. They integrate movement, theater, and first-voice to examine the nuances of human relationships, the negotiation of identity, cultural memberships, and belonging and difference. Dismantling the infrastructure of oppressive social relationships also plays a role in their work.

Mary Jane Jacob is a curator, professor, and executive director of Exhibitions and Exhibition Studies at the School of the Art Institute of Chicago. Shifting her workplace from museums to the street, she critically engaged the discourse of public space with landmark exhibitions *Places with a Past* in Charleston, South Carolina, *Culture in Action* in Chicago, and *Conversations at the Castle* in Atlanta. Among her publications are the co-edited books *Buddha Mind in Contemporary Art*; *Learning Mind: Experience into Art*; *The Studio Reader: On the Space of Artists*; and *Chicago Makes Modern: How Creative Minds Changed Society*.

Paige K. Johnston is a curator, writer, and maker whose work explores the intersecting relationships of artists' publishing, design, and contemporary craft. While serving as manager of Special Collections for the Flaxman Library at the School of the Art Institute of Chicago, Johnston curated numerous exhibitions and produced a wide range of public programs. She previously worked in publishing and exhibition planning in Berlin and Boston. Johnston is one half of the collaborative duo life after life, which debuted their first work at Bétonsalon, Paris in the spring of 2014. She is

currently adjunct faculty in the Department of Interdisciplinary Arts at Columbia College, Chicago.

Faheem Majeed is an artist, educator, curator, and community facilitator. He blends his experience as a non-profit administrator, curator, and artist to create works that focus on institutional critique and exhibitions that leverage collaboration to engage communities in meaningful dialogue. From 2005 to 2011, Majeed served as executive director and curator for the South Side Community Art Center, during which he curated exhibitions of numerous artists including Elizabeth Catlett, Dr. David Driskell, Charles White, and Theaster Gates. In 2012 Majeed served as artist in residence for the University of Chicago's Arts in Public Life Initiative, and is currently is associate director and faculty of the School of Art and Art History at the University of Illinois at Chicago.

Danny Orendorff is an independent curator, writer, activist, and researcher whose work focuses on issues of non-normativity, social justice, affect, and DIY/craft-oriented contemporary art production. From 2013-2014 he was the curator in residence and interim director of artistic programs for The Charlotte Street Foundation in Kansas City, Missouri and has curated large group exhibitions for The Center for Craft, Creativity and Design, Asheville, North Carolina; SFCamerawork, San Francisco; Glass Curtain Gallery at Columbia College, Chicago; and MU Gallery, Eindhoven, The Netherlands. He has contributed criticism to numerous publications, including *Art in America Online* and *Bad at Sports*, and has written exhibition catalog essays for Grand Arts, Threewalls, and the Chicago Cultural Center.

Mary Patten has exhibited and screened video installations, videos, artists' books, and mixed-media projects for over twenty-five years in alternative spaces, university museums, and festivals, locally and internationally. Writing plays a significant role in her interdisciplinary art and media work, as well as autonomously. Her book-length pictorial essay, *Revolution as an Eternal Dream: the Exemplary Failure of the Madame Binh Graphics Collective,* was published by Half Letter Press in 2011. She has devoted much energy to ambitious collaborative and public projects, including the Chicago Torture Justice Memorials Project and Feel Tank Chicago. From 1993-96, Patten was editor of *White Walls*. Since 1993 she has taught in the Department of Film, Video, New Media, and Animation at the School of the Art Institute of Chicago.

John Ploof is an artist and professor of Art Education at the School of the Art Institute of Chicago. He works with participatory projects that uti-

lize art and visual culture to galvanize activity around social issues. He produced over twenty projects with the four-person art collective Haha. His publications include three books on social issues and contemporary art: *The Object of Labor: Art, Cloth, and Cultural Production* (MIT Press and SAIC Press, 2007); *With Love from Haha, Essays and Notes on a Collective Practice* (White Walls and University of Chicago Press, 2008); and *Culture as Commons, Art and Social Justice Education* (Routledge Press, 2012).

Michelle Puetz is the 2013-2015 Andrew W. Mellon Postdoctoral Curatorial Fellow at the Museum of Contemporary Art, Chicago. There, she has curated a solo exhibition with Chicago-based artist Lilli Carré and a group exhibition titled *Body Doubles* that explores gender fluidity, doubling and the performance of identity. She received her PhD from the University of Chicago in 2012 where she completed a dissertation titled "Variable Area: Hearing and Seeing Sound in Structural Cinema, 1966-1978." Michelle teaches in the Department of Film, Video, New Media and Animation at the School of the Art Institute of Chicago.

Lane Relyea teaches in the Department of Art Theory and Practice at Northwestern University and is the editor in chief of *Art Journal*. He has written widely on contemporary art since 1983, and his book, *Your Everyday Art World*, on the effects of communication networks on artistic practice and its contexts, was published by MIT Press in 2013.

Dieter Roelstraete is currently Manilow Senior Curator at the Museum of Contemporary Art, Chicago, and a member of the curatorial team convened by artistic director Adam Szymczyk to organize Documenta 14 in Kassel, Germany, in 2017. Roelstraete has published extensively on contemporary art and related philosophical issues in numerous catalogs and journals including *Afterall*, *Artforum*, *Frieze*, and *Mousse Magazine*.

Abigail Satinsky is a writer, curator, and organizer. She is currently the associate director at Threewalls in Chicago where her work includes editing *Phonebook* (a national directory of artist-run spaces and projects), and co-founding Hand-in-Glove, a national conference on grassroots arts organizing. She is also a founding member of InCUBATE and co-initiator of Sunday Soup, an international micro-granting project. InCUBATE's work has been shown nationally, most notably with Creative Time and the Smart Museum of Art at the University of Chicago. She is a regular contributor to the *Bad at Sports* podcast and her writing has appeared in *the Journal of Aesthetics and Protest*, *AREA Chicago*, and *Proximity*.

Cauleen Smith is an interdisciplinary filmmaker whose work reflects upon the everyday possibilities of the imagination. Smith's films, objects, and installations have been featured in group exhibitions at the Studio Museum of Harlem, New York; Houston Contemporary Art Museum; Blanton Museum of Art, Austin; San Diego Museum of Contemporary Art; New Museum, New York; DB 21 Liepzig, Germany; and Contemporary Art Center, New Orleans. She has had solo shows at The Kitchen, New York; Museum of Contemporary Art, Chicago; Schaulaher Laurenz Foundation, Switzerland; threewalls, Chicago; and Women & Their Work, Austin. Smith is the recipient of several grants and awards including the Rockefeller Media Arts Award, Chicago 3Arts Grant, and the Foundation for Contemporary Arts Grant.

Buzz Spector makes frequent use of the book in his work, both as subject and object, and is concerned with relationships between public history, individual memory, and perception. His work has been shown in museums and galleries including the Art Institute of Chicago; Museum of Contemporary Art, Chicago; Corcoran Gallery of Art, Washington, DC; and Mattress Factory, Pittsburgh. In addition to his editorship of *White Walls*, Spector has written extensively on topics in contemporary art and culture for *American Craft, Artforum, Art on Paper*, and *New Art Examiner*, among others. His recent book, *Buzzwords*, was published in 2012 by Sara Ranchouse Publishing in Chicago. Spector is professor of Art in the Sam Fox School of Design and Visual Arts at Washington University, St. Louis.

Encarnación M. Teruel is a cultural arts activist, artist, curator, educator, and funder. His collaboration with Violet Banks, *Sex Show/Cultural Perspectives on Sexuality in Society* was included in the exhibition *Art in Chicago 1945-1995* at the Museum of Contemporary Art, Chicago. He established the Performing Arts Department at the National Museum of Mexican Art, was the first Performing Arts Director at the Field Museum and named one of the *1996 Chicagoans of the Year for Culture* by the Chicago Tribune. Currently he is the director of Visual Arts, Media Arts and Multi-Disciplinary Programs at the Illinois Arts Council Agency.

Nato Thompson is chief curator at Creative Time in New York City where he has worked since 2007. There he has organized major projects such as The Creative Time Summit (2009-2013), Kara Walker's *A Subtlety...* (2014), Suzanne Lacy's *Between the Door and the Street* (2013), Trevor Paglen's *The Last Pictures* (2012), and *Living as Form* (2011). In 2005, he received the *Art Journal* Award for distinguished writing. His writings have appeared in numerous publications, *BookForum, Frieze, Art*

Forum, Parkett, Cabinet, and *The Journal of Aesthetics and Protest* among them. His book *Seeing Power: Art and Activism in the Age of Cultural Production* is forthcoming from Melville House.

Lynne Warren is curator at the Museum of Contemporary Art in Chicago where she has organized over twenty-five solo exhibitions of artists including *Robert Heinecken: Photographist* in 1999; *Dan Peterman: Plastic Economies* in 2004; and *Jim Nutt: Coming Into Character* in 2011. She served as the project director for the *Art in Chicago, 1945–1995*, the 1996 exhibition, which produced the first comprehensive book of Chicago's unique art history; project director and curator of the H.C. Westermann exhibition and catalog raisonné projects; and curator for the 2010 exhibition *Alexander Calder and Contemporary Art: Form, Balance, Joy* and edited the book of the same name. She has authored over thirty exhibition catalogs published by the MCA on national, international, and Chicago-based artists, and Chicago history and alternative spaces.

Mike Wolf currently resides in Rockford, Illinois, where—out of consideration for his neighbors and driven by a pragmatic aesthetic sense—he makes adequate effort to keep the lawn mowed. He finds it all quite acceptable and is generally happy. Of course, while he agrees with the wisdom that every place is interesting, he suspects wiser still is the understanding that wherever you live is good enough!

Kate Zeller is assistant curator in the Department of Exhibitions and Exhibition Studies at the School of the Art Institute of Chicago (SAIC). She has worked in recent years with artists Moon Kyungwon and Jeon Joonho, Kimsooja, and Wolfgang Laib to create site-specific installations for SAIC's Sullivan Galleries. Zeller is assistant editor of *Chicago Makes Modern: How Creative Minds Changed Society* and *The Studio Reader: On the Space of Artists.*

Index